British Fabrics

An illustrated sourcebook
of textiles, lace, trimmings,
rugs and carpets

Edited by Kylie Sanderson
Introduction by Paula Rice Jackson

WHITNEY LIBRARY OF DESIGN
an imprint of Watson-Guptill Publications/New York

First U.S. Publication in 1988 in New York by Whitney Library of Design
an imprint of Watson-Guptill Publications
a division of Billboard Publications, Inc.
1515 Broadway, New York, NY 10036

Published in Great Britain by Columbus Press Ltd

Copyright © 1987 by Columbus Press Ltd

Library of Congress Cataloging-in-Publication Data
British fabrics/edited by Kylie Sanderson;
 introduction by Paula Rice Jackson; designed by Nigel Simpson.

 p. cm.
 Bibliography: p.
 Includes index.
 ISBN 0-8230-0527-5
 1. Textile fabrics – Great Britain – Catalogs. 2. Textile industry – Great Britain – Directories. I. Sanderson, Kylie.
TS1768.B75 1988
67'.0029'441 – dc19 88-14241
CIP

While every care has been taken in the compilation of this book, the publishers cannot accept responsibility for any inaccuracies or omissions.

All rights reserved. No part of this publication may be reproduced or used in any form or by any means – graphic, electronic, or mechanical, including photocopying, recording, taping, or information storage and retrieval systems – without written permission of the publisher.

Typeset by Systemset Ltd, Hitchin and Island Graphics, Chesham.
Color Reproduction by David Brin Ltd, London EC1
Printed and bound in Hong Kong by Regent Publications Limited

Fabric pictured on the cover is Winslow Pastel cotton chintz by Sekers Fabrics Ltd., London. Used with permission of Clarence House, through whom the fabric is available in the United States.

Manufactured in Hong Kong

1 2 3 4 5 6 7 8 9 / 93 92 91 90 89 88

British Fabrics

Editor	Kylie Sanderson
Consultant Editor	Caroline Clifton-Mogg
Designer	Nigel Simpson
Layout Design	Steve Hollingshead
Design Assistant	Jane Wilby
Additional Research	Maxine Carew and Tess Leakey
Still Life Art Direction	Nigel Simpson
Still Life Photography	Lucinda Douglas-Menzies
Still Life Styling	Jane Phipps
Production	Brian Quinn

ACKNOWLEDGEMENTS

With thanks to Hugh Fleetwood, Mary Hill, Debra Stottor, Sasha Burn and Jill Mackie. Special thanks to Kay Douglas and Diana Cawdell for their help and suggestions throughout the writing of the book, and to LAPADA, for its help with the Antique Section. Produced in consultation with Williams & Grace Partnership. Props used in the still life pictures courtesy of LASSCo, London EC2 (architectural salvage); Paul Harnden, London SE1 (hand made shoes); Julie Foster, E1 (accessories); F&H Percussion, London E14 (drum).

The publishers would like to thank all those producers who provided fabric samples and photographs.

HOW TO USE THIS BOOK

British Fabrics is a directory listing quality fabric producers primarily for the furnishing fabric market. Certain sections, such as Wool, Linen and Speciality Fabrics, list fabrics not conventionally associated with furnishing, but which are listed by virtue of their pre-eminence in the British fabric tradition.

While the bulk of the book is concerned with British fabric, there is an International section which lists some of the best overseas fabric producers represented in Britain. British producers who supply the fabrics of international fabric companies are cross referenced to the International section.

The cross referencing itself is self-explanatory, and each section is preceded by a short note in defining the category and the types of fabric within it. The addresses given at the end of each entry are of the showrooms only, except in the case of the wool and linen mills, where the address of the mill is given together with, where applicable, a London agent. In the case of retail shops, the head office is given, with a note to ask the reader to enquire for the most convenient outlet. North American sources for many of the companies are supplied in the reference section.

The reader should note that some of the fabric producers within this book supply exclusively to interior designers or account holders; others, particularly the wool and linen mills, require a large minimum order (60-70 meters or more). It should be noted that these producers are *not* open to the retail market, casual enquirers or small-scale purchasers, and this will be indicated by "Trade" marked at the foot of the entry, or clearly stated within the text.

CONTENTS

Chintz	1
Cotton Prints	23
Cotton Weaves	61
Linen Union	75
Silk Prints	81
Silk Weaves	95
Linen	105
Wool	111
Childrens Fabrics	131
Lace & Sheers	135
Trimmings	147
Speciality Fabrics	155
Carpets & Rugs	169
Antique Fabrics	201
International	209
Reference	225

INTRODUCTION

Perhaps no characteristics of British fabrics are more distinguishing than their comfort and their opulence. To Americans who expect a certain standard of "performance" from textiles, whatever their function, the personal sense of ease and abundance that chintzes, tweeds, and the famed silk weaves produce continues to be sought after by homeowners, interior designers, and architects alike. As for the glamour of British textiles, it is, indeed, world class. Because the traditions governing much of what the English produced in the nineteenth century reflected the extent of Britain's global presence, the entire world profits today by the bringing together of varied and disparate textile manufactures that the British undertook to reproduce and thereby preserve.

Access to British textiles is growing in the American market. While certain firms still maintain a policy of exclusivity to the public at large, more manufacturers, through their distributors, are going public so that the city-style showroom is no longer the only place where fine British fabrics may be purchased. This is especially evident where mail-order catalogs now make availability that much easier, reducing the Atlantic to something of a pond. And with great commercial names such as Laura Ashley and Designers Guild strengthening their participation within the home-furnishings markets, greater awareness of the beauty and quality of fine English textiles is resulting in greater demand.

British fabrics also serve a didactic purpose on the American scene. Anyone who loves and appreciates the era of the grand British interior designers – Nancy Lancaster, the American Lady Astor, John Fowler, and the American Elsie de Wolfe, who brought back

to America lessons learned in England – knows the names of the firms whose fabrics were used with confident abandon throughout the great country houses of Britain: Colefax & Fowler, Liberty of London, and Warner & Sons, to name only a few. This book, *British Fabrics*, serves not only as a source guide but also as a barometer of what is being updated to meet the more eclectic trend that is beginning to emerge in American design as we face the 1990s. In fact, it is this special tradition of British fabric manufacturers – to adapt to the changing needs of markets – that makes the design, color, and construction of the fabrics uniquely British. It is what keeps the British textile industry vital, interesting, and essential to any professional who is working in fashion or home fashions today.

The American public's continuing interest in the English Country Style of decorating provides a growing, ever-ready audience that learns, uses, and profits by the classic motifs England has given the world. Americans, especially, appreciate a sense of enduring romance, high quality, an understated sense of color, a substantial product, and a devotion to inspired detail – all attributes exemplified by British fabrics. America's leading doyenne of English interior design, Georgina Fairholme, accurately describes this book as "a very helpful and informative book on a very wide range of fabrics." It should be added that the section on floorcoverings introduces a sector of the textile trade not well known in North America.

As with a great many things in life, "timing is everything." This volume's timely arrival comes at a moment when America's interest in British fabrics has never been greater.

PAULA RICE JACKSON
Executive Editor, *Interiors*

CHINTZ

Popular and well-known definitions of a chintz are taken from the origin of the word, which is the Hindi 'chint', meaning a vari-coloured cloth, introduced to Britain in the early 17th century from India. Later a chintz was taken to mean a certain style of pattern, usually, but not necessarily, with a glazed finish. However, these days a chintz has become synonymous with the glazed finish on cotton, and most fabric houses define a chintz as 100% glazed cotton. As there are very few exceptions to this rule, all fabrics included in the Chintz section are 100% cotton with a glazed finish.

Bloomsbury (below) *Ferndale* by Jane Churchill

Laura Ashley Decorators Collection

The latest *English Chintz* and *French Garland* collections are rapidly giving Laura Ashley a reputation for high quality chintzes; the Decorator Collection is very much more sophisticated than the High Street fabrics originally intended for interior decorators. The *English Chintz* collection includes *Donwell Abbey, Barton Cottage* and *Somerton Lacey* - appropriately 'rural' in feel. The colours include warm reds and browns. The *French Garlands* collection, including *Fantaisie, Fete, Georgian Stripe* and *Quartet*, is inspired by 18th century French silk ribbons. The two collections are well balanced, and the classic stripes and trellis designs have two coordinating all-over patterns, *Weed* and *Seaweed*.
See also under *Cotton Prints; Linen Union; Laces & Sheers; Trimmings*

Trade *Tel: (01) 730 1771/4632*

71/73 Lower Sloane Street
London SW1W 8DA
Fax: (01) 730 3369

GP & J Baker

Over 100 years old, GP & J Baker is one of the original and best known chintz houses producing their famous prints on untreated cotton and cotton chintz. One of the two founding brothers, George Percival, in the mid-nineteenth century, was a botanist and horticulturalist, and, in the course of his work, collected fabric designs from all over the world. These designs now constitute Baker's archives, which are traditionally based on designs from the Orient. New collections incorporate some traditional designs as well as modern geometrics, with sources as diverse as eighteenth century wallpaper fragments (as in *Hydrangea Bird, Canton* and *Peony*) and, in their recent collection *East to West*, traditional English floral designs (such as *Pencarrow Pelargonium* from prints found in a house in Cornwall); others include the flamboyant *Holyhead* and *Persimon; Tropical Paisley* and the floral *Primavera*.
See also under *Cotton Prints; Linen Union*

Trade *Tel: (01) 636 8412*

18 Berners Street
London W1P 4JA
Tlx: 83511 PARTEX G

Boras International (UK) Ltd

See under *International*

Nina Campbell Ltd

Nina Campbell, a successful interior decorator, has introduced her own chintz collections. Highly successful, the designs are based on traditional chintz and floral motifs. Recent ranges include *Tulip*, available in six colourways; *Sponge Chintz*, an all-over pattern; *Sprig Chintz*, small sprigs with a dotted ground; *Alice*, a faintly dotted trellis arrangement with carnations; and

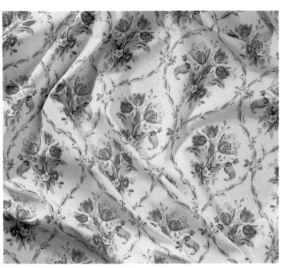

Scarborough Fair by Laura Ashley

Aquarius Collection by Chelsea Green

Nina, an abstract design. Still available from the first collection are *Carnation*, flowers with in a bold ribbon trellis; *Ribbon Trellis*; *Rose Chintz* and *Lily of the Valley*. Co-ordinating linens are being added to the collections, as are tiles and accessories.
See also under *Linen Union*

Tel: (01) 584 9401

9 Walton Street
London SW3 2JD
Tlx: 929480 NCAMPB

Manuel Canovas

See under *International*

Chelsea Green Fabrics

The standard ranges of designs are available on chintzes (and can be printed on heavy weight cotton satin on request). Chelsea Green's ranges include the largely abstract designs of *Aquarius*, available in five colourways with four designs on white ground, using pearlised shimmery finishes to pick out shell shapes. The *Flower Show* collection uses floral motifs for a more 'country house' effect, incorporating small floral prints, bouquets tied with ribbons and larger scale flower arrangements, available in four to six colourways, many of which intermix. *Flower Show* is printed on buttermilk ground. Both collections use fresh spearmint and lemony colours. Special designs can be made up on request.
See also under *Cotton Prints; Lace & Sheers*

Tel: (01) 581 2556

6 Cale Street
London SW3 3QV
Tlx: 268633 SABINT

Jane Churchill Ltd

Jane Churchill's look is an extremely successful one. Reminiscent of English country houses, her chintzes are based on traditional English floral motifs, and include *Bloomsbury*, with bouquets of pansies linked by chains of leaves and buds on a

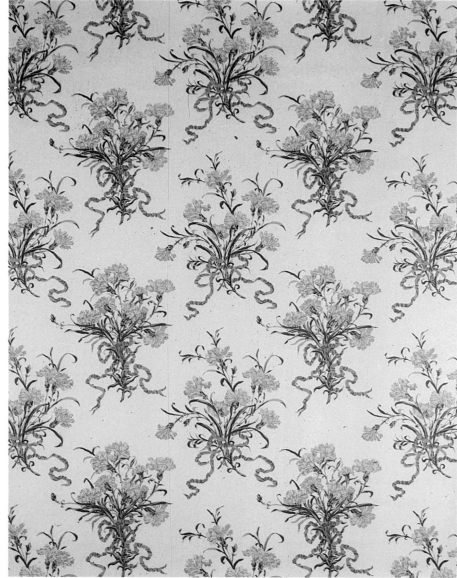

Ribbon Carnation by Cole & Son

striped background; there is *Ferndale,* available in four colourways, with roses on a background of ferns; *Holyrood,* a traditional damask with paisley motifs, available in three colourways; and *Cranbourne,* an abstract arrangement of small flowers on a marbled shell-like pattern.
See also under *Cotton Weaves*

Tel: (01) 824 8484

137 Sloane Street
London SW1X 9AY
and
13 Old Bond Street
Bath BA1 1BP
Tel: (0225) 66661
and
21 The Market Place
Kingston-upon-Thames KT1 1JP
Tel: (01) 549 6292

Cole & Son

A long established wallpaper company, Cole & Son launched their first chintz fabric collections in November 1986, taken from their vast archive of nineteenth century designs. The two collections are *Moire Prints* and *Traditional Chintz Fabrics,* both available in superb colours on top quality cotton, taken from the original blocks.
See also under *International*

Tel: (01) 580 1066

PO Box 4BU
18 Mortimer Street
London W1A 4BU

Colefax & Fowler

The company which, with the inimitable interior designers Sybil Colefax and John Fowler first launched the 'English country house' look on the world in the 1920s, has a vast range of chintzes for which it is justifiably famous. Many are taken from document prints. Recent ranges incorporate large scale designs, including *Clarissa*, a romantic, loose ribbon and floral arrangement; *Paeony*, using trailing bouquets; *Hampton*, small leaf motifs defined by dotted shading effects; and *Foxglove*, a striking large scale bouquet arrangement. *Geranium Leaf* comprises small leaf motifs, and *Convolvulus* has flowers on a tiny clover ground. Doyens of the chintz producers, all Colefax & Fowler's fabrics are of first rate quality.
See also under *Cotton Prints; Cotton Weaves; Linen Union; Laces & Sheers; Trimmings; Carpets & Rugs*

Tel: (01) 493 2231

*39 Brook Street
London W1 2JE
and
110 Fulham Road
London SW3 6RL
Tel: (01) 244 7427
Tlx: 8953136*

The Coloroll Store

Coloroll has, in its flagship store, two chintzes, *Ophelia* and *Daniella*, using traditional patterns.

Clarissa, Colefax & Fowler

Coloroll offers a wide range of cotton prints and an excellent childrens collection.
See also under *Cotton Prints; Childrens Fabrics*

Tel: (01) 434 0784

*156 Regent Street
London W1R 5TA
Tlx: 268426 CLRROL G*

Colour Counsellors Ltd

Primarily an interior design service, Colour Counsellors visit the home with a large colour co-ordinated range of fabrics. Colour Counsellors have now brought out their first range of fabrics, the *Parsons Green Collection*, based on designs from Courtaulds. The six ranges include chintzes and cotton prints, which are taken from Victorian chintzes from the Design Archives (see

CHINTZ

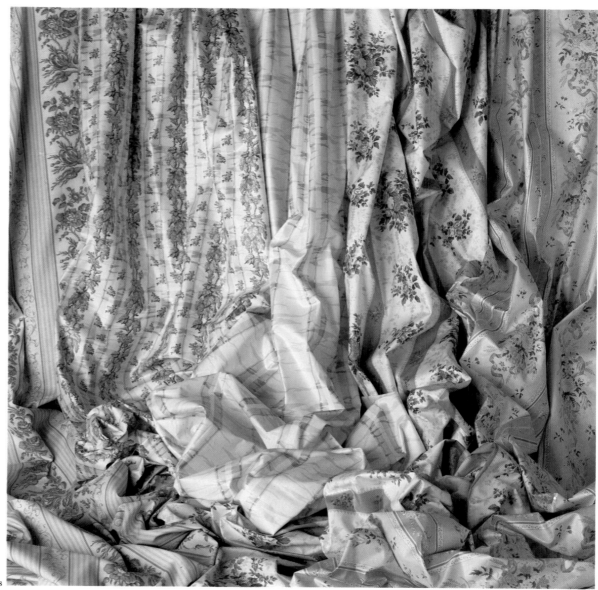

Parsons Green Collection by Colour Counsellors

under separate entry). The chintzes are *Floral Trail*, *Nosegay* and *Lilac Crinkle*, featuring small floral bouquets and stripes and traditional chintz motifs of ribbons and sprigs.
See also under *Cotton Prints*

Tel: (01) 736 8326

187 New Kings Road
London SW6 4SW

The Design Archives

Part of Courtaulds, the recently founded Design Archives produces magnificent prints taken from the largely unexploited Courtaulds archives, which remains one of the largest collections of document prints in Britain. From a choice of hundreds of thousands of documents, the Design Archives have selected a range of prints which include superbly coloured traditional floral motifs, adapted from prints which date back two hundred years. All fabrics are top quality, and include *Appassionata* (a large floral design on broad stripes), and *Chelsea Bouquet*, a Victorian style small floral design.
See also under *Cotton Prints; Silk Prints*

Trade *Tel: (01) 629 9080*

13-14 Margaret Street
London W1Z 3DA
Tlx: 28607
Shop:
79 Walton Street
London SW3

Appassionata by Design Archives

Designers Guild

Designers Guild, under the leadership of Tricia Guild, produces highly distinctive modern floral patterns often in pastel colours; other colourways are also available and are becoming more prevalent. Their chintzes include the *Ornamental Garden* ranges, and the *Waterleaf*. These large prints of full blown flowers are coloured with an attractive watercolour effect. Designers Guild offer a wide selection of co-ordinating fabrics and accessories for the home.
See also under *Cotton Prints; Cotton Weaves; Linen Union; Carpets & Rugs*

Tel: (01) 351 5775

271 & 277 Kings Road
London SW3 5EN
Tlx: 916121
Fax: (01) 352 7258

Dovedale Fabrics Ltd

A new and rapidly expanding company, Dovedale Fabrics has recently launched eight

Audley from *Effects II* by Dovedale

new ranges of fabrics. Of these, *Effects II* is perhaps the most interesting; whilst the inspiration derives from Louis XIV and XV Rococo, the designs are reminiscent of the newly fashionable Victorian Gothic in colour and feel, particularly in the red and brown colourway. *Effects II* is available in five styles (including stripes) and ten colourways. Other chintzes include *Kenilworth, Portland, Radcliffe* and *Longleat,* featuring crinkled fabric motifs.
See also under *Cotton Prints, Cotton Weaves*

Trade Tel: (0443) 815520

Caerphilly Road
Ystrad Mynach
Mid Glamorgan CF8 8TW
Tlx: 497680

Philip Edwards

Philip Edwards is a small company, producing chintzes and cotton prints. Chintzes include *Les Ciels,* an all-over shadowed design (nine colourways); *Shiraz,* an art nouveau style design (four colourways); and *Tania,* a floral design (four colourways). Philip Edwards also has prints from their collection of designs of the artist Caroline Hill. These include *Everlasting Flowers* (four colourways), *Tree and Trellis* (six colourways), *Daisy Ribbons* (five colourways), and *Pineapple,* an attractive pineapple print. All ranges provide adaptable, versatile prints and are available with co-ordinating wallpapers.
See also under *Cotton Prints*

Tel: (0306) 76166/885722

4 Guildford Road
Westcott
Dorking
Surrey RH4 3NR
Tlx: 8950511 ONEONE G

Mary Fox Linton

See under *International*

Susanne Garry Ltd

See under *International*

Charles Hammond

Established in 1907 to furnish the town and country houses of wealthy merchants, Charles Hammond has a huge range of chintzes taken

from the company's archives, which date from the early eighteenth century. New ranges include many traditional designs from England, France and India: some are hand block printed. Ranges include traditional designs such as *Carleton* (taken from a mid-nineteenth century print) and the dense floral arrangements of *Palmyra;* the Indian style floral designs of *Kanpur;* and the Oriental, butterfly motifs of *Chinese Winter.* Typically 'English' ranges include such country garden ranges as *Hollyhock & Ribbon*, and *Whigham*, both incorporating posies and ribbon motifs; *Brinklow* uses birds and squirrels while *Trentham Hall* is a magnificent design of vertically twisting branches with flowers and leaves. These fabics are seen to great advantage at the London Interior Design Centre, shared with Pallu & Lake, which has now merged with Charles Hammond.
See also under *Cotton Prints; Linen Union*

Tel: (01) 627 5566

Trade showroom:
London Interior Design Centre

1 Cringle Street
London SW8 5BX
Tlx: 25812 ARTEX G

Nicholas Haslam Decoration

Well-respected as interior designers, Nicholas Haslam offers a select range of cotton chintz. Expensive and original, the range incorporates

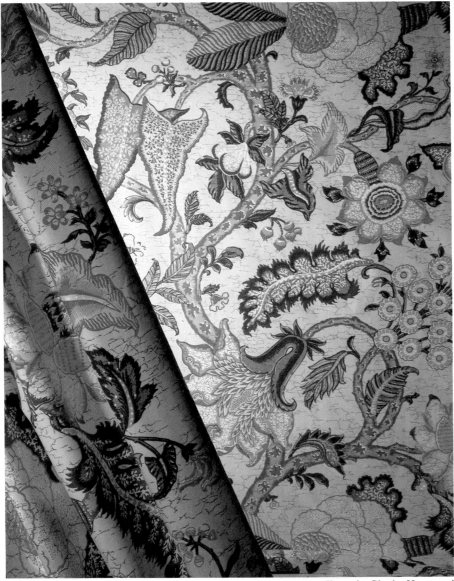

Kanpur by Charles Hammond

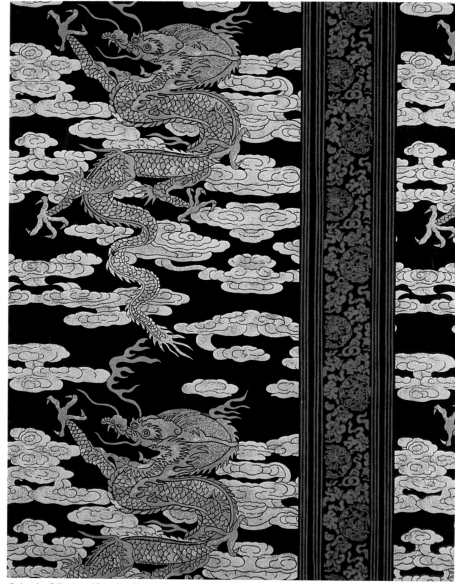

Opium by Liberty of London Prints

stripes available in superb colours on white ground.

Trade *Tel: (01) 730 8623*
12 Holbein Place
London SW1

David Hicks

David Hicks, the internationally known and highly successful interior designer, has launched the first new ranges of fabrics for ten years. The first, called *La Premiere,* comprises chintzes, cotton prints and cotton weaves. The chintzes are all available in three colourways and include *Dogger,* featuring ribbons in diamond shaped designs joined by a bow on striped background; *St Brides,* with flowers and the ribbon motif in Dogger on white ground; *Shannon,* using heraldic style prints, drawn in a linear, two-dimensional fashion on white ground; and *St Catherines,* comprising church style damask design in dark browns, fawn and grey. Other fabrics are being brought out in conjunction with Bernard Thorpe.
See also under *Cotton Prints; Cotton Weaves*

Tel: (01) 627 4400
101 Jermyn Street
London SW1Y 6EE
Tlx: 8812724 FALCON G
Fax: (01) 720 8907

Hill & Knowles

Simple but clever stencil-style designs; these

come with co-ordinating wallpapers and borders. The colours are attractive and soft. The *Perrywood Collection* has three designs *Foxden*, *Winterbourne* and *Bower*.
See also under *Cotton Prints*

Trade
Tel: (01) 948 4010
133 Kew Road
Richmond
Surrey TW9 2PN
and
9B Best Lane
Canterbury
Kent CT1 2JB
Tel: (0227) 454773

John Lewis Contract Furnishing

John Lewis, Oxford Street, has its own fabric and furnishing name, Jonelle, which is the name of the goods made in John Lewis' own work rooms or produced for the company. Jonelle comprises a wide collection of prints and weaves, available both as retail or for contract work. The chintzes are mainly floral, with abstract and all-over designs. Ready made curtains are also available. John Lewis Contract Furnishing is able to take on large scale contract work, and can negotiate contract prices on fabrics.
See also under *Cotton Prints; Cotton Weaves; Lace & Sheers; Childrens Fabrics*

Tel: (01) 629 7711
278-306 Oxford Street
London W1A 1EX
Tlx: 27824 JONEL LONDON

St Catherines by David Hicks

Liberty of London Prints

The wholesale division of the famous shop in Regent Street, Liberty PLC, all Liberty goods are produced here along with the furnishing fabrics, which are sold at Liberty retail outlets (of which there are ten throughout Britain and abroad). Liberty of London's recent chintz range is the *East Indian Collection*, comprising nine ranges, available in thirty-nine colourways. These include *Opium*, in the style of Chinese silk embroidery, with swirling dragons and clouds; *Suki*, a floral design; the rich, densely coloured *Mariana*; and *Capriccio*, uneven stripes. All fabrics from Liberty of London are characteristically stylish and sophisticated in colouring and design; many are taken from their extensive archives.
See also under *Cotton Prints; Linen Union*

Tel: (01) 870 7631
313 Merton Road
London SW18 5JS
Tlx: 928619
Fax: (01) 871 3175

Shirley Liger Designs

A new and sophisticated designer, Shirley Liger's collections, which include *Pot-Pourri* and *Impressions*, may be printed to order on a variety of fabrics including chintz. Her standard ranges are hand printed onto plain cotton; *Pot-Pourri* comprises a modern interpretation of garden images, such as butterfly, trellis and rose motifs printed on an attractive buttermilk coloured ground, available in seven colourways. In contrast, *Impressions* gives a smart, tailored look in strong colour combinations. Colours of fabrics can be matched to clients' specifications. Shirley Liger is known for having designed fabrics for Bernard Thorpe and Chelsea Green Fabrics.
See also under *Cotton Prints; Linen Union; Silk Prints*

Tel: (01) 673 3441

27 Narbonne Avenue
London SW4 9JR
Tlx: 8951182

Marvic Textiles

See under *Cotton Prints; Cotton Weaves; International*

Monkwell Fabrics

Monkwell offer a wide range of contract quality furnishing fabrics; reliable and well-established ranges include modern designs and traditional motifs.

Jean by Mrs Monro Ltd

See also under *Cotton Prints; Cotton Weaves; Linen Union*

Trade *Tel: (0202) 762456*

(Semple and Company Ltd)
10-12 Wharfdale Road
Bournemouth BH4 9BT
Tlx: 417179 MONKWELL
Fax: (0202) 762582

Mrs Monro

Considered absolutely at the top of the English chintz establishment, many of Mrs Monro's fabrics are still hand block printed. The chintzes are taken from document prints exclusive to the company; all the ranges are rich in colour, subtle in design and represent the quality of chintz production for which England is world famous.

Trade *Tel: (01) 589 5052*

11 Montpelier Street
London SW7 1EY

Nobilis-Fontan Ltd

See under *International*

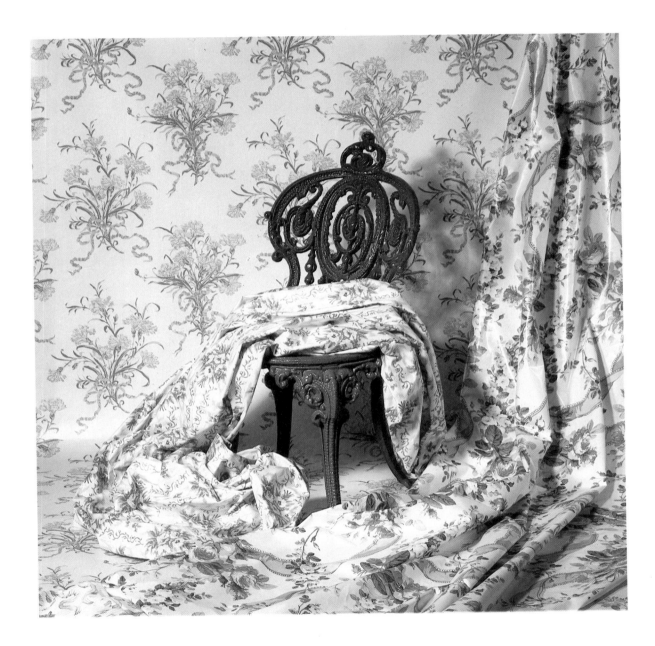

CHINTZ

Chintzes (clockwise from bottom left hand corner) *Dublin Rose* by Jane Churchill; *Ribbon Carnation* by Cole & Son; *Maryport* by Warner & Sons; (centre) *Bloomsbury* by Jane Churchill

Chesterfield by Ramm, Son & Crocker

Osborne & Little

Well-known for sophisticated and eclectic styles, Osborne & Little offers a continuous stream of new designs and ideas. Modern and inventive, the colours and patterns are always exciting. Chintzes include the modern floral motifs of *Arcadia*; *Siena*, an all-over marble effect; *Streamline*, a narrow stripe overlaid with a small ikat pattern from the *Regatta* collection; and *Stippleglaze*, offering plain chintzes to co-ordinate with the *Sirius* collection; Osborne & Little also distribute the Zandra Rhodes chintz collection (see under separate entry). All fabrics come with co-ordinating wallpapers and borders. There are also facilities for one-off specialist services. Osborne & Little also has showrooms in Edinburgh and Manchester.

See also under *Cotton Prints; Cotton Weaves; Silk Weaves; Trimmings; International*

Tel: (01) 352 1456

304 Kings Road
London SW3 5UH
Tlx: 8813128
Fax: (01) 673 8254
and;
43 Conduit Street
London WC1
Tel: (01) 734 5254

Pallu & Lake

See under *International*

Paper Moon

See under *International*

Parkertex Fabrics

Parkertex, now part of GP & J Baker, has a small selection of chintzes ideal for the contract market. *Fuchsia Bower* from the *Tatton Park Collection* is an example of the Parkertex style of prints, which is available with a matching cotton lace.

See also under *Cotton Prints; Cotton Weaves; Silk Prints; Lace & Sheers*

Trade *Tel: (01) 636 8412*

18 Berners Street
London W1P 4JA

Ramm, Son & Crocker Ltd

Over 100 years old, Ramm, Son & Crocker produce top quality chintzes using their archive prints to recreate the Victorian styles for which they were, at the turn of the century, well known. The latest range of chintzes are *Ispahan*, a nineteenth century floral print, using bold, elaborate motifs clearly inspired by styles of the Indian subcontinent; the late Victorian *Chesterfield*, a large-scale floral bouquet pattern; *Dorchester*, also taken from a late Victorian print, incorporating chrysanthemum bouquets on a broad stripe background; and the superb *Bangalore*, a classic tree of life design, based on a

nineteenth century Indian document. *Bangalore*, available in three colourways, is the most expensive of the new ranges, using striking, rich colours and exquisite designs. A large number of their ranges are hand screen printed in order to maintain both quality of reproduction and authenticity of design. Over one hundred and fifty designs are available in extensive colourways.

See also under *Cotton Prints; Linen Union*.

Trade *Tel: (06285) 29373*

13-14 Treadaway Technical Centre
Treadaway Hill
Loudwater
High Wycombe
Bucks HP10 9PE
Tlx: 848901

History of Ramm, Son & Crocker Ltd

Charles Ramm founded Ramm, Son & Crocker in 1891; prior to this, Ramm was closely associated with Warner & Sons (as it is now known). An expert in the textile business, Ramm joined Benjamin Warner in 1871, and in 1879 and the company was styled Warner & Ramm. Advertised as furniture silk manufacturers, their varied silks were highly regarded and often technically extremely complicated. As well as high quality silks and silk weaves, the company also printed cottons and chintzes and it was Ramm who was largely in charge of developing the printed fabric and tapestry side of the business. One of the reasons for Warner & Ramm's success as a company was their courting of 'upper class' taste, and their highly skilled reproductions of classic period designs. In 1885 Warner & Ramm took over one of the suppliers to the royal household, Norris & Co, and as a result received two years later probably their first order for fabrics for Windsor Castle. Warner & Ramm was dissolved in 1891, and Ramm, Son & Crocker established themselves as producers of chintzes, using designs influenced by India and the Far East as well as documents from Europe. Since that time the company has been in continuous production.

Rich & Smith

See under *International*

Ispahan by Ramm, Son & Crocker

Bangalore by Ramm, Son & Crocker

CHINTZ

Zanica by Zandra Rhodes

Zandra Rhodes

The Zandra Rhodes collection of glazed cotton is dynamic and powerful in design and colouring. The ranges include five designs, *Zanica, Srinagar, Balsas, Roccoco* and *Ruffles*. Inspired by the Orient and the Indian sub-continent, the fabrics are in bright, singing colours which complement Osborne & Little's own fabrics.

Trade *Tel: (01) 352 1456*

Available through:
Osborne & Little
304 Kings Road
London SW3 5UH
Tlx: 8813128
Fax: (01) 678 8254
and
43 Conduit Street
London W1
Tel: (01) 734 5254
and
Barton Arcade
Deansgate
Manchester M3 2AZ
Tel: (061) 834 0475

Sahco Hesslein UK Ltd

See under *International*

Arthur Sanderson & Son

Sanderson offers a huge range of fabrics; their chintzes include plains (which co-ordinate with their printed fabrics); seersuckers (poly/cotton

glaze); as well as their books of chintzes which include many of the well-known Sanderson floral designs. Most of the Sanderson ranges are however in cotton prints and linen unions, which includes their William Morris designs. Sanderson have the William Morris blocks, and their stock wallpapers includes the superb hand blocked William Morris collection. All ranges of fabrics are designed and coloured to mix-and-match.
See also under *Cotton Prints; Cotton Weaves; Linen Union; Carpets & Rugs*

Tel: (01) 636 7800

*52 Berners Street
London W1P 3AD*

Ian Sanderson (Textiles) Ltd

Ian Sanderson's recent chintz collection, *Show Case*, offers a range of floral designs on plain and striped background. *Show Case* includes *Garden Party*, sprigs of small flowers; *Blue Ribbons*, small flower and berry arrangements on a broad striped ground; and the larger prints of *Showpiece*. The *Hampton* collection offers complementary designs. Other chintzes include the *Pucker* and *Plain* range, comprising seersuckers and plains.
See also under *Cotton Prints; Cotton Weaves; Laces & Sheers; International*

Tel: (01) 580 9847

*70 Cleveland Street
London W1P 5DF*

Designs by Julia Fieldwich available through Schemes

Schemes

An Interior design company, Schemes produces its own small range of fabrics, designed by Julia Fieldwick. Attractive, lively, simple in design, the fabrics are easy to use, aimed to fit in with both modern and traditional interiors. They also have co-ordinating wallpaper, borders and tiles.

Tel: (01) 727 3775/1148

*56 Princedale Road
London W11 4NL
Fax: (01) 602 8480*

Muriel Short Designs

Distributes the *Wild Orchids* and *Claridge Stripe* collections by Titley & Marr (see under separate entry), showing characteristically rich colours and powerful designs. Other fabrics are from the *Return to India* collection. Muriel Short Designs also distributes a number of imported ranges, and produces wallpapers and borders. The parent company, ME Short Ltd, is known for a variety of interior design products.

Tel: (0483) 271211

Hewitts Estate
Elmbridge Road
Cranleigh
Surrey GU6 8LW
Tlx: 859313 MSHORT G

Sekers Fabrics Ltd

Sekers has an enormous variety of fabrics for both domestic and contract use. Chintzes from the latest collection *Inspirations* include *Illia*, a splashy, watercolour style floral; *Istra*, comprising gold diagonal stipes with similar colourings; and *Imalia*, a dotted pattern. In the *Classic Print Collections* are some wonderful, colourful paisleys. Alongside these are the seersucker glazed cottons and a wealth of co-ordinating fabrics. Sekers also has its own archives, from which traditional prints are re-designed and coloured to produce 'English' high quality prints.

Bladon through Spencer Churchill Designs

See also under *Cotton Prints; Cotton Weaves; Wool Trade*

Tel: (01) 636 2612

15-19 Cavendish Place
London W1M 9DL
Tlx: 265550 SEKINI G
Fax: (01) 631 5340

Spencer-Churchill Designs Ltd

Spencer-Churchill's first collection of fabrics, wallpapers and borders was launched for the 1987 IDI. The *Woodstock Collection* comprises seven designs using chiselled, crisply drawn leaf, flower and trellis motifs in geometrically precise arrangements. All designs incorporate relatively small scale prints, using art deco influenced motifs (as in *Wychwood*, *Evenlode* and *Windrush*); stylised, hard-edged bouquets in small leaf trellises (as in *Woodstock* and *Glympton*); or wrought iron styled circular leaves *(Burford)* and dotted trellis with random leaf motifs *(Bladon)*. Fabrics are available in five to seven colourways.

Tel: (01) 376 5428/9

55 Hollywood Road
London SW10 9HX

Clockwise from bottom left hand corner: *Helios* by Warner & Sons; *Longford* by Colefax & Fowler; silk weave by the Gainsborough Weaving Company Ltd

Empire Collection by Sue Stowell

Sue Stowell

Sue Stowell launched her first collection of fabrics in 1985. This has been enormously successful, and her recent collection, *The Classic Collection*, is the third and largest so far. *Lattice* and *Rose* (both available in five colourways) compliment each other; *Rose* comprises roses in large vases against a lattice background, while *Lattice* comprises loose lattice shapes. *Florentine* (five colourways) comprises a herring bone stitch pattern; but comprises small buds, and *Azelea* has large blooms with buds in the background. *Hydrangea* (four colourways) is an all-over design. Fabrics from the *Empire Collection*, the most recent from Sue Stowell, is illustrated above.

Retail *Tel: (01) 731 2050*

813 Fulham Road
London SW6
Tlx: 265871 MONREF G

Michael Szell Ltd

Michael Szell is unique. He hand prints designs in exquisite colours to customer specifications. The show room has on display lengths from many of his designs - recently Oriental and Regency in feel. His colours are subtle and very beautiful, ranging from gold to pinks and French greens. Any colour can be matched; the fabrics are his own (cotton, sheers, chintz, moire, velvet, light and heavyweight silk).
See also under *Cotton Prints; Cotton Weaves; Silk Prints; Lace & Sheers*

Trade *Tel: (01) 589 2634*

47 Sloane Avenue
London SW3 3DH

Textra Ltd

Textra offer a comprehensive range of fabrics ideal for the contract market. All collections are designed to co-ordinate or blend together, providing a certain amount of cohesion throughout. Their chintz collection is the *Bowes Collection*, offering five ranges of traditional floral chintz motifs, which are also available in linen unions. Other chintzes include *Wisteria & Laburnum*, *Wildrose* and *Hollyhock*. Ranges are available in about six colourways; on large enough orders Textra can produce special colourways to customer specification.
See also under *Cotton Prints; Cotton Weaves; Linen Union*

Trade *Tel: (01) 637 5782/3*

16 Newman Street
London W1P 4ED
Tlx: 837961 MACJEN G

Tissunique

See under *International*

Thorp & May Designs Ltd

Originally an interior decoration partnership, Anne Bigwood and Joanna Thorp launched their first range of chintzes and co-ordinating wallpaper for the Fine Art & Antiques Fair (1987). The designs are reworkings of traditional

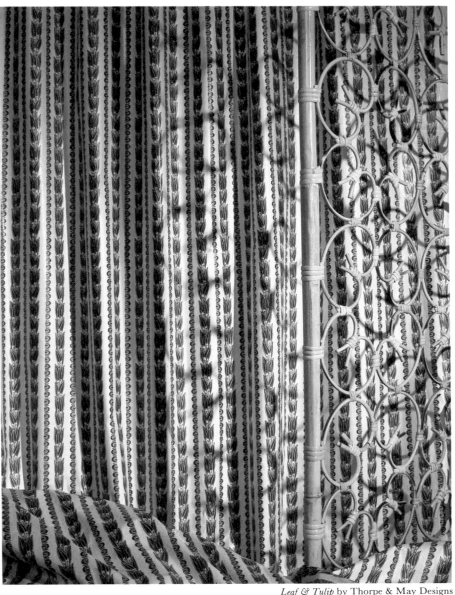

Leaf & Tulip by Thorpe & May Designs

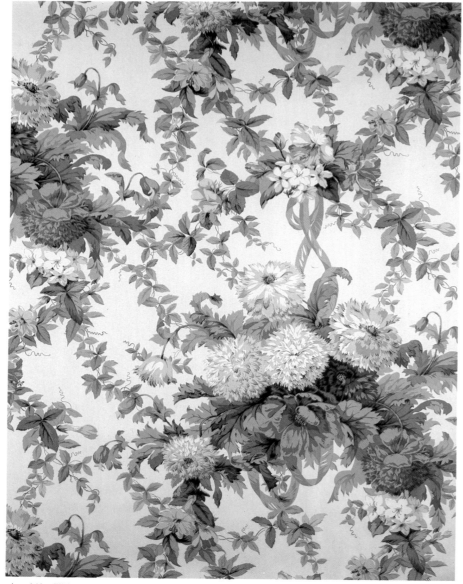

Arundel by Titley & Marr

chintz motifs, simplified to suit younger, more modern tastes. Fabrics are in floral, stripes and one-colour designs on cream or white ground. Each of the seven fabrics is available in four to five colourways, and special colourways can be produced to customer specification. Stripes and strip motifs include *Venetia* and *Georgiana;* florals include *Leaf & Tulip, May Garland, Thorpe Urn* and *Joanna;* and a small repeating leaf motif, *Caroline,* is available.

Tel: (01) 228 5044

Unit 6
Ransome's Dock Business Centre
35/37 Parkgate Road
London SW11 4NP

Bernard Thorpe

Hand screen printed custom designed fabrics are available in any of Bernard Thorpe's 108 standard colours on a variety of different fabrics. While all designs are produced by commission, the show room has an impressive range of show lengths should the client require a choice of past designs. The colours are fabulous; the designs are always fashionable.
See also under *Cotton Prints; Cotton Weaves; Linen Linen Silk prints; Lace & Sheers*

Trade *Tel: (01) 352 5745*

6 Burnsall Street
London SW3 3SR
Tlx: 9419778 THORPE G

Titley & Marr

Volume Two, Titley & Marr's recent collection, is characteristically vigorous and bold in design, making use of strong colours. All the designs are based on document prints dating back to 1827 available in five to six colourways. *Suffolk* is a tone-on-tone imitation damask; *Sandringham* is a lattice of ribbons; *Kensington Bows* is a winding ribbon and loosely tied bow arrangement; *Ulverston* incorporates a trellis of oak leaves and acorns on a thin striped ground; and *Hadleigh* uses looped ribbons on a white ground, with ivy leaves and tiny dotted speckles. Titley & Marr have designed fabrics for a number of other companies (including their *Wild Orchids* and *Claridge Stripe* for Muriel Short); they are now distributing all their own designs except those of Muriel Short.

Trade *Tel: (0730) 894351*

141 Station Road
Liss
Hampshire GU33 7AJ
Tlx: 86502 TITMAR G

Turnell & Gigon

See under *International*

Verity Fabrics

A fabric and ceramic tile producer, Verity hand screen print designs to customer specifications on a variety of different fabrics, including chintz. A huge range of designs is available in the showroom, some of which co-ordinate with their tiles.
See also under *Cotton Prints; Silk Prints; Childrens Fabrics*

Tel: (01) 245 9000

7 Jerdan Place
London SW6

Warner & Sons Ltd

Over 100 years old, Warner & Sons have a massive collection of fabrics, adding new collections each season. Many designs are taken from their extensive archives, reworked by their well-respected design studio. Greeff Fabrics in North America work in conjunction with the Warner studio, and many of Warners fabrics are from North America. Their chintzes are always superb in quality, ranging from traditional floral chintzes to modern abstracts.
See also under *Cotton Prints; Cotton Weaves; Linen Union; Silk Weaves; Wool; Lace & Sheers*

Trade *Tel: (01) 439 2411*

7-11 Noel Street
London W1V 4AL
Tlx: 268317

Brian Yates

The *Silverdale* collection is the British range of the stylish Brian Yates fabrics, designed by Sheila Combes. Inspired by the light and colours of the Southern Lakeland, this large collection contains floral prints, including the attractive *Borrowdale* and *Grasmere*. Fresh and sunny, *Buttermere* and *Ambleside* are particularly pretty. The fabrics co-ordinate with wallpaper and borders and corner friezes.
See also under *International*

Trade *Tel: (0524) 35035*

3 Riverside Park
Katon Road
Lancaster LA1 3PE
Tlx: 65264 YATES

Zipidi

Sunny, Mediterranean and versatile designs printed onto a variety of fabrics including chintz in the clients' own choice of colour.
See also under *Cotton Prints; Linen Union; Childrens Fabrics*

Trade *Tel: (01) 491 2151*

5 Deanery Mews
London W1

Chintzes by Brian Yates

Zoffany

A specialist producer of authentic period designs in wallpapers and co-ordinating fabrics, the *Temple Newsam Collection* of wall papers and fabrics date from designs of the 1500s. The first chintz, *Chintz Design*, dates from the mid to late nineteenth century, and comprises exotic birds and flowers on continuous vertically twisting branches. Recent ranges are the smartstriped cotton chintzes *(Hertford Stripe)* and fifty marbled cotton chintzes. Zoffany's colours are tasteful powdery tones and rich reds and browns.
See also under *Cotton Prints; International*

Tel: (01) 235 5295/7241

27a Motcomb Street
London SW1X 8JU
Tlx: 291120
Fax: (01) 259 6549
and
327 Upper Street
London N1
Tel: (01) 226 8643
Tlx: 291120
Fax: (01) 354 4074

COTTON PRINTS

Now one of the most versatile and widely used fabrics, the East India Company first brought printed calicoes, or chintzes, to London from the Orient during the early 1600s. These calicoes were much admired for their designs and colours, particularly because the English had no knowledge of how to fix colours onto cloth. It was not until 1676 that William Sherwin discovered the use of mordants, and from that time printing onto cotton spread from London to Lancashire and throughout the north of England. Because of the adaptability of cotton, most designers and companies have ranges of cotton prints, and the section includes a vast range of styles and designs ranging from *Toiles de Jouy* to contemporary abstracts by some of the most talented artists in Britain.

COTTON PRINTS

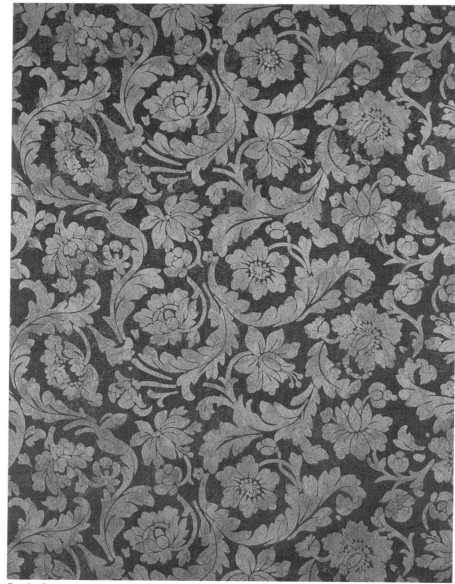

Doge by Laura Ashley

Laura Ashley Decorator Collection

Laura Ashley is rapidly moving up-market with its ranges of chintzes, many of which are also available on cotton satins. The Decorator Collection offers a more expensive range of fabrics than the high street branches, catering as it does for interior designers; its recent ranges include the *French Garlands Collection*, comprising traditional style floral and ribbon arrangements, and the *Venetian Collection*, a heavy cotton drill printed with dyes and metallic pigments giving an antique effect. The *Venetian Collection* is an interesting example of the newly fashionable gothic look, incorporating heavy damasks and damask style prints in rich Victorian colours and inspired by Italian Renaissance church designs. Ranges include *Doge, Rosario, Logetta, Caterina, Verona, Veneto, Torcello* and *Verona:* the names being as magnificent in tone as the style of the fabric.
See also under *Chintz; Linen Union; Lace & Sheers; Trimmings*

Trade　　　　　　　　　　*Tel: (01) 730 1771/4632*

*71/73 Lower Sloane Street
London SW1W 8DA*

Laura Ashley Home Furnishing

Not to be confused with Laura Ashley Decorator Collection, the Home Furnishing branches offer a smaller, more accessible range of fabrics, tiles and accessories. Cotton prints are available in a

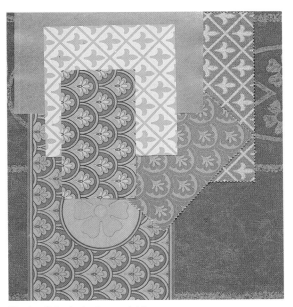

Venetian Collection by Laura Ashley

countrified, cottagey look. The address below can give addresses of branches throughout England.

See also under *Linen Union; Childrens Fabrics; Lace & Sheers; Trimmings; Carpets & Rugs*

Retail
Ask for Customer Service
Tel: (0628) 39151

Laura Ashley Ltd
Braywick House
Braywick Road
Maidenhead
Berks SL6 1DW
Tlx: 848508
Fax: (0628) 71122

Aurora Fabrics Ltd

Aurora Fabrics is the British contract division of Boras International, offering flame-proof contract quality fabrics for hospitals and county councils. Recent ranges are *Strawberry Bank*, large scale designs of patchwork fields, woods and cottages; *Arna*, horizontal zig-zag lines; and *Florentine*, a trompe l'oeil design using false perspectives and architectural motifs, painted in bright, dramatic colours. All fabrics are treated with Pyrovatex finish.

Trade
Tel: (0283) 41521

Unit 4A Boardman Industrial Estate
Heathcote Road
Swadlingcote
Burton-on-Trent
Tlx: 341989

GP & J Baker

Over 100 years old, GP and J Baker is one of the original and best known chintz houses, producing its famous prints both on cotton and chintz. Baker's archives are largely based on designs from the Orient. New collections incorporate traditional motifs as well as modern geometrical patterns. Cotton prints include the flamboyant *Holyhead*, and the painterly *Valley*, which are both available on soil resistant cotton; the recent *Midhurst* collection launched in May 1987 offers a huge range of plains on cotton satin in fifty colourways.

See also under *Chintz; Linen Union*

Trade
Tel: (01) 636 8412
18 Berners Street
London W1P 4JA
Tel: (01) 636 8412
Tlx: 83511 PARTEX G

Paisley by Bentley & Spens

Animal Solo by Celia Birtwell

Bentley & Spens

Bentley & Spens use a distinctive technique of batik and hand painting for prints on silk, linen and cotton. Sheers are also available. Formerly in the fashion business, Kim Bentley and Sally Spens have recently been working on projects with interior designers; work is taken on commission, and show lengths of their work can be seen at the address below.

See also under *Silk Prints; Lace & Sheers*

Trade Tel: (01) 352 5685

Studio 25
90 Lots Road
London SW10 0QD

Fish by Bentley & Spens

Celia Birtwell

Famous from the 1960s when she designed fabrics for Ossy Clark, Celia Birtwell's deceptively simple designs in the recent *Portobello Collection* are hand blocked onto a variety of fabrics including cotton. The colours are either blue on white or red on white (others, including black and gold, are available to order). The ranges are often interlinked through carrying over design themes, developing a simple motif into formal or more complicated arrangements. For instance, *Animal Solo* and *Animal Trellis* both feature emblematical style animals, the latter incorporating *Animal Solo* motifs within a trellis. The four *Westbourne Star Stripe* ranges (*Westbourne Star Stripe 1, 2, 3 and 4*) feature star and stripe motifs, which also appear in the striking *Starry Stripe*. Other designs include *Fancy Trellis Blotch; Pagodas; Portobello Paisley* and *California Positive*.

See also under *Linen Union; Silk Prints; Lace & Sheers*

Tel: (01) 221 0877

71 Westbourne Park Road
London W2 5QH

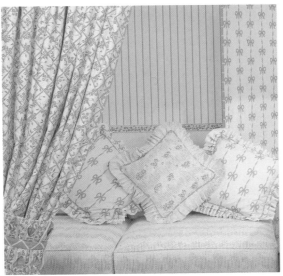

From the *Blossom & Stripes Collection* by Blossom (Fabrics) Ltd

Blossom (Fabrics) Ltd

Blossom has two collections, the latest is *Blossom & Stripes*. Designs of floral prints and stripe or broken stripe motifs on white or natural ground fabric are available in four to six colourways. Ranges may also have matching sheers and wallpapers, many of which are hand screen printed. Already easy to live with and versatile prints, special colourways can be produced to customer specification for large orders.
See also under *Lace & Sheers*

Trade *Tel: (01) 837 5856*

24 Duncan Terrace
London N1 8BS

Gabrielle Bolton

A small-scale producer of prints on hand loomed cotton and silk from India, Gabrielle Bolton's fabrics complement her designs on ceramics. The style is traditionally based, using balanced repeat patterns. Gabrielle Bolton will take commissions from the address below.
See also under *Silk Prints*; *Speciality Fabrics*

Tel: (01) 748 7062

128 Riverview Gardens
Barnes
London SW13 9RA

Boras International (UK) Ltd

See under *International*

Bowland Prints Ltd

A producer of fabrics and bedlinen, into which roughly half the fabrics are made, Bowland Prints is a member of the Raylon Group, offering a wide range of prints including their new *Downham Collection*. The designs are in mellow colours using floral and abstract prints. The *Downham Collection* is hand screen printed, and can incorporate individual designs and colour combinations for those requiring exclusivity. The designs are available on satinised cotton, suitable for curtains and upholstery. Other ranges include *Nocturne* and *Caprice*.

Trade *Tel: (0978) 843444*

Hall Lane
Rhos
Wrexham
Clwyd LL14 1TG

COTTON PRINTS

Cotton satin fabrics by Gabrielle Bolton

Linda Bruce Studio

The first fabric range from this talented designer is the *Opera Collection*, which includes such ranges as *Traviata*, a trompe l'oeil design; *Rigoletto*, a ribbon arrangement; and *Tosca & Aida*, crumpled stripes.

Trade *Tel: (01) 741 0604*

17 Powis Terrace
London W11 1JJ

Chelsea Green Fabrics

The firm's standard ranges are available on heavy weight cotton satin on request, and include the semi-abstract designs of *Aquarius*, available in five colourways with four designs on white ground, using pearlised shimmery finishes to pick out shell shapes. The *Flower Show* collection uses floral motifs for a more 'country house' effect, incorporating small floral prints, bouquets tied with ribbons, and larger scale flower arrangements, available in four to six colourways, many of which intermix. *Flower Show* is printed on buttermilk ground. Both *Aquarius* and *Flower Show* use fresh, spearmint and lemony colours. Special designs can be made up on request.
See also under *Chintz; Lace & Sheers*

Trade *Tel: (01) 581 2556*

6 Cale Street
London SW3 3Q
Tlx: 268633 SABINT

Opera Collection by Linda Bruce

Colefax & Fowler

Colefax & Fowler is famous for its chintzes, many of which are taken from document prints. Ranges available on cotton include the ever popular *Oak Twig*, an all-over design incorporating oak leaves; *Berkeley Sprig*; *Bailey Rose*, a full-blown rose motif available with a chintz; *Strawberry Leaf* and *Hunting Scene*.
See also under *Chintz; Cotton Weaves; Linen Union; Laces & Sheers; Trimmings; Carpets & Rugs*

Tel: (01) 493 2231

39 Brook Street
London W1 2JE
and
110 Fulham Road
London SW3 6RL
Tel: (01) 244 7427
Tlx: 8953136

Collier Campbell

Susan Collier and Sarah Campbell, the well-known sister design team and winners of several awards for their designs, are distributed through

Our Garden and (left) *Sherpa* by Collier Campbell

Christian Fischbacher. The cotton prints are extremely inventive; painterly in style, they preceded the Munro and Tutty team, which is also distributed through Fischbacher. The most recent range is *Carte Blanche*, on a Scotchguarded fabric and comprising exciting colourways including unusual chocolate brown shades. Designs include the impressionistic still life, *Room with a View;* the zig-zag, bold *Blaise; Savoy*, geometric in pattern; the ikat effects of *Sherpa;* the large bouquet on plain ground in *Mary's Room;* and *Our Garden*, wavy line motifs with leaves loosely over painted. Confident in execution and concept, Collier Campbell's other

COTTON PRINTS

Cotton prints by Sarah Collins

ranges include the successful *Six Views Collection* and *Painted Scenery*.

Trade *Tel: (01) 580 8937*

Available through:
Christian Fischbacher
42 Clipstone Street
London W1P 8AL

Dancing Men by Sarah Collins

Anne Collin

A small producer, Anne Collin prints abstract designs on cotton satin and calico. Her prints work well on large scale areas. The colours range from white and pale yellow on natural ground to deep greens and soft mauves on white. Successful commercially, Ann Collin has a large stock of her ranges (which include *Clifton I & II*, *Maisie*, *Charlotte* and *Lavinia*) and can print special colourways on other fabrics including sheers.
See also under *Lace & Sheers*

Trade *Ask for Ann Collin*
Tel: (01) 607 5126

91 Lofting Road
London N1

Sarah Collins

A small-scale producer of prints on silk and cotton, Sarah Collins works to commission, specialising in modern, geometrical hand-printed designs specifically for antique furniture. Sarah works from home and has a small outlet, 'By George'.
See also under *Silk Prints*

Ask for Sarah Collins
Tel: (058) 283 3483

Home Farm
Delaport Gustard Wood
Wheathampstead
Herts AL4 8RQ
Shop:
'By George'
23 George Street
St Albans
Herts
Tel: (0727) 53032

The Coloroll Store

Coloroll has, in its flagship store, a wide range of cotton prints, including floral, countrified styles and bold geometrics. Coloroll has a little of all the fashionable styles, presenting a good range of designs.
See also under *Chintz; Childrens Fabrics*

Tel: (01) 434 0784

156 Regent Street
London W1R 5TA
Tlx: 268426 CLRROL G

COTTON PRINTS

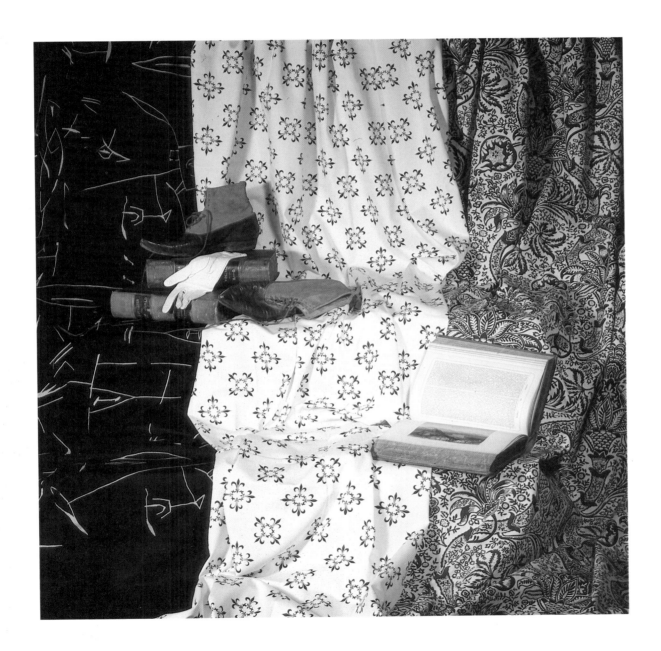

Left to right: print by Jasia Szerszynska; *Fleur-de-Lis* by Palmer-Phipps Design Associates; *Indian* by Arthur Sanderson

Colour Counsellors Ltd

Primarily an interior design service, Colour Counsellors visit the home with a large colour co-ordinating range of fabrics. Colour Counsellors has now brought out its first range of fabrics, the *Parsons Green Collection*, based on designs from Courtaulds. The six ranges include chintzes and cotton prints, taken from Victorian chintzes in the Design Archives documents. Cotton prints are the paisley *Ottoman Stripe;* and *Rambling Rose*, featuring a wild rose design within broad stripes. These fabrics are designed to co-ordinate easily with a variety of colour schemes.
See also under *Chintz*

Tel: (01) 736 8326

187 New Kings Road
London SW6 4SW

The Contemporary Textile Gallery

The Contemporary Textile Gallery (CTG) is a division of the Vigo Carpet Gallery, one of the longest established Oriental Rug Galleries in Britain. The CTG serves as a showroom and stockist of British handtufted rugs, tapestries and wall-hangings, and, to a lesser extent, artists producing printed fabrics. Commission may be taken through the CTG, and for those interested in good quality, interesting, specialised fabrics of an entirely modern nature, the CTG is highly recommended.

See also under *Silk Prints; Speciality Fabrics; Carpets & Rugs*

Tel: (01) 439 9070

10 Golden Square
London W1R 3AF

Corney & Company

Corney & Company produce attractive prints in one colour, using dusty browns, blues and greens on white or buff backgrounds. Designs, including the famous *Loganberry*, are simple and abstract on rough textured cotton. *Landscape, Hollow Landscape* and *Outlines* are wavy horizontal lines on white or cotton satin.
See also under *Silk Prints*

Trade Tel: (0580) 712177

Available through:
Foursquare Designs
Coursehorn Lane
Cranbrook
Kent TN17 3NR
Tlx: 98691 TLX1R

Creation Baumann

See under *International*

Danielle

Danielle Ltd's prints, best seen on silk, are also available on cotton. The prints, which are either hand or machine printed, include pretty,

Annie Doherty (see under *Silk Prints*)

feminine, ideal bedroom fabric and more exotic and formal designs. All five books co-ordinate, and thus give a sense of continuity in colour throughout the collection. The names of the ranges, such as *Anastasia*, appropriately recall both a touch of Russian elegance and the English Woman's garden. Wallpapers, tiles and accessories are also available.

See also under *Silk Prints; Lace & Sheers*

Tel: (01) 584 4242/1990

148 Walton Street
London SW3 2JJ

The Design Archives

Part of Courtaulds, the recently founded Design Archives produces magnificent cottons and chintzes, taken from the largely unexploited Courtaulds archives which remain one of the largest collections of documents in Britain. From a choice of hundreds of thousands of documents, the Design Archives has selected a range of prints which include the dramatic *Caliph*, incorporating exotic, Eastern motifs in striking, 'masculine' colours, and two superb *Toiles*, *Harvest* and *Amadeus*, dating from the early

nineteenth century, available in green, red and blue.
See also under *Chintz; Silk Prints*

Trade *Tel: (01) 629 9080*

13-14 Margaret Street
London W1Z 3DA
Tlx: 28607
Shop:
79 Walton Street
London SW3

Designer Style

Designer Style's *Pastiche Collection* offers seven ranges, each in three to four colourways, featuring florals, both on plain and marbled grounds; and diamond and lattice shapes with borders. The colours available are muted stone shades and pastels. The latest ranges in the new *Jacquards & Silks* collection are listed in a separate section.
See also under *Cotton Weaves*

Tel: (0268) 777831

27-29 Eastwood Road
Rayleigh
Essex
Tlx: 993169 STYLE G

Designers Guild

Designers Guild's instantly recognisable and popular designs by Trisha Guild are available in cotton prints, notably the *Filigree* range, *Gardenia* and *Trees*. Some of the more interesting cotton prints are those from Caroline Grey, whose painterly designs are also available to order on silk. These are free in design, and slighly off-key for the general style of the company.
See also under *Chintz; Cotton Weaves; Linen Union; Carpets & Rugs*

Tel: (01) 351 5775

271 & 277 Kings Road
London SW3 5EN
Tlx: 916121
Fax: (01) 352 7258

Dovedale Fabrics Ltd

A new and rapidly expanding company, Dovedale Fabrics has a wide range of cotton prints available on cotton satin, plain and heavy weight cotton qualities. Classical floral designs, stripes, abstracts and Oriental inspired designs, and a large collection of plains are available. Dovedale also distribute the Kenneth Turner floral prints (see under separate entry).
See also under *Chintz, Cotton Weaves*

Tel: (0443) 815520

Caerphilly Road
Ystrad Mynach
Mid Glamorgan CF8 8TW
Tlx: 497680

Jason D'Souza Designs

Jason D'Souza's prints on silk, cotton and voiles show a mixture of the eastern exotic and English floral. All ranges are hand printed; gold and silver metallic threads are often used. The style of Jason D'Souza's fabrics gives a sense of glamour, and he has captured something of this market. Quilted covers, cushions and pillows are also produced.
See also under *Silk Prints; Lace & Sheers*

Tel: (01) 253 9294

28 Graham Street
London N1 8JX
Tlx: 296716 DIESPK G

Edinburgh Weavers

Edinburgh Weavers is the contract side of Sundour Fabrics, which is part of the Home Furnishing Division of Courtaulds. The firm's range of cotton prints is available with special finishing (Scotchguard and flame retardancy). Ranges include the ikat style *Glen Urquhart*, a floral design in three colourways; the masculine *Gleneig*, geometric designs, the lines of which smudge and appear to run into each other, available in 4 colours; and *Glenfinnan*, again, masculine in style and colours, using wavy, geometric designs. Edinburgh Weavers offers a

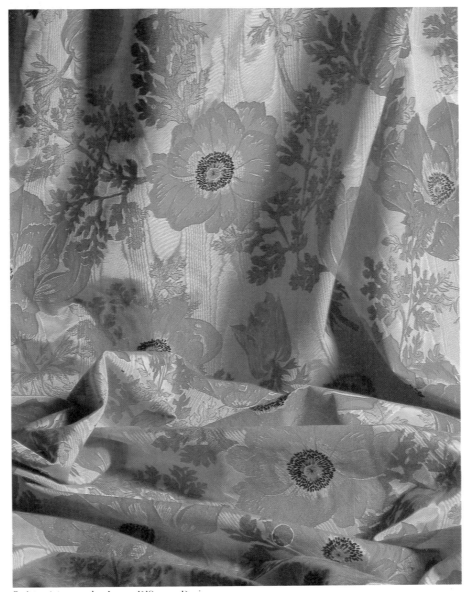

Sculptured Anemone by Jason D'Souza Designs

COTTON PRINTS

Monet by Philip Edwards

professional, efficient service to the contract market.
See also under *Cotton Weaves*

Trade

Tel: (0204) 387802
Sundour Fabrics
Robin Hood Mill
Lever Street
Bolton
Lancashire BL3 6NY
Tlx: 635293 SNDOUR

Philip Edwards

A small company, Philip Edwards produces chintzes and cotton prints in versatile, highly adaptable designs, most of which are available with wallpapers. The *Pimlico Collection* is hand screen printed, featuring seven geometrical designs (seven colourways). Other prints include the popular *Monet,* a mottled design on cotton satin (thirty colourways); and the rag-rolled

Tindale Fell by Foursquare Designs

effect, *Ragtime* (twenty-four colourways); *Stripes,* a shirting-style stripe (nine colourways); the stripe-cum-braiding effect of *Brooklands;* and the thin broken lines of *Ashley* (seven colourways). See also under *Chintz*

Tel: (0306) 76166/885722

4 Guildford Road
Westcott
Dorking
Surrey RH4 3NR
Tlx: 8950511 (ONEONE G)

English Eccentrics

Established fashion designers, English Eccentrics' first furnishing fabric collection,

Rough Cast by Anna French

designed by Helen Littman, includes the *Gaudi* range, available in three designs (three colourways), taking its inspiration from Gaudi-esque broken pavement effects in dusty, powdery colours. Co-ordinating fabrics also available. The new shop offers off-key accessories for home decoration.

Tel: (01) 729 6233

9-10 Charlotte Road
London EC2A 3DH
Tlx: 23354
and
155 Fulham Road
London SW3 6SN
Tel: (01) 589 7156

Christian Fischbacher

See under *International*

Foursquare Designs

Bold, painterly and highly original, Foursquare Designs' collections are available on white ground, using pared-down strikingly simple images. *Tindale Fell*, using one colour, incorporates images of cows and cottages. *Venezia* is an effective watercolour style design of vertical strips of short horizontal dashes in co-ordinating colours. Other fabrics include *Carnakio* and *Naiad*. Foursquare also act as agents for Corney and Company (see under separate entry).
See also under *Lace & Sheers; International*

Tel: (0580) 712177

Corsehorn Barn
Corsehorn Lane
Cranbrook
Kent TN17 3NE
Tlx: 896691 TLM1R

Anna French Fabrics

Best known for laces, Anna French's recent range is the *Surfaces Collection*, richly designed abstracts in mix and match co-ordinating rusts, red/oranges, browns and turquoise, available in a resin glaze. Other ranges include the country garden floral collections, *Isolde, Sweet Pea* and the attractive *Mimi Intermezzo*. One of the prettiest is the *Indira*, Eastern-derived style of large bunches of flowers arranged between two verticle borders. Another modern style is the *Skylights Collection*, geometric blocks, short brush strokes in crayon-like print; these include *Jumping Jack* and *Angry Arthur*. Anna French also handles the distribution of Missoni Margo Fabrics.
See also under *Lace & Sheers; International*

Tel: (01) 351 1126

343 Kings Road
London SW3 5ES

Tapestry and *Glaze* by Anna French

Graham & Green

Graham & Green specialise in imported fabrics from India, and have a small range of their own printed cottons. The three ranges, *Jungle*, *Paw*, and *Star*, are spikey designs in one colour on natural ground, available in black, pastels and reds.

Retail
Ask for Antonia Graham
Tel: (01) 727 4594

4 & 7 Elgin Crescent
London W11 2JA

Paw by Graham & Green

Charles Hammond

Best known for its huge archives and chintzes, Charles Hammond has a relatively small collection of cotton prints which include *Regency Stripe*, available in about ten colourways on cotton satin; the traditional style *Buckingham Toile*; the monotone *Matley* and the modernistic *Birdwatch* of highly stylised birds.
See also under *Chintz; Linen Union*

Tel: (01) 627 5566

Trade showroom:
London Interior Design Centre
1 Cringle Street
London SW8 5BX
Tlx: 25812 ARTEX G
Fax: (01) 622 4785

David Hicks

David Hicks, the well-known and successful interior designer, has launched his first new range of fabrics for ten years, called *La Premiere*.

Front: *La Chasse* by Marvic Textiles; (backing fabric) *Amadeus* by The Design Archives; (centre) *Country Trophy* by Kenneth Turner

Fabrics from *La Premiere Collection* by David Hicks

It consists of chintzes and cotton weaves. The cotton print designs are *Bailey*, a fairly small print of stylised flowerheads in trellis design; and *Viking*, a flat, surface design incorporating adapted heraldic motifs in tasteful, clever colours. Both designs are available in five colourways.
See also under *Chintz; Cotton Weaves*

Tel: (01) 627 4400

101 Jermyn Street
London SW1Y 6EE
Tlx: 8812724
Fax: (01) 720 8907

Hill & Knowles

Hill & Knowles has several cotton print collections, including the American oil cloth style *Kent* and *Stencil Collection.* These are artlessly effective, both printed onto plain, off white natural background in a stencil style, using stoney, dusty colours. The *Ragging Collection* comes with the *Bird & Leaves* fabric, blue on white, or white on blue. All collections co-ordinate with wallpapers and borders.
See also under *Chintz*

Trade *Tel: (01) 948 4601*

133 Kew Road
Richmond
Surrey TW9 2PN
and
9B Best Lane
Canterbury
Kent CT1 2JB
Tel: (0227) 454773

Hinchcliffe and Barber

Best known for their spongeware platters and ceramics, Hinchcliffe and Barber has expanded into furnishing fabrics, yet still employing the successful 'sponged'-look designs. Block printed fabrics incorporating animal and bird designs, and discharge printed lightweight fabrics are also available.

Tel: (07255) 549

5 Town Farm Workshop
Sixpenny Handley
Salisbury
Wilts SP5 5PA
Tlx: 937400 ONECOM G

Interior Selection

All fabrics are modern in design, and available with wallpapers, borders and accessories. The most recent collection incorporates dramatic

colour schemes and designs. Ranges include *Andante*, a painterly, loosely drawn abstract with stippled effects; *Caspia*, which makes use of deep blues and sea greens; and strong designs, such as *Balthazar*, featuring geometric floral prints. Other fabrics include the *Porcelain* range, with the popular *Crackle Glaze*, a semi-plain fabric overlaid with lines imitating the cracked surface of pottery.
See also under *Cotton Weaves; Trimmings*

Trade Tel: (01) 602 7250

Springvale Terrace
London W14 OAE
Tlx: 296961 INTSEL G

David Ison Designs Ltd

David Ison has two collections of cotton prints, the most recent being *The Country Way*, available with wallpapers, borders and twenty eight fabrics. David Ison also import a large number of French and American fabrics.

Tel: (01) 2551557

75 Newman Street
London W1

JAB International

See under *International*

K & K Designs

K & K Designs' first original range, *Littleprints*, is, as the name suggests, a range of two-colour

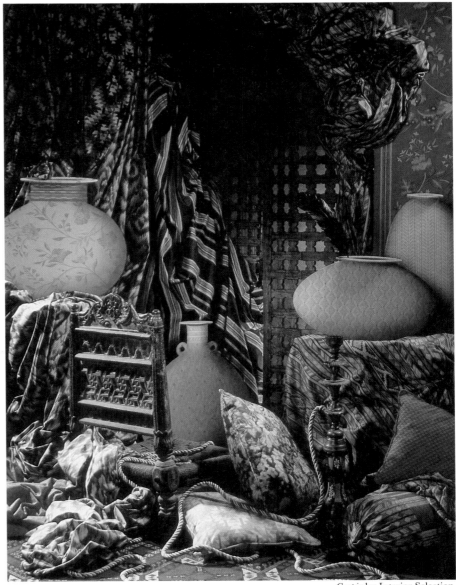

Caspia by Interior Selection

prints of sprigs, sprays and small flowers. Colourways include pastels, fresh lemon and green, and deep navy and red. These versatile designs are available with vinyl wallcoverings, borders and accessories. *Littleprints* is K & K Designs' follow-up to its successful Lina Brown collection from Germany.

Trade

Tel: (01) 367 2011
123/125 Baker Street
Enfield
Middx EN1 3HA
Tlx: 21700 G

Stefan Keef Ltd

Stefan Keef has its own print works where its designs are printed onto a variety of fabrics, mainly top quality cotton and silk. The latest collection, *Phase 1*, consists of ten abstract designs (ten colourways). Its *Classic Range*, seen at its most striking in black and white, can be printed in any colour on a choice of materials, including voile, silk and cotton. Other ranges include the animal designs.
See also under *Silk Prints; Lace & Sheers*

Tel: (0634) 718871
No 7 Henley
Trident Close
Sir Thomas Longley Road
Frindsbury
Rochester
Kent ME2 4ER

Kendix Designs

See under *International*

Ivy by Kenneth Turner;
Little Prints by K&K Designs

Glendowan and *Tralee* by Jonelle, John Lewis Contract Furnishing

Christopher Lawrence

Christopher Lawrence's designs are hand screen printed using metallic colours (seen in the *Venice* range) and strong, rich colourways (seen in *Alternative Lines*). The collections include both traditional floral prints and modern designs and small abstract motifs.

Tel: (01) 385 5167

Christopher Lawrence Textiles & Lighting Ltd
283 Lillie Road
London SW6 7LN
Tlx: 27950

John Lewis Contract Furnishing

John Lewis, Oxford Street, has its own fabric and furnishing name, Jonelle, which is the name of the goods made in John Lewis' own work rooms or produced for the company. Jonelle comprises a wide collection of prints and weaves, available both as retail or for contract work. Its cotton prints are mainly floral, with abstracts and all-

over designs. Ready made curtains are also available. John Lewis Contract Furnishing is able to take on large scale contract work, and can negotiate contract prices on its own fabrics.
See also under *Chintz; Cotton Weaves; Lace & Sheers; Childrens Fabrics*

Tel: (01) 629 7711

278-306 Oxford Street
London W1A 1EX
Tlx: 27824 JONEL LONDON

Liberty of London Prints

Liberty of London Prints is the wholesale division of the famous shop in Regent Street, Liberty PLC, and produces all Liberty goods, including the furnishing fabrics, to be sold at Liberty retail outlets (of which there are ten throughout Britain and abroad). Liberty of London's cotton prints are the well-known *Chesham I* collection, comprising twelve ranges in twenty-five colourways; and the recent *Chesham II* collection of fourteen designs in thirty to thirty-five colourways. All fabrics from Liberty of London are characteristically stylish and sophisticated in colouring and design; many are taken from its extensive archives.
See also under *Chintz; Linen Union*

Tel: (01) 870 7631
313 Merton Road
London SW18 5JS
Tlx: 928619
Fax: (01) 871 3175

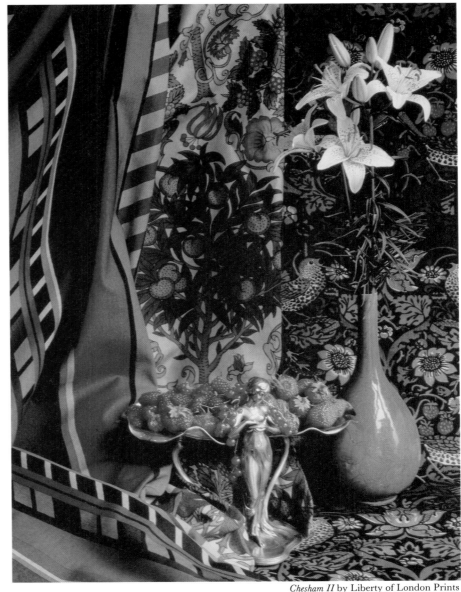

Chesham II by Liberty of London Prints

COTTON PRINTS

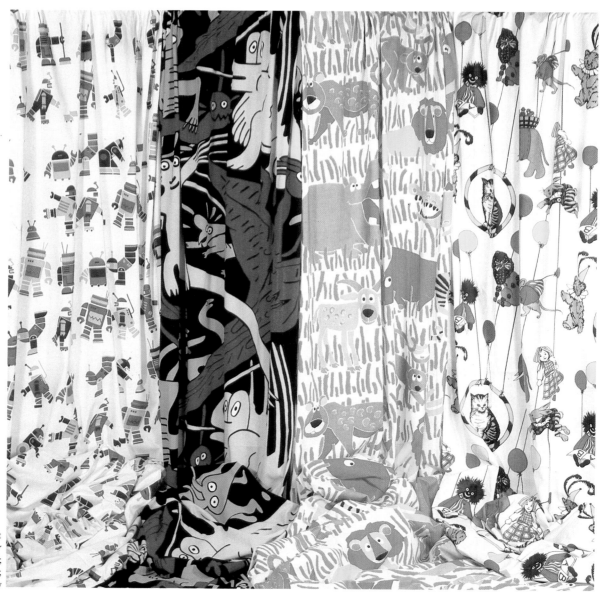

Left to right
Robots by Habitat; *Monster* by Boras International (UK) Ltd; *Jungle Crazy* by the Coloroll Store; *Circus* by the Nursery Window

Eldorado from the *Colonial Collection* by Edith de Lisle

Shirley Liger Designs

A new and sophisticated designer, Shirley Liger's collections, which include *Pot-Pourri* and *Impressions*, may be printed to order onto a variety of fabrics. Her standard ranges are hand printed onto plain cotton; *Pot-Pourri* comprises a modern interpretation of garden images, such as butterfly, trellis and rose motifs printed on an attractive buttermilk coloured ground, available in seven colourways. In contrast, *Impressions* gives a smart, tailored look in strong colour combinations. Colours can be matched to clients' specifications. Shirley Liger has also designed fabrics for Bernard Thorpe and Chelsea Green Fabrics.
See also under *Chintz, Linen Union; Silk Prints*

Tel: (01) 673 3441

27 Narbonne Avenue
London SW4 9JR
Tlx: 8951182

Edith de Lisle Designs

Fabric by Edith de Lisle Designs, from Quenby Prints in Leicester, is distributed exclusively in this country though Pallu & Lake. The designs currently available are *Les Toiles D'Edith de Lisle*, neo-classical style motifs in a single colour on plain ground, a personalised version of the newly fashionable *Toiles de Jouy; Colonial*, damask style prints with a slight grained effect; and *Stuart I and II*, in flamboyant, lemony, fresh colours with a slight metallic sheen, using excellent quality cotton satin.
Trade

Tel: (01) 627 5566

Available through:
Pallu & Lake
London Interior Design Centre
1 Cringle Street
London SW8 5BX
Tlx: 917976

Ian Mankin

One of the few natural fibre specialist shops in England, Ian Mankin supplies a range of cottons, including poplin shirting, unbleached calico, gingham and Oxford cotton. Both stripes and plains are available. Ian Mankin also supplies traditional English ticking, fully shrunk, in seven colourways. Also available are imported cottons from Egypt and India.
See also under *Cotton Weaves; Lace & Sheers; International*

Tel: (01) 722 0997

109 Regents Park Road
Primrose Hill
London NW1 8URTlx: 8951182 GECOMS

Papillon and *Nosegay Stripe* by Shirley Liger

(Left) *Les Amours*; (right) *La Chasse* by Marvic Textiles

Marvic Textiles Ltd

The British range is the *Toiles de Jouy* collection printed in the traditional manner on copper rollers, re-introduced after being originally launched 30 years ago. The four classic designs are *Les Amours*, *Les Enfants*, *La Chasse* and *Pompadour;* colours include sepia on ecru; navy on white; olive green on ecru; and black on white. Marvic specialises in superb printed moires and imported jacquards, and has undertaken design commissions from the National Trust and owners of historic houses to copy faded eighteenth and nineteenth century fabrics.

See also under *International*

Trade *Tel: (01) 580 7951*

12-14 Mortimer Street
London W1N 7RD
Tlx: 23331 MARVIC G

Fish by Janet Milner

Janet Milner

Bold, black and white modern prints mainly on cotton, Janet Milner has successfully completed commissions from clients in New York as well as London. Although most work is for fashion these prints are ideal for larger areas such as curtain fabric. She also prints onto PVC and makes a wide range of accessories with her fabrics.

Trade *Tel: (01) 481 3273*

A1 Landside
Metropolitan Wharf
Wapping Wall
London E1 9SS

Monkwell Fabrics

Monkwell Fabrics offers a wide range of virtually every type of fabric; reliable and well established, this is an ideal for the contract market.
See also under *Chintz; Cotton Weaves; Linen Union*

Trade Tel: (0202) 762456

(Semple and Company Ltd)
10-12 Wharfdale Road
Bournemouth BH4 9BT
Tlx: 417179 MONKWELL
Fax: (0202) 762582

Moygashel

Moygashel produces a range of cotton prints, both in traditional floral designs and abstract designs, making it an ideal company for the contract market.
See also under *Linen Union*

Trade Tel: (0868) 722231

Moygashel Mills
Dungannon
Co Tyrone
Northern Ireland BT7 1QS
Tlx: 74613

Munro & Tutty

Sandra Munro and Liz Tutty began their partnership designing fashion fabrics; they have successfully moved to the furnishing fabrics world where the larger surfaces are ideal for their dramatic, painterly style. Their ranges use both blazing, vivid colours and cool, muted tones; their designs are unmistakable, owing a great deal to modern painters such as Kandinsky. The collection *Adventures* comprises the loose floral designs of *Secret Garden;* stipes in *Hotline;* the bold slashes of *On the Rocks;* and the abstract arrangements of zig-zag lines, triangles, crosses and dots of *Graffiti*. The recent *Grand Tour* collection cleverly combines English garden motifs, Eastern patterns, African motifs and New York inspired designs, again in muted or strident colourways. Munro & Tutty also design exclusively for Dorma bedlinen.

Trade Tel: (01) 580 8937

Available through:
Christian Fischbacher
42 Clipstone Street
London W1P 8AL
Tlx: 265662

Henry Newbery & Co Ltd

Established in London over two centuries ago, Henry Newbery specialises in trimmings for curtains and upholstery. The firm now offers a selection of poly/cotton prints to match, available in ten colours, and include wavy stripes and checks. Colours are Primrose, Apple Greens, Apricot, and Lilac, Gray/yellows and Turquoise/coffee.
See also under *Trimmings*

Trade Tel: (01) 636 2053/5970

18 Newman Street
London W1P 4AB
Tlx: 265830 NEWTRM G

Grand Tour by Munro & Tutty

Next Interiors

Next Interiors has a rapid turnover of fabric ranges, all of which are well in tune with changing tastes in designs and style. The first collection included soft, pastel colours; recent collections show a bolder use of colour and design. Cotton Prints include *English Garden*, a floral design, *Checkers* and *Neopolitan* (in aqua and peach). Next Interiors also offers a wide range of accessories.
See also under *Cotton Weaves; Linen Union; Carpets & Rugs*

Tel: (0533) 866411

Head Office:
Desford Road
Enderby
Leicester LE9 5AT
Tlx: 34415 NEXT G
Fax: (0533) 848998

Nobilis-Fontan

See under *International*

Osborne & Little

Well-known for its sophisticated and eclectic style, Osborne & Little offers a continuous stream of new designs and ideas to their collections. Modern and inventive, its colours are always exciting. Cotton prints include *Darkwood*, a striking leaf and branch motif; the geometric designs of *Sirius;* and fabrics from the *Regatta* range. All fabrics come with wallpapers and borders with added facilities for one-off specialist services. Osborne & Little also has showrooms in Edinburgh and Manchester.
See also under *Chintz; Cotton Weaves; Silk Weaves; Trimmings; International*

Tel: (01) 352 1456

304 Kings Road
London SW3 5UH
and:
43 Conduit Street
London W1
Tel: (01) 734 5254

Pallu & Lake

See under *International*

Palmer-Phipps Design Associates

A recently formed company, Jane Palmer's first collection comprises strikingly effective designs in black on cream or shrimp pink on cream hand finished cotton satin. Taking inspiration from art nouveau flowers, Victorian artefacts or heraldic

Fleur-de-Lis by Palmer-Phipps

Tulip by Palmer-Phipps Design Associates

COTTON PRINTS

Clockwise from bottom left hand corner:
Aztec by Shirley Liger; *Colonial* by Edith de Lisle; *Elveden Stripe* by Colefax & Fowler; *Block Moire* by Cole & Son

symbols from antique wallpaper, a single motif, such as that in the *Fleur-de-Lis* range, is re-designed for an entirely contemporary style print. Co-ordinating fabrics are available with four wallpaper designs and matching borders. Jane Palmer also offers a special service in which designs and colourways can be made to order.

Tel: (01) 723 2455

10 Upper Montagu Street
London W1H 1RN

Paper Moon

See under *International*

Parkertex Fabrics

Parkertex, now part of GP & J Baker, has a classic cotton collection ideal for the contract market. These include prints from the *Tatton Park Collection*, some of which have complementary laces. Parkertex also offers an excellent range of plains and striped moire.
See also under *Chintz; Cotton Weaves; Silk Prints; Lace & Sheers*

Trade *Tel: (01) 636 8412*

18 Berners Street
London W1P 4JA
Tel: (01) 636 8412

Ploeg

See under *International*

Animals by Reputation

Ellen by Putnams Collection Ltd

Putnams Collections Ltd

The original eight designs from the *Putmans Collection* of cotton prints were taken from Antoinette Allsopp's collection of antique Staffordshire pottery, dating from about 1820. These delicate patterns have been translated directly onto fabrics, using the original blue and white colours; Putnams is one of the very first companies to produce prints on fabric from pottery. Recent ranges include six new fabrics in blues, terracotta, green and pink; these are all upholstery weights, and available with matching table linen, cushions and quilts. Fresh, very English, the fabrics are delightful and unique.

Tel: (01) 431 2935

72 Mill Lane
London NW6 1NL

Ramm, Son & Crocker Ltd

Specialises in reproducing its extensive document prints from the firm's archives which date back to the 18th century; Ramm, Son & Crocker is over 100 years old, and until 1891 was closely associated with Warner. While the majority of the prints are available as high quality chintz, Ramm, Son & Crocker's cotton prints include such designs as *Ludlow,* a rose and trellis design taken from a nineteenth century French wallcovering.

See also under *Chintz; Linen Union*

Trade *Tel: (06285) 29373*
13-14 Treadaway Technical Centre
Treadaway Hill
Loudwater
High Wycombe
Bucks HP10 9PE

Reputation

1950s style prints, jazzy and very hip. The majority of its prints are on cotton; Reputation can also print to order in special colours on other fabrics. Of its ranges, *Cactus* is perhaps the most representative, available in several colourways including reds, pinks, yellow and green, and comprising variations on cactus designs in boxes of different background colours. Plastic coated cotton organza is also available, along with dress weight silks, flocked cotton and cambrics.

Tel: (01) 221 7641
186 Kensington Park Road
London W11 2EF

Cactus by Reputation

Buttermilk & Roses by Rosine Ltd

Fabrics from the *Island Collection* by St Leger

Rich & Smith

Rich & Smith's own ranges of printed cotton sateen include *Tangle; New England;* and *Chinascreen,* all single colour on white or, as in the case of *Chinascreen,* a reversed out design. *Tangle,* available in thirteen colourways, is an all-over pattern of spaghetti-like lines; *New England* comprises an acorn and oak leaf arrangment separated by lengthways borders of leaves; and *Chinascreen* is an attractive stencil-style sprig of fruit, vegetables and flowers. Rich & Smith also distributes exclusive ranges from Waverly Schumacher.
See also under *International*

Tel: (0935) 824 696

North Street Farm
Stoke Sub Hamdon
Somerset TA14 6QR

Rosine Ltd

Rosine's recent collection, designed by Vanessa Burroughs, is *Country Images,* using delightful floral motifs on lightly textured backgrounds of light stencilled diamond shapes. All fabrics are available with wallpapers and borders. Still available is the *Buttermilk & Roses* collection, consisting of six designs (in six colourways) with matching wallpapers and borders, all in attractive floral designs of fresh and original colourways on white ground.
See also under *Childrens Fabrics*

Tel: (01) 960 8508

2nd Floor
Block A
124-126 Barlby Road
London W10 6BL

Sahco Hesslein UK Ltd

See under *International*

St Leger Fabrics

Designed by Christopher Lawrence, the fabrics have a hand painted look and reflect his interest in things tropical and exotic. *Island Collection* includes *Hawaii*, which features hot, tropical flowers on cool green background; and *Mandalay,* speckled ground with plant motifs in similar hot colours; the lattice-style patterns of

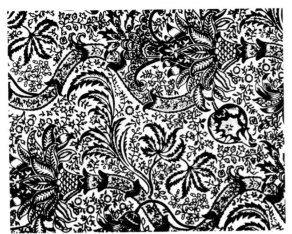

Indian (William Morris design) by Arthur Sanderson & Son

Moorea and *Ariandne*, and lattice with flowers *Kyoto*; and, one of the most effective, *Tokonoma*, loose sprig designs on a rough stripe background. Other collections are the *Pacific Collection*, and *Capri 2*, a new collection comprising the best of earlier *St Leger* designs, which include *Coromandel, Mississippi Naxos* and *Malacca*.
See also under *Cotton Weaves; International*

Tel: (01) 736 4370

68 Maltings Place
Bagley's Lane
London SW6
Tlx: 265871 MONREF G

Arthur Sanderson & Son

Arthur Sanderson & Son offers a huge range of fabrics, some of the best known designs, of course, being the William Morris prints. The recent collections, *Options* and *William Morris II*, contain florals and Indian paisleys (as in *Talisman*); all-over patterns (*Intermezzo*); and the *William Morris Compton, Vine* and *Willowbough Minor*. Sanderson has the William Morris wallpaper blocks, and offers the superb hand blocked William Morris wallpaper, along with matching wallpaper for other well-known Sanderson prints. Sanderson designs give a reliable, mix-and-match style of fabrics.
See also under *Chintz; Cotton Weaves; Linen Union; Carpets & Rugs*

Tel: (01) 636 7800

52 Berners Street
London W1P 3AD

Ian Sanderson (Textiles) Ltd

Ian Sanderson offers a selection of cotton prints, all of which can be printed onto the client's choice of fabric and colourways. The *Matsu Moire* and *Lyon* collections, using stencil-style floral designs, are both available as moires, cotton satin prints and sheers. A popular range is the effective *Paisley Prints*, using one colour on a plain background; and the *Oadby* range, a damask-style print on plain ground, using traditional church motifs in one colour (which has a slight shading or blush over it). Also available is ticking - which includes the *Pym Stripe* collection and the *Eton Plain*, is available in 27 colours.
See also under *Chintz; Cotton Weaves; Lace & Sheers; International*

Tel: (01) 580 9847

70 Cleveland Street
London W1P 5DF

COTTON PRINTS

Fabrics from the *Inspirations Collection* by Sekers Fabrics Ltd

Sekers Fabrics Ltd

Sekers has an enormous variety of fabrics for both domestic and contract use. Cotton Prints from its latest collection, *Inspirations* and the *Classic Print Collection*, combine traditional and modern styles, using splashy, washy colours and bold designs. Beautifully conceived and subtle in style, Sekers uses its own archive materials, re-designed and coloured for the authentic 'English' look. Sekers also has a wealth of co-ordinating fabrics.
See also under *Chintz; Cotton Weaves; Wool*

Trade
Tel: (01) 636 2612

15-19 Cavendish Place
London W1M 9DL
Tlx: 265550 SEKINI G
Fax: (01) 631 5340

Skopos Design Ltd

Skopos is a rapidly expanding company, planning to move into the retail market throughout the UK. The *Country Fair* range takes its inspiration from the country, using floral motifs and colours designed to 'capture the essence of Old England'. The latest range, the *China Garden Collection*, comprises four designs each in five colourways: *Ming Blossom*, *Pagoda*, *China Maze* and *Topaz* are in cotton sateen, using unusual and striking colour combinations and outlined in gold, giving a mixture of Oriental and Byzantine effects. All ranges can be fully flame retardant treated.

Fabrics come with wallpapers and matching borders.
See also under *Cotton Weaves; Wool*

Tel: (0924) 465191
Providence Mills
Earlsheaton
Dewsbury
West Yorkshire WF12 8HT
Tlx: 556150 SKOPOS G

Michael Szell Ltd

Michael Szell's hand printed designs are available on cotton; eccentric, different and very good, clients may choose from show lengths or use their own designs. His colours are subtle and very beautiful, ranging from gold to pinks and French greens. Any colour can be matched; the fabrics are his own, which are cotton, sheers, chintz, moire, velvet and light and heavy weight silks.
See also under *Chintz; Cotton Weaves; Silk Prints; Lace & Sheers*

Trade　　　　　　　　　　　　*Tel: (01) 589 2634*

47 Sloane Avenue
London SW3 3DH

Textra Ltd

Textra offers a comprehensive range of fabrics ideal for the contract market. All collections are designed to co-ordinate or blend together, providing a certain amount of cohesion throughout. Cotton Prints include traditional

Alnwick by Textra Ltd

floral style designs as well as more modern styles and all-over patterns along with a good range of plains. On large enough orders Textra can produce special colourways to customer specification.
See also under *Chintz; Cotton Weaves; Linen Union*

Trade　　　　　　　　　　　*Tel: (01) 637 5782/3*

16 Newman Street
London W1P 4ED
Tlx: 837961 MACJEN G

Bernard Thorpe

Custom designed prints in any of its 108 standard colours; all fabrics are produced by commission although the showroom has an impressive range of show lengths. Designs are always in vogue.
See also under *Chintz; Cotton Weaves; Linen Union; Silk Prints; Lace & Sheers*

Trade　　　　　　　　　　　　*Tel: (01) 352 5745*

6 Burnsall Street
London SW3 3SR
Tlx: 9419778 THORPE G

COTTON PRINTS

Timney Fowler Prints

Black and white prints, inspired by Piranesi's 18th century classical motifs, are used here in huge prints. Very modern and very good, Timney Fowler has enjoyed success abroad. Prints are on cotton sateen, silk noile - a rough, cream coloured silk - and velvet; some prints in grey and white, gold and black.
See also under *Silk Prints*

Tel: (01) 351 6562

388 Kings Road
London SW3 5UZ
Tlx: 9413716 TIMSOW

Today Interiors

Of the established ranges, one is designed by top interior designer Mary Fox Linton, comprising abstracts, all-over patterns and geometrical box shapes in varied subtle colours. *Ultra* is Today Interiors' other current range, using pastel colours, pale greys and buff colours. All fabrics come with matching wallpapers.
See also under *Cotton Weaves*

Tel: (01) 636 0541

146 New Cavendish Street
London W1M 7FG

Turnell & Gigon

See under *International*

Print by Timney Fowler

Country Trophy by Kenneth Turner

Kenneth Turner

Famous for his unique fresh and dried flower arrangements, Ken Turner's first collection of furnishing fabrics has five designs, *Camelia*, *Avery Row*, *Country Trophy*, *Basket Weave* and *Ivy*. All ranges are available in six colourways, which include superbly rich Victorian greens, burgundies and spice shades.

Tel: (0443) 815520

Available through:
Dovedale
Caerphilly Road
Ystrad-Mynach
Mid Glamorgan CF8 8TW
Tlx: 497680

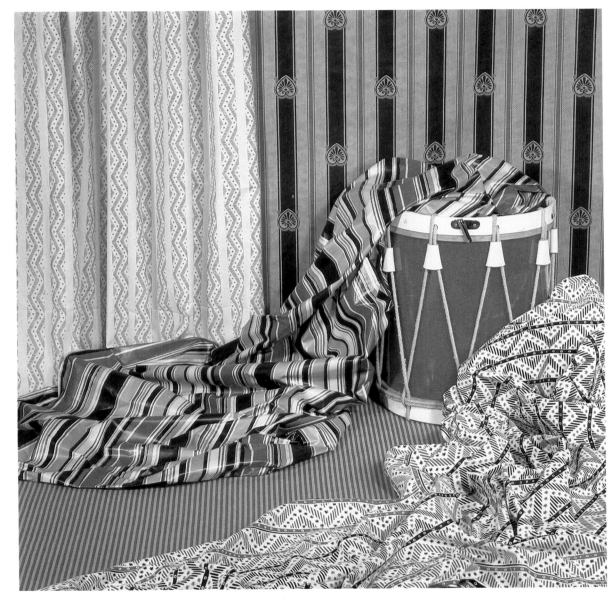

Clockwise from bottom left hand corner: *Coutil Stripe* by Jamasque; *Capriccio* by Liberty of London Prints; *Westbourne Star Stripe* by Celia Birtwell; *Burlington* by Dovedale; *Starry Stripe* by Celia Birtwell

Upstairs Shop

Specialists in accessories for the bedroom, the Upstairs Shop has a range of cotton prints in fresh green/blues, pinks and yellows. All prints are on white background, and with names such as *Cherry Bud*, *Honey Suckle* and *Summer Strawberries* the general theme is of summer gardens. Accessories include bedspreads, valances and cushions.

Tel: (01) 730 9179

22 Pimlico Road
London SW1 8LJ

Verity Fabrics

Fabric and ceramic tile producers, Verity hand screen print designs to customer specifications on a variety of different fabrics, including cotton. A huge range of designs is available from which to choose in the showroom, some of which co-ordinate with their tiles.
See also under *Chintz: Silk Prints; Childrens Fabrics*

Trade *Tel: (01) 245 9000*

7 Jerdan Place
London SW6

Print by Verity

Viyella

Now world famous for the cloth of the same name, Viyella dates back to 1784, when a group of business men set up a spinning mill in Pleasley

The Lisbon, Watts & Co

Vale on the edge of Sherwood Forest. In 1893 new cloth using merino wool and long staple cotton was introduced. Dyed to an extrordinary depth of colour, so successful was this fabric that its name, taken from the Derbyshire valley Via Gellia, was adopted by the company - 'Viyella'. Viyella's cotton qualities include their *Viyella Original Blend*, 55% finest merino lambswool and 45% cotton; and the *Viyella Cotton Lawn*, available in floral prints and colour weaves.
See also under *Wool*

Retail *Tel: (0623) 810345*

William Hollins & Company Ltd
The Viyella Mills
Pleasley Vale
Mansfield
Nottinghamshire NG19 8RL
Tlx: 377361

Sasha Waddell

Sasha Waddell carry work from a number of designers, including Jenny Gaylore, who produces wonderful modern, bright, hand printed work. Sasha Waddell also stocks and has a library of samples of ticking, Indian cottons, ginghams and many other fabrics; the style is Swedish in natural, off-white colours.
See also under *Cotton Weaves; Silk Prints; Linen; Wool*

Tel: (01) 603 0474

22 Northend Parade
Northend Road
London W14 0SJ

Watts & Co Ltd

Watts & Co was founded in 1874 by three church architects, George Frederick Bodley, Thomas Garner and Gilbert Scott the Younger, all pupils of Sir Gilbert Scott, one the the leaders of the Gothic Revival. The partners provided embroidery, textiles and needlework, inspired by the late-gothic art of northern Europe and rivalled only by Morris & Co. Watts is now recolouring its ranges in order to achieve the authentic Victorian colourways. Still using the original designs, its cotton prints are *The Valencia*, a Renaissance style design, using an intricate filigree of flowers and leaves; and *The Lisbon*, a superbly coloured adaptation of a tapestry, incorporating graceful bird and leaf motifs, in dark greens, blues and deep reds. Watts has a range of silk weaves, incorporating Victorian colours and gothic designs, and a collection of wallpapers which can be coloured as the client requires.
See also under *Cotton Weaves; Silk Weaves; Lace & Trimmings*

Tel: (01) 222 7169/2893/1978

7 Tufton Street
London SW1P 3QE

Warner & Sons Ltd

Over 100 years old, Warner & Sons has a massive collection of fabrics, adding new collections each season. Many designs are taken from the firm's extensive archives, reworked by its well-respected and flourishing design studio. Greeff Fabrics in North America work in conjunction with the Warner studio, and many of Warner's fabrics are from America. Its cotton prints are always superb in quality, ranging from traditional florals to modern abstracts. The recent collection includes *Farfalla*, an attractive butterfly and moth design.
See also under *Chintz; Cotton Weaves; Linen Union; Silk Weaves; Wool; Lace & Sheers*

Trade *Tel: (01) 439 2411*

7-11 Noel Street
London W1V 4AL
Tlx: 268317

Jenny Gaylore (Sasha Waddell)

Hand blocked fabrics by Yately Industries for the Disabled

Yately Industries for the Disabled

Small producers of hand blocked printed cottons in lengths of three metres or multiples of three metres, Yately Industries is a registered charity producing fabrics and a huge variety of made-up items. Yately is fifty years old, and has collected roughly 7000 blocks from which a client can choose a design - all of which are available in twenty to thirty colours. The prints are beautifully done; however, since the process is laborious, delivery time will be six weeks or over.

Tel: (0252) 872337

Mill Lane
Yately
Camberley
Surrey GU17 7TS

Zipidi

Originally from Greece, the two designers, Maria Zolota and Lia Polemi produce sunny, Mediterranean and versatile designs hand printed onto a variety of fabrics, including cotton. Some of the most attractive ranges are the shell designs on plain backgrounds using blues, pale greens and yellows; the graceful, flowing design, *Birds;* the simple *Chinese Leaf;* and a range of stripes.
See also under *Chintz; Linen Union; Childrens Fabrics*

Trade *Tel: (01) 491 2151*

5 Deanery Mews
London W1

Zoffany

Zoffany produces the *Temple Newsam Collection* of wallpaper and coordinating chintzes (which include the *Hertford Stripe* collection), and a range of over fifty marbled cotton chintzes and cotton prints, (including the art deco inspired *Waterlily*). Zoffany's colours tend to be pale and deep browns, reds and pinks. Zoffany also distributes the American Van Luit range, and the Pierre Balmain collection of cotton sateens and chintzes.
See also under *Chintz; Silk Weaves; International*

Trade *Tel: (01) 235 5295/7241*

27a Motcomb Street
London SW1X 8JU
Tlx: 291120
Fax: (01) 259 6549
and
327 Upper Street
London N1
Tel: (01) 226 8643
Tlx: 291120
Fax: (01) 354 4074

COTTON WEAVES

This section includes fabric made from 100% cotton, cotton and man made fibre mixes, and 100% Trevira CS (flame retardant fabric). Designs range from the simple dobby pattern (small, geometric figures on a plain ground) to complex jacquard weaves.

COTTON WEAVES

Shyam Ahuja

See under *International*

J Brooke Fairbairn & Company

Offers a range of inherently fire proof weaves suitable for upholstery.

Trade *Tel: (0638) 665766*

The Railway Station
Newmarket
Suffolk CBA 9BA

Jane Churchill Ltd

The new woven cotton ranges available from Jane Churchill come in five natural colours: light beige, cream, soft green, dark beige and pearl grey, all of which co-ordinate and blend with the cottons. The new designs are dobby weaves, and include *Kingston*, a pineapple-shaped design; *London Check*, diamond shape; and *Bath*, a flower motif.
See also under *Chintz*

Tel: (01) 824 8484

137 Sloane Street
London SW1X 9AY
and
13 Old Bond Street
Bath BA1 1BP
Tel: (0225) 66661
and
21 The Market Place
Kingston-upon-Thames KT1 1JP
Tel: (01) 549 6292

Colefax & Fowler

Best known for its chintzes, Colefax & Fowler offers a large range of smart cotton mix weaves suitable for upholstery purposes, including *Nina* (cotton and worsted wool mix); *Chevron Stripe* (cotton, viscose and flax mix); *Dalmation Cloth*, and a range of diamond shaped designs, the latter in flax, cotton and viscose mix. All weaves come in various powdery shades of mustard, wedgewood blue, olive and dusty reds.
See also under *Chintz; Cotton Prints; Linen Union; Lace & Sheers; Trimmings; Carpets & Rugs*
Tel: (01) 493 2231

39 Brook Street and 110 Fulham Road London SW3 6RL
London W1 2JE
Tel: (01) 244 7422
Tlx: 895 3136

Collins and Hayes Ltd

Manufactures of upholstered furniture, Collins and Hayes has an exclusive range of upholstery weight weaves bought in from outside suppliers. These include *Charmelle*, a velvet suitable for heavy duty wear, stain resistant and easy to clean. *Charmelle* is available in 35 colourways and 6 designs; colourways include strong shades, pastels and creams. Other ranges include fine closely woven weaves; jacquards and thick, rough textured weaves, some of which are coloured by the company's own design team.

Trade *Tel: (0424) 720027* *Ponswood*
Hastings
Sussex TN34 1XF
Tlx: 957101

Creation Baumann

See under *International*

De Mont & Wright Designers

A small company, the Lisette De Mont and Steve Wright partnership designs and weaves cotton fabrics to order on an exclusive, one-off basis. Their standard range is the *Ivory Collection*, a superbly soft fabric woven using a cotton warp and silk, in attractive geometric designs. These are available in natural, cream colours, and include *Ivory Silk, Ivory Squares, Ivory Bricks* and *Ivory Blocks*. 100% silk fabrics are available to customer specification; fabrics can be piece dyed and can be fireproofed.
See also under *Carpets & Rugs*

Ask for Steve Wright
Tel: (0686) 24652

Unit 29
Vastre Industrial Estate
Kerry Road
Newtown
Powys SY16 1DZ
Tlx: 35851 CYM EX

Designer Style

Designer Style's woven viscose/cotton mix collection, *Jacquards & Silks*, is available in 24 colourways in woven jacquard designs, together with wallpapers and wallcoverings. Available exclusively through Designers Style, *Jacquards & Silks* are in all-over designs or small repeating patterns, with a glossy, silky effect. Colours are pastel, designed to co-ordinate with their cotton print range, *Pastiche*.
See also under *Cotton Prints*

Tel: (0268) 777831

27-29 Eastwood Road
Rayleigh
Essex
Tlx: 993169 STYLE G

Designers Guild

Designers Guild's instantly recognisable designs are available as cotton weaves, notably their *Filigree* collection, which includes *Fal-de-Lal*, a cotton damask comprising broad horizontal stripes of differing colours with a rose motif weave, broken by borders of posies. The range *Cotton Twist*, ideal for heavy duty upholstery use, has a soil resistant finish. This fabric is textured, giving an attractive bumpy effect, and is available in plain colours co-ordinating with the Designers Guild print collections. *Cotton Twist* comes in 14 colours.
See also under *Chintz; Cotton Prints; Linen Union; Carpets & Rugs*

Retail
Tel: (01) 351 5775

271 & 277 Kings Road
London SW3 5EN
Tlx: 916121
Fax: (01) 352 7258

Iona by Edinburgh Weavers

Dovedale Fabrics Ltd

Offering chintzes and cotton prints, Dovedale's recent range in cotton and manmade fibres is *Minstrels Gallery*, a jacquard weave collection comprising six designs in seven colourways. The designs are modern and available in striking colourways, ranging from deep, rich tones to lighter pastels. Other collections are the *Renaissance* range, comprising jacquard woven stripes, large zig-zag flame stitches and palm motifs; and the *Hardwick Collection*, plain dobby weaves in attractive trellis shapes, available in 23 colours.
See also under *Chintz; Cotton Prints*

Trade *Tel: (0443) 815520*

Caerphilly Road
Ystrad Mynach
Mid Glamorgan CF8 8TW
Tlx: 497680

Edinburgh Weavers

Edinburgh Weavers is the contract side of Sundour Fabrics, which is part of the Home Furnishing Division of Courtaulds. The range of 100% cotton weaves includes *Iona*, a geometric, pocket weave available in four colourways; *Elgin*, an interesting weave in which the design gives the effect of a loosely woven lattice over the surface of the cloth, available in seven colourways; and *Edinburgh*, diamond trellis shapes over an impressionistic trellis design, available in four colourways.
See also under *Cotton Prints*

Trade *Tel: (0204) 387802*

Sundour Fabrics
Robin Hood Mill
Lever Street
Bolton
Lancs BL3 6NY
Tlx: 635293 SNDOUR

Christian Fischbacher

See under *International*

Fox & Floor

Known for its imaginative designs in natural fibres, Fox & Floor offers a superb collection of cotton weaves, including jacquards and dobbies. Its design service can match and co-ordinate patterns, and all fabrics are made to order.
See also under *Silk Weaves; Wool*

Trade *Tel: (01) 2671467/8*

142 Royal College Street
London NW1 0TA
Tlx: 261334 SXFG

Mary Fox Linton

See under *International*

Humphries Weaving Company

Humphries Weaving Company, of De Vere Mill, Castle Hedingham, is the only company in England producing silks, cottons and wool on traditional hand looms. Cotton weaves available are seersuckers, tabourette stripe and damasks. Cotton and silk mixes are also available. Design and colours can be made up to customer specifications.
See also under *Silk Weaves*

Trade *Tel: (01) 627 5566*

Available through:
Pallu & Lake
London Interior Design Centre
1 Cringle Street
London SW8 5BX
Tlx: 917976 HAMON G

The Gainsborough Silk Weaving Co Ltd

A small, privately owned company, Gainsborough Silk Weaving was founded in 1903 and weaves silk, cotton and cotton flax, formerly on hand looms, although these are now used primarily for experimental purposes. Cotton weaves available include jacquards; damasks in 100% cotton and cotton mixes (silk or rayon); brocatelles and dobby weaves. Stock designs are available, and Gainsborough can produce

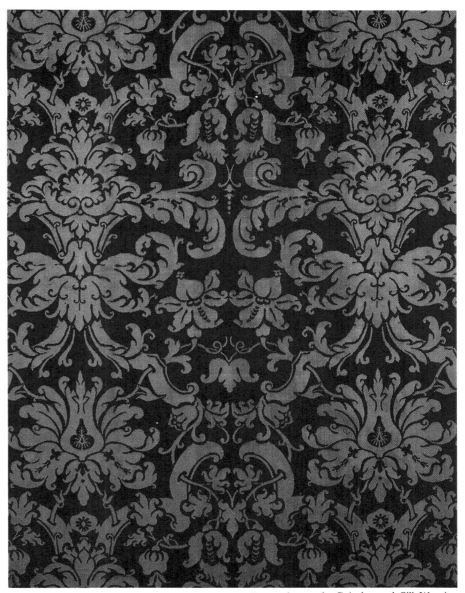

Jacquard weave by Gainsborough Silk Weaving

designs and colourways to customer specification.
See also under *Linen Unions; Silk Weaves*

Trade *Tel: (0787) 72081*

*Alexandra Road
Chilton
Sudbury
Suffolk CO10 6XH
Tlx: 987562*

David Hicks

David Hicks, the well-known interior designer, has brought out several new ranges of fabrics, the first for many years. *La Premiere* comprises superb cotton weaves, and includes *Cromer*, an interlocking ribbons design; *Fisher*, a pique weave in one colour; *Flannan*, a fine cotton damask with an all-over design; *Forties*, a trellis shape with hanging flowers in the middle; *Holyhead* and *Lundy*, both using small geometric shapes; and *Rockall*, a strip design. David Hicks also has a collection brought out in conjunction with Bernard Thorp, comprising striking herringbone and stripe designs; trellis and stripes; and a check design.
See also under *Chintz; Cotton Prints*

Trade *Tel: (01) 627 4400*

*101 Jermyn Street
London SW1Y 6EE
Tlx: 8812724 FALCON-G
Fax: (01) 720 8907*

La Premiere Collection by David Hicks

Interior Selection

Interior Selection's recent collection of 100% Trevira CS, an inherently flame retardant material, is the *Isu* collection, comprising abstract and geometric patterns. Ranges are *Strata*, stripes woven in different colours; *Ceramica*, a crackle glaze effect; *Camber*, small shell patterns; *Samar* and *Lattice*, geometric patterns; and *Sirocco*, wavy lines in different colours.
See also under *Cotton Prints; Trimmings*

Trade *Tel: (01) 602 7250*

*Springvale Terrace
London W14 0AE
Tlx: 296961 INTSEL G*

Jamasque Ltd

Jamasque are specialist producers of superb quality 100% combed cotton damask. Now over two years old, their early ranges include the smart *Coutil Stripe*, a narrow stripe design available in ten colours; *Moire Range*, woven to give a moire effect available in thirteen colours; *Lacewing*, a small, all-over design available in eight colours; and the slightly larger all-over design of *Rosanallis*, available in thirteen colours. All the early ranges are in dusty, powdery colours and attractively muted tones. Their two new collections, *Cadenza* and *Classics*, show much more vigorous, richer colours; using the same 100% combed cotton, *Cadenza* includes *Rosetti*, using ribbon and sprig motifs; *Florentine*, incorporating bold, large-scale zig zag and star motifs; and *Chinoiserie*, a vaguely geometrical all-over pattern. *Classics* offer recoloured versions of previous ranges: these are *Coutil Stripe; Moire;* and the chevron design *Stellar*. Both collections are available in nine to twelve colours.

Trade
Tel: (01) 736 9498

At The Glasshouse
11/12 Lettice Street
London SW6 4EH
Tlx: 896691

John Lewis Contract Furnishing

John Lewis, Oxford Street, has its own fabric and furnishing name, Jonelle, which is the name of the goods made in John Lewis' own work rooms or produced for the company. Jonelle comprises a wide collection of prints and weaves, available both as retail or for contract work. The cotton and man made fibre weaves include plain diamond designs and simple dobbies, jacquards and brocatelles. John Lewis Contract Furnishing is able to take on large scale contract work, and can negotiate contract prices on their fabrics.
See also under *Chintz; Cotton Prints; Lace & Sheers; Childrens Fabrics*

Tel: (01) 629 7711

278-306 Oxford Street
London W1A 1EX
Tlx: 27824 JONEL LONDON

Rosetti by Jamasque

Florentine by Jamasque

COTTON WEAVES

Kendix Designs

See under *International*

Kinnasand UK Ltd

See under *International*

Ian Mankin

Specialists in natural fabrics including linen, raw silk, muslin, linen scrim and poplin shirting, Ian Mankin has its own original woven designs, *Park Range*, in attractively rough textured 100% cotton. *Park Range* includes *Park Stripe 1*, broad stripes alternating with narrow stripes in a herringbone design; and *Park Stripe 2*, narrow herringbone stripes of equal width; *Park Check*, a check-within-a-check pattern; *Park Spot*, small square shapes woven within a twill; and the *Park Twill*. Ian Mankin also has its own ticking, and the checked *Regent Street Range*, available in several colourways, is suitable for upholstery and curtaining.
See also under *Cotton Prints; Laces & Sheers; International*

Tel: (01) 722 0997

109 Regents Park Road
Primrose Hill
London NW1 8UR

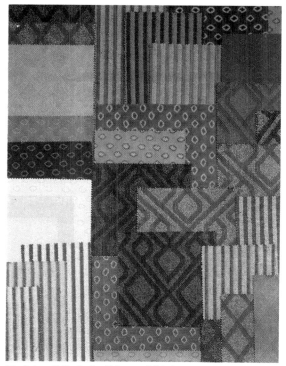

The Sahara Collection by Osborne & Little

Marvic Textiles

See under *Cotton Prints; International*

Monkwell Fabrics

Offers a wide range of furnishing fabrics suitable for the contract market, including cotton weaves. Monkwell is reliable and well-establihed.
See also under *Chintz; Cotton Prints; Linen Union*

Trade *Tel: (0202) 762546 Tlx: 417179*

(Semple and Company Ltd)
10-12 Wharfdale Road
Bournemouth BH4 9BT

Next Interiors

Next Interiors' cotton weaves ranges include *Ottoman*, available in seven colours, and *Straw Weave*, comprising diagonal lines, available six colours.
See also under *Cotton Prints; Linen Union; Carpets & Rugs*

Trade Tel: (0533) 866411

Desford Road
Enderby
Leicester LE9 5AT
Tlx: 34415 NEXT G
Fax: 848998

Osborne & Little Plc

Fashionable and highly inventive, Osborne and Little iswell-known for its designs and weaves. From the *Tamesa Weaves* are the natural coloured jacquards, twills, seersuckers and plain weaves. Colours are white, cream, oatmeal, browns and dark greys. The *Genoa & Griffin* collection comprises plain velvets from 100% cotton. *Genoa* is a crushed velvet in ten colours, from deep burgundy to cream; *Griffin* is available in twelve matt shades of chenille. The *Weaves* collection is available in two designs: *Sunstitch* comprises a trellis design with a small sun motif, in twenty four colourways, with a brocade finish; and *Aspen*, a leaf motif on a small checks background, in ten colours. One of its most dramatic ranges is the *Sahara* collection of four designs, including stripes, spotted patterns and diamond and geometric designs. Colours are rich, earthy and reminiscent of stone, sand and African shades. Osborne & Little also has outlets in Manchester and Edinburgh.
See also under *Chintz; Cotton Prints; Silk Weaves; Trimmings; International*

Tel: (01) 352 1456

304 Kings Road
London SW3 5UH
Tlx: 8813128
Fax: (01) 673 8254
and
43 Conduit Street
London W1
Tel: (01) 734 5254

Parkertex Fabrics

Offers a good range of weaves, including velvets available in plain colours, or with stripes and check patterns, and damasks using Italian Renaissance style motifs. Pocket weaves, herringbone patterns, plain weaves and simple dobby patterns are also available, along with more intricate jacquards (including *Poitiers; Shiraz* and *Kerman*). Parkertex is well-known for its upholstery weight weaves, and offers an ideal contract range.
See also under *Chintz; Cotton Prints; Silk Prints; Laces & Sheers*

Trade Tel: (01) 636 8412

18 Berners Street
London W1

Pallu & Lake

See under *International*

Ploeg

See under *International*

Sahco Hesslein UK Ltd

See under *International*

St Leger Fabrics

St Leger Fabrics's *Woven Collection* comprises cotton polyester mix weaves which co-ordinate with the printed collection. The ranges are *Fastnet*, available in four colourways, and made up of small diamonds against a light ground; *Glyfada*, in four colourways, square shapes within which are criss-crossing lines; and *Colony*, loose intersecting lines in a diamond trellis shape, also in four colourways. Several imported ranges are also available.
See also under *Cotton Prints; International*

Tel: (01) 736 4370

68 Maltings Place
Bagleys Lane
London SW6 2BY
Tlx: 265871 MONREF G
Quote ref: NNGO54

Arthur Sanderson & Son

Sanderson offers a huge range of fabrics; of which the best known are, of course, the William Morris prints. The cotton weave ranges include a selection of plain velours (in roughly 10-15 colours) and plain cotton weaves, including those with herringhone patterns, dobby weaves and zig-zag designs. Sanderson offers something of everything in a reliable, mix-and-match style of fabrics.
See also under *Chintz; Cotton Prints; Linen Union; Carpets & Rugs*

Tel: (01) 636 7800

52 Berners Street
London W1P 3AD
Trade

Ian Sanderson (Textiles) Ltd

New cotton weave collections include *Atlantis*, available in eight colourways; *Alton* available in 16 colourways; and the *Premiere* range, available in trellis designs. *Biba*, *Biba Boundary* and *Park* are still available, from 100% cotton, comprising trellis and bow designs.
See also under *Chintz; Cotton Prints; Lace & Sheers; International*

Trade

Tel: (01) 580 9847

70 Cleveland Street
London W1P 5DF

Sekers Fabrics Ltd

Sekers has an enormous variety of fabrics for both domestic and contract use. Sekers has its

own weaving plant in Whitehaven, producing both wool and cotton weaves. The recent range, *Vesuvio*, made of 100% Trevira CS (inherantly flameproof fabric), is available in six designs and 25 colourways, with a plain Trevira CS fabric in slub, duppion effect design available in 50 colourways. The designs include floral motifs, diagonal lines in a mock herringbone design; and broad dash-like lines interlocking in repeat patterns. Other jacquards and dobby designs are constantly being developed from fine quality cotton; plains with subtle colour variations, and viscose/cotton mixes are woven to give a satin effect. Many of these fabrics are flame retardant treated and are suitable for both curtains and upholstery.

See also under *Chintz; Cotton Prints; Wool*

Trade Tel: (01) 636 2612

15-19 Cavendish Place
London W1M 9DL
Tlx: 265550 SEKINT G

Skopos Design Ltd

Skopos is a rapidly expanding company, planning to move into the retail market throughout the UK. The most recent cotton weave collection is the *Orient Collection*, comprising three designs in cotton jacquards, available in four to seven colourways. These all co-ordinate with the *China Garden* cotton print collection. Fabrics are suitable for upholstery and curtaining, and can be flame retardant treated. Trevira CS

(Left) *Crocodile* and (centre and right) *Zebra* by Textra Ltd

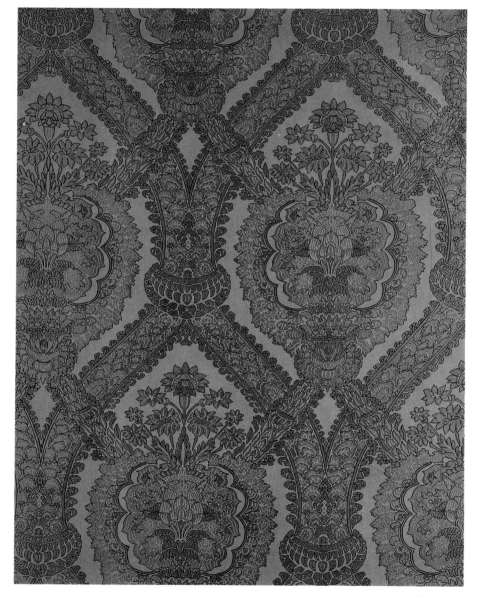
Memlinc by Watts & Co

(inherantly flame retardant) fabrics are also available.
See also under *Cotton Prints; Wool*

Tel: (0924) 465191

Providence Mills
Earlsheaton
Dewsbury
West Yorks WF12 8HT
Tlx: 556150 SKOPOS G

Michael Szell Ltd

Michael Szell's hand printed designs are available on velvet; his designs are custom made or can be taken from the large range of show lengths, from which colours can be changed at no extra cost. Eccentric, different and very good, the colours range from the rich, sumptuous use of the gold and silver, to pinks and light greens. Michael Szell prints onto his own fabrics, which are cotton, sheers, chintz, moire, velvet, and silk.
See also under *Chintz; Cotton Prints; Silk Prints; Laces & Sheers*

Trade *Tel: (01) 589 2634*

47 Sloane Avenue
London SW3 3DH

Textra Ltd

Offers a wide range of fabrics suitable for the contract market. Its cotton weaves include a new departure for Textra, comprising 100% mercerised cotton jacquards in two designs,

Zebra and *Crocodile*, available in 30 colourways each. Textra also has a huge collection of plains and flame retardant fabrics. All Textra's fabrics are designed and coloured with the entirety of their collection in mind, giving a certain amount of cohesion throughout.
See also under *Chintz; Cotton Prints; Linen Union*

Trade　　　　　　　　　　　　　　*Tel: (01) 637 5782/3*

16 Newman Street
London W1P 4ED
Tlx: 837961 MACJEN G

Today Interiors

The cotton and viscose mix fabrics from Today Interiors are the *Zig* and *Zag* ranges, available in seventeen colours each. The *Zig* range is a flame stitch, chevron design; the *Zag* range is a herringbone pattern.
See also under *Cotton Prints*

Tel: (01) 636 0541

Showroom
146 New Cavendish Street
London W1M 7FG

Bernard Thorpe

Custom designed prints in any of the firm's 108 standard colours are available on cotton weaves; all fabrics are produced by commission although the showroom has an impressive range of show lengths. On the hand screen prints, the colours and designs are superb. Note that Bernard Thorpe has brought out a range of weaves in conjunction with David Hicks (see above).
See also under *Chintz; Cotton Prints; Silk Prints; Linen Union; Lace & Sheers*

Trade　　　　　　　　　　　　　　*Tel: (01) 352 5745*

6 Burnsall Street
London SW3 3SR
Tlx: 9419778 THORPE G

Sasha Waddell

Sasha Waddell carries a range of extremely interesting fabrics, including off-white and cream or white weaves; these are Swedish in style, and are available in a number of designs and weights. There are also samples of ticking, Indian cottons, ginghams and many other fabrics which can be ordered; tartans are also available. Sasha Waddell also carry the work of a number of designers, including Jeny Gaylore and Victoria Richards, who produce work on cotton and silk respectively.
See also under *Cotton Prints; Silk Prints; Linen; Wool*

Tel: (01) 603 0474

22 Northend Parade
Northend Road
London W14 0SJ

Warner & Sons Ltd

Warner offers an excellent range of weaves. The most recent cotton and cotton mix weaves

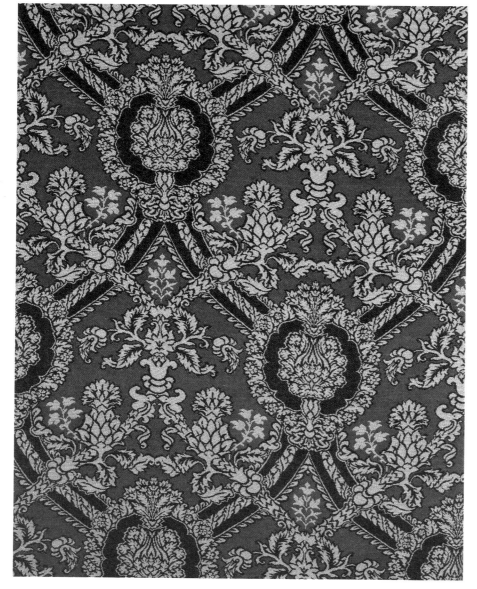

The Pine by Watts & Co

suitable for upholstery purposes are *Kimberly Trellis*, a 100% cotton dobby weave with a floral motif printed over the top, available in four colourways; *Definitive Damask* and *Siesta Walls*. Warner's embroidery style fabrics from the *Lisere* collection include *Clare Lisere* and *Ranleigh Stripe*, in spun viscose and cotton.

See also under *Chintz; Cotton Prints; Silk Weaves; Linen Union; Wool; Lace & Sheers*

Trade *Tel: (01) 439 2411*

7-11 Noel Street
London W1V 4AL
Tlx: 268317

Watts & Co Ltd

Watts & Co, leading exponent of the Gothic Revival, is now recolouring its ranges, yet still using the original designs from the nineteenth century. The cotton mix weaves are *The Windsor*, a cotton/rayon mix, comprising fruit and flower motifs in a reworking of an Elizabethan embroidery; *Memlinc*, woven in a tapestry weave and using superb floral and formal curving stems; and the medieval, opulent *The Pine*, a cotton and wool mix.

See also under *Cotton Prints; Silk Weaves; Trimmings*

Tel: (01) 222 7169/2893/1978

7 Tufton Street
London SW1P 3QE

LINEN UNION

A 'union' is a fabric in which the warp and the weft are made of different fibres. A linen union comprises a cotton warp and a linen weft, forming a strong, hard wearing fabric generally of a fairly rough texture and feel.

LINEN UNION

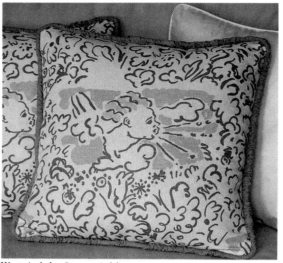

Westwinds by Laura Ashley

Laura Ashley Decorator Collection

The recent *French Garland Collection* comprises a range of plain linen unions, available in Burgundy, Smoke, Apricot, Primrose Yellow, Cream, White and Aqua. These co-ordinate with the chintzes from the same collection, all of which are now giving the Laura Ashley Decorator Collection a reputation for up-market fabrics in relatively sophisticated designs.
See also under *Chintz; Cotton Prints; Lace & Sheers; Trimmings*

Trade *Tel: (01) 730 1771/4632*

71/73 Lower Sloane Street
London SW1W 8DA
Fax: (01) 730 3369

Laura Ashley Home Furnishing

Laura Ashley Home Furnishing is the retail side of their fabrics, offering less expensive ranges than the Decorator Collection. The address below can give addresses of branches throughout England. Their cottagey-style prints are available on linen unions.
See also under *Cotton Prints; Childrens Fabrics; Lace & Sheers; Trimmings; Carpets & Rugs*

Retail *Ask for Customer Service*
Tel: (0628) 39151

Braywick House
Braywick Road
Maidenhead
Berks SL6 1DW
Tlx: 848508
Fax: (0628) 71122

GP & J Baker

Well-known for their chintzes, GP & J Baker's linen union qualities include three new ranges for the autumn, as well as roughly 20 ranges in stock. Their linen unions are gradually being replaced by heavy cotton qualities.
See also under *Chintz; Cotton Prints*

Trade *Tel: (01) 636 8412*

18 Berners Street
London W1P 4JA
Tlx: 83511 PARKTX G

Celia Birtwell

Celia Birtwell's deceptively simple designs in the new *Portobello* collection are hand blocked on cotton and cotton muslin, and are also available on linen union. The colours are either blue on

white or red on white (others available to order). See also under *Cotton Prints; Silk Prints; Lace & Sheers*

Tel: (01) 221 0877

71 Westbourne Park Road
London W2 5QH

Nina Campbell Ltd

The linen and cotton weaves for upholstery include their *Acorn* range, comprising an acorn shaped dobby weave on plain ground; *Chevron*, a herringbone pattern; and *Campbell Stripe*, broad stripes with alternating herringbone patterns. These weaves are in a variety of colourways, co-ordinating with the highly successful Nina Campbell ranges of chintz. New ranges of linens are being added to the collection, as are tiles and accessories.
See also under *Chintz*

Tel: (01) 584 9401

9 Walton Street
London SW3 2JD
Tlx: 929480 NCAMPB

Manuel Canovas

See under *International*

Colefax & Fowler

Colefax & Fowler is best known for chintzes, and has a select range available on linen union. These include the *Belton Damask*, a mid-nineteenth century design of dramatic scale; *Longford*, a trailing leaf design of the gothic revival period; and *Elveden Stripe*. Also available on linen union are two of their chintz designs, *Tree Poppy* and *Bailey Rose*.
See also under *Chintz; Cotton Prints; Cotton Weaves; Lace & Sheers; Trimmings; Carpets & Rugs*

Tel: (01) 493 2231

39 Brook Street
London W1 2JE
and
110 Fulham Road
London SW3 6RL
Tel: (01) 244 7427
Tlx: 8953136

Designers Guild

Several of Designers Guild's highly distinctive and popular prints are also available on linen union. These include *Bourbon Rose* and *Willow* from the *Ornamental Garden* collection, both available in four colourways. *Ornamental Garden* ranges are otherwise available as cotton chintzes.
See also under *Chintz; Cotton Prints; Cotton Weaves; Carpets & Rugs*

Tel: (01) 351 5775

271 & 277 Kings Road
London SW3 5EN
Tlx: 916121
Fax: (01) 352 7258

Tree Poppy by Colefax & Fowler

Charles Hammond

Charles Hammond is well known for classic chintzes: generally the linen union range is of a more exotic, Oriental feel. The latest ranges of linen union include many traditional designs from England, France or India, some of which are hand block printed. Linens available with a chintz are *Hollyhock HB* (a floral design), *Sevillia* (incorporating arabesque, Moorish designs), *Perak* (available in dark colourways with vertical trailing brances), and *Bradstock HB* (floral).
See also under *Chintz; Cotton Prints*

Tel: (01) 627 5566

Trade Showroom:
London Interior Design Centre
1 Cringle Street
London SW8 5BX
Tlx: 25812 ARTEXT G
Fax: (01) 622 4785

Liberty of London Prints

Liberty Prints' linen union collection comprises exotic chinoiserie-based designs and traditional floral motifs. Ranges include *Tambourine* and *Kasak* (part of the *Chesham Collection*) and *Ianthe*, a 1930s art deco style. All three co-ordinate with each other. Others are *Haibak*, adapted from a nineteenth century Persian carpet; *Zeback*, from the *Chesham I Collection*; *Petronella*, a large floral design; *Ikato*, an Oriental design; and *Penelope*, taken from their original nineteenth century archive documents.
See also under *Chintz; Cotton Prints*

Tel: (01) 352 6581

313 Merton Road
London SW18 5JS
Tlx: 928 619
Fax: (01) 871 3175

Shirley Liger Designs

Shirley Liger's sophisticated designs can be printed to order on linen union; her standard ranges are available on cotton.
See also under *Chintz; Cotton Prints; Silk Prints*

Tel: (01) 673 3441

27 Narbonne Avenue
London SW4 9JR
Tlx: 8951182

Monkwell Fabrics

Monkwell Fabrics offers a huge range of fabrics, including linen unions. Monkwell's fabrics are ideal for the contract market.
See also under *Chintz; Cotton Prints; Cotton Weaves*

Trade *Tel: (0202) 762546*

(Semple and Company Ltd)
10-12 Wharfdale Road
Bournemouth BH4 9BT
Tlx: 417179 MONKWELL
Fax: (0202) 762582

Moygashel

A range of linen unions in traditional floral prints and abstract designs, ideally suited for the contract market.
See also under *Cotton Prints*

Trade　　　　　　　　　　　*Tel: (0868) 722231*

*Moygashel Mills
Dungannon
County Tryrone
Northern Ireland BT7 1QS
Tlx: 74613*

Next Interiors

Next Interiors' recent collection includes the floral range *Dahlia*, available on linen union, in two colourways (damson and tangerine).
See also under *Cotton Prints; Cotton Weaves; Carpets & Rugs*

Tel: (0533) 866411

*Head Office:
Desford Road
Enderby
Leicester LE9 5AT
Tlx: 34415 NEXT G
Fax: (0533) 848998*

Nobilis-Fontan

See under *International*

Pallu & Lake

See under *International*

HA Percheron

See under *International*

Ramm, Son & Crocker Ltd

Ramm, Son & Crocker has a superb collection of Victorian chintzes, and the best examples of their document prints can be found in the chintz collection. Ranges available in linen union are *Latima* and *Lord Clive*, both of which are hand screen print designs from their archives.
See also under *Chintz; Cotton Prints*

Trade　　　　　　　　　　　*Tel: (06285) 29373*

*13-14 Treadaway Technical Centre
Treadaway Hill
Loudwater
High Wycombe
Bucks HP10 9PE
Tlx: 848 901*

Sahco Hesslein

See under *International*

Arthur Sanderson & Son

Some of the best of Sanderson's designs are available on linen union, notably their *William Morris* prints. Sanderson offers a huge range of fabrics, including chintzes, plains, seersuckers, cotton weaves and carpets, designed and coloured to mix and match. Sanderson has the William Morris blocks, and a range of hand blocked wallpapers.

See also under *Chintz: Cotton Prints; Cotton Weaves; Carpets & Rugs*

Tel: (01) 636 7800

52 Berners Street
London W1P 3AD

Textra Ltd

Textra offers a wide range of fabrics ideal for the contract market. Textra's linen unions include the *Bowes* collection using traditional floral designs. With large enough quantities, colourways can be specifically made up to customer requirements. Many of the fabrics are flame resistant.
See also under *Chintz; Cotton Prints; Cotton Weaves*

Trade Tel: (01) 637 5782/3

16 Newman Street
London W1P 4ED
Tlx: 837961 MACJEN G

Bernard Thorpe

All fabrics are designed to customer specification, or may be taken from any number of the show lengths on display. A huge variety of designs is available on a variety of different fabrics, including linen union. Colours may be matched or altered according to clients' requirements.

See also under *Chintz; Cotton Prints; Cotton Weaves; Silk Prints; Lace & Sheers*

Trade Tel: (01) 352 5745

6 Burnsall Street
London SW3 3SR
Tlx: 9419778 THORPE G

Warner & Sons Ltd

Known for its vast archives and superb chintzes and weaves, Warner has a collection of plain linen unions, *Surrey Union*, which co-ordinates with the print ranges.
See also under *Chintz; Cotton Prints; Cotton Weaves; Silk Weaves; Lace & Sheers; Wool*

Trade Tel: (01) 439 2411

7-11 Noel Street
London W1V 4AL
Tlx: 268317

Zipidi

Sunny, Mediterranean and versatile designs are hand printed onto a variety of fabrics, including linen unions.
See also under *Chintz: Cotton Prints; Childrens Fabrics*

Tel: (01) 491 2151

5 Deanery Mews
London W1

SILK PRINTS

Silk printing in Britain took place a long while before printing onto calico, or cotton, which began to flourish in the mid-17th century. Because of the nature of the dyes and fixes used to print on silk, the quality of colour is often stunning, ranging from jewel-like intensity to subtle shades and tones. Because of the expense, many of the silk printers in this entry work to commission only, using a variety of silk qualities, including fine chiffon, the heavier habotai, and the rough textured dupion.

Printed silk by Bentley & Spens

Printed silk by Sarah Collins

Bentley & Spens

Small-scale producers using a distinctive technique of batik and hand painting for their prints on silk, sheers, linen and cotton. Kim Bentley and Sally Spens work to commission; show lengths of their work can be seen at the above address.
See also under *Cotton Prints; Lace & Sheers*

Commission　　　　　　　　　*Tel: (01) 352 5685*

Studio 25
90 Lots Road
London SW10 OAD

Celia Birtwell

Famous from the 1960s when Celia Birtwell designed fabrics for fashion designer Ossy Clark, her well-known, deceptively simple designs are available on a number of different quality silks, including dupions, princess and dress weight habotai. All designs are printed by hand, usually available in a single colour on white.
See also under *Cotton Prints; Linen Union; Lace & Sheers*

Tel: (01) 221 0877

71 Westbourne Park Road
London W2 5QH

Gabrielle Bolton

A small producer using hand loomed cotton and silk from India, Gabrielle Bolton prints fabrics to complement her designs on ceramics: the style is traditionally based, using balanced repeat patterns. Commissions are taken from the address below.
See also under *Cotton Prints*

Commission　　　　　　　　　*Tel: (01) 748 7062*

128 Riverview Gardens
London SW13 9RA

Sarah Collins

A small producer specialising in modern designs on cotton and silk. Many of Sarah Collins' prints

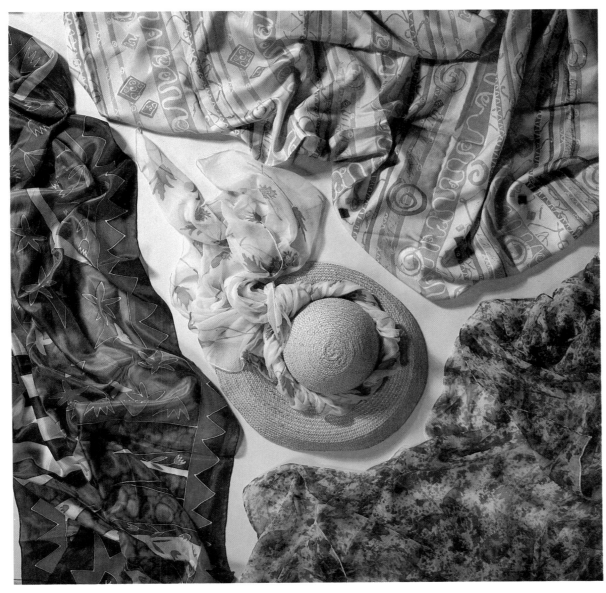

Silk chiffon hand painted scarves by Alexandra Lacey; (top right) silk print by Sarah Collins

SILK PRINTS

Printed silk by Sian Tucker available through CTG

are especially designed for antique furniture, and commissions are taken from the address below. See also under *Cotton Prints*

Tel: (058) 283 3483

Home Farm
Delaport Gustard Wood
Herts
Shop:
'By George'
23 George Street
St Albans
Herts
Tel: (0727) 53032

Contemporary Textile Gallery

The Contemporary Textile Gallery (CTG) is a division of the Vigo Carpet Gallery, one of the longest established Oriental rug galleries in Britain. While the CTG serves as a showroom and stockist primarily of hand made rugs, tapestries and wall-hangings, a number of fabric designers are represented here, including Sian Tucker and Fanny Wilder. Although best on rugs and tapestries, the CTG can commission work from any of the people specialising in printed silk for clients.
See also under *Cotton Prints; Speciality fabrics; Carpets & Rugs*

Tel: (01) 439 9070/1

10 Golden Square
London W1R 3AF

Tulip Maze silk by Danielle

Corney & Company

Distributed exclusively through Foursquare Designs, Corney & Company have several ranges of prints on raw, heavy-wefted silk: *Harlequin* comprises diamond shapes with zig-zag edges in three muted colours; *Butterflies & Leaves* is particularly attractive, again in the same muted colours; and *Labyrinth Donkey* is an abstract pattern of convoluted lines. The designs work well with the rough texture of the silk, complementing its natural look.
See also under *Cotton Prints*

Trade *Tel: (0580) 712177*

Available through
Foursquare Designs
Coursehorn Lane
Cranbrook
Kent TN17 3NR
Tlx: 896691 TLX1R G

Danielle

Danielle's prints are best seen on silk, either hand or machine printed on dupions. Her designs include pretty, feminine ideal bedroom styles and some more exotic or formal designs. All five of her books co-ordinate to an extent, giving a sense of continuity in colour throughout the collection. The names of the ranges, such as *Anastasia*, appropriately recall both a touch of the English woman's garden and a distinctly Oriental feel. Wallpapers, tiles and accessories are also available.
See also under *Cotton Prints; Lace & Sheers*

Tel: (01) 584 4242/1900
148 Walton Street
London SW3 2JJ

The Design Archives

Part of Courtaulds, the recently founded Design Archives produces magnificent chintzes and a small collection of silk prints, taken from the largely unexploited Courtaulds archives, which remains one of the largest collections of documents in Britain. The silks are screen printed by hand in France on silk taffeta, and include *Josephine*, a silk *toile* available in three colourways. All fabrics are of first rate quality.
See also under *Chintz; Cotton Prints*

Trade *Tel: (01) 629 9080*

13-14 Margaret Street
London W1Z 3DA
Shop:
79 Walton Street
London SW3
Tlx: 28607

Printed silk by Annie Doherty

Annie Doherty

Hand painted silks in flowing designs, Annie Doherty works as a decorative artist, producing silks, ceramics and furniture to commission. Annie Doherty has worked as an interior designer, and aims to create a whole environment out of her designs, which may also include wall hangings and pictures.

Tel: (01) 928 0681

Southbank Craft Centre
164-165 Hungerford Arches
South Bank
London SE1 8XU

Jason D'Souza Designs

Silks in a variety of weights, using a mixture of the eastern exotic and English floral. All ranges are hand printed; gold and silver metallic threads are often used, giving a sense of glamour. Quilted covers and cushions/pillows are also produced.
See also under *Cotton Prints; Lace & Sheers*

Trade *Tel: (01) 253 9294*

38 Graham Street
London N1 8JX
Tlx: 296716 DIESPK G

David Evans

A subsidiary of Sekers International, and known as the 'last of the old London Textiles Printers', David Evans is famous for its silk prints (used mainly for apparel), using extensive archive documents. David Evans has printed onto fabrics for over one hundred and forty years, continuing the fabric printing tradition of the River Cray in Kent first started at the end of the seventeenth century. The paisley or 'pine' motif was first developed here in the 1840s, and David Evans has a vast collection of these original paisley designs, taken from a Kashmir shawl first brought to London by the East India Company. Other designs include Victorian floral motifs, art nouveau, and art deco styles; the archives are open to those interested in the documents. All

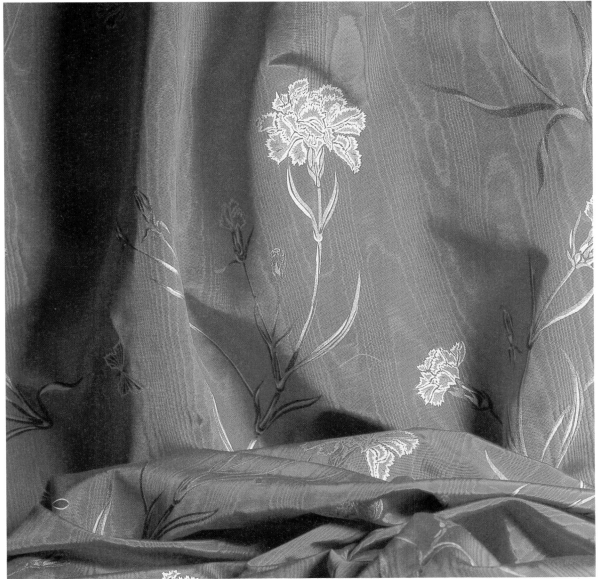

Printed silk by Jason D'Souza Designs

Silks by Ian & Marcel

Ian & Marcel

Printed silks by Penny Beard available through IDF

fabrics are printed to order, minimum quantity 44 metres.

See also under *Wool; Speciality Fabrics*

Trade Tel: (0322) 57521

Bourne Road
Crayford
Kent DA1 4BP

Ian & Marcel

Producing hand painted silk, Ian & Marcel is probably best known for couture work using superb designs, often with rubber applied to complement the patterns. Ian & Marcel produce silks for curtains, blinds, upholstery, cushions, bedding and wall hangings, all of which can be matched or colour co-ordinated for upholstery. They will also design and paint silk for a specific piece of furniture. Colours and themes are painterly in style, varying from bold geometric abstracts to floral and oriental motifs. Ian & Marcel produce instantly recognisable silks in a style which is very much their own.

Trade Tel: (01) 499 7147

Showroom:
49a South Street
London W1Y 5PD
Studio:
111-113 Great Titchfield Street
London W1
Tel: (01) 580 1722

Independent Designers Federation (IDF)

A newly established co-operative of young designers' work, some of the textile designers represented here are very good. Names to look

for include Peter Smith, Jane Spurway and Janet Taylor. Peter Smith produces hand printed/stencilled eastern style formal motifs using Victorian Gothic colours; very sumptuous and rich in effect. The silk is yarn-dyed and hand-loomed, and the prints are given a blushing or hand toning treatment to create a subtle depth of colour. Jane Spurway produces hand-painted lengths in silk or wool, developing a pattern over the entire surface with no repeats. The effect is soft, with a stained-glass window feel when held up to light. Janet Taylor works with silk, velvet, brocades and organza. The IDF is worth visiting to see the exciting uses of fabric with new designs and new treatments. All the fabric here is exclusive, expensive and original in design and concept.

See also under *Speciality Fabrics*

Tel: (01) 485 4555

30 Bruges Place
Randolph Street
London NW1 0TL

Stefan Keef Ltd

Stefan Keef has its own print works, used to print their designs onto a variety of fabrics, mainly top quality cotton and silk. Their latest collection, *Phase I*, consists of ten abstract designs (ten colourways). Their *Classic Range,* seen at its most striking in black and white, can be printed in any colour on a choice of materials, including voile, silk and cotton. Other ranges include the company's animal designs.

Printed silk by Alexandra Lacey

See also under *Cotton Prints; Lace & Sheers*

Tel: (0634) 718871
No 7 Henley
Trident Close
Sir Thomas Longley Road
Frindsbury
Rochester
Kent ME2 4ER

Alexandra Lacey

A small-scale producer working to commission, Alexandra Lacey's silk prints are of superb quality, ranging from bold geometrics to subtle textures, often based on plant forms. Working on

Printed silk by Tessa Lambert

natural fibres, and specialising on fine chiffon silk, Alexandra both hand-paints and screen prints, and combines this with decorative paint finishes for use in the interior. Silks are available as screens or for soft furnishing, hangings or drapes.

Tel: (01) 968 9306
249-251 Kensal Road
London W10 5DB

Tessa Lambert

A small producer of hand painted silk, using a wax resist technique and cold water dyes, Tessa Lambert's work is characterised by clean, geometric styles and stunning colours, from pastels to singing primaries. Having designed largely for the fashion fabric industry, Tessa is now moving into the furnishing world, producing accessories such as cushions, quilts and screens, and is happy to work with interior designers or individual customers.

Tel: (01) 326 4804
Designer 2
2 Gironde Road
London SW6 7DZ

Printed silk by Tessa Lambert

Shirley Liger Designs

Shirley Liger's collections, which include *Pot-Pourri* and *Impressions*, may be printed to order on a variety of fabrics, including silk. *Pot-Pourri* comprises a modern interpretation of garden images, such as butterfly, trellis and rose motifs printed on an attractive buttermilk coloured ground, available in seven colourways. *Impressions* gives a smart, tailored look, in strong colour combinations. Colours can be matched to clients' specifications.
See also under *Chintz; Cotton Prints; Linen Union*

Tel: (01) 673 3441

27 Narbonne Avenue
London SW4 9JR
Tlx: 8951182

Nobilis-Fontan

See under *International*

Parkertex Fabrics Ltd

Offers a good selection of silks, including a range of dupions and attractively coloured plains. *Jaipur* is an all-over smudgey design, co-ordinating with *Krishna*. Plains are also available. Colours are soft, natural tones or pastels. Parkertex has a range of fabrics ideal for the contract market.
See also under *Chintz; Cotton Prints; Cotton Weaves; Lace & Sheers*

Trade *Tel: (01) 636 8412*

18 Berners Street
London W1P 4JA
Tlx: 83511

HA Percheron

See under *International*

Silk Association of Great Britain

A useful organisation for those requiring more information on the manufacture, history and types of silk. They produce booklets, samples and journals on silk and its production, care and uses.
See also under *Silk Weaves; Reference*

Tel: (0625) 28362

Parkett Hayes House
Broken Cross
Macclesfield
Cheshire SK11 8TZ

SILK PRINTS

Curtains by Peter Smith (IDF);
(backing fabric, centre) *Doge* by Laura
Ashley Decorator Collection

Michael Szell Ltd

Hand painted fabrics available on lightweight and heavyweight silks; eccentric, different and very good, clients many choose from show lengths or use their own designs. Michael Szell's designs are best seen on silk; ranging from the rich, sumptuous use of gold and silver to pinks and French light greens, any colour can be matched. The fabrics are his own, and include cotton, sheers, chintz, moire and velvet. Michael Szell's silk fabrics are among the best available, and highly recommended for the expensive, exclusive touch.
See also under *Chintz; Cotton Prints; Cotton Weaves; Lace & Sheers*

Trade *Tel: (01) 589 2634*
47 Sloane Avenue
London SW3 3DH

Timney Fowler Prints

Black and white prints using architectural motifs, printed onto silk noile - a rough, slubby silk - and cotton; some designs are available in grey and white, or gold and black.
See also under *Cotton Prints*

Tel: (01) 351 6562
388 Kings Road
London SW3 5UZ
Tlx: 9413716 TIMSOW

Tissunique

See under *International*

Printed silk by Timney Fowler

Bernard Thorpe

All fabrics are designed to customer specification, or may be taken from any number of the show lengths on display. A huge variety of designs, the silks show Bernard Thorpe's work off at its best. Wonderful colours, all of which can be altered or changed to suit clients' tastes, and always in vogue.
See also under *Chintz; Cotton Prints; Cotton Weaves; Linen Union; Lace & Sheers*

Trade *Tel: (01) 352 5745*
6 Burnsall Street
London SW3 3SR
Tlx: 9419778 THORPE G

Details from mans suit by Victoria Richards available through Sasha Wadell

Verity Tiles & Fabrics

Fabric and ceramic tile producers, Verity hand screen print designs to customer specifications on a variety of different fabrics, including silk. A huge range of designs is available in the showroom, some of which co-ordinate with their tiles.

See also under *Chintz; Cotton Prints; Childrens Fabrics*

Trade
Tel: (01) 245 9000

7 Jerdan Place
London SW6

Sasha Waddell

Sasha Waddell carries a number of different designers, including the work of Victoria Richards, who produces beautiful silks using discharge printing methods on damasks. Sasha Waddell also has a library of fabrics, including linens, ticking, and Indian cottons, all of natural off-white colours.

See also under *Cotton Prints; Cotton Weaves; Linen; Wool*

Tel: (01) 603 0474

22 North End Parade
Northend Road
London W14 0SJ

SILK WEAVES

Silk weaves comprise some of the most expensive and beautiful of all fabrics. Introduced into Europe by the Romans in 53BC, silk cloth was first produced by the Chinese, probably in Neolithic times. The art of sericulture remained a closely guarded secret for centuries; the Romans were forced to trade through the Persians, and silk remained costly and rare in Europe until the end of the Middle Ages. The heyday of silk weaving in Britain took place in the 17th to early 19th centuries in Spitalfields, London. Since that time, the silk weaving industry has declined; However, modern day silk weavers still continue traditional methods of weaving, with recourse to document designs and producing exquisite quality fabric. The entry also includes young designers weaving contemporary patterns, and silks produced by the wool mills which have a distinctive, often rough texture, many of which are available in tweed styles.

Woven silk by Rosemary Atkinson

Shyam Ahuja

See under *International*

Alexanders

Alexanders of Kirkburn Mills has brought out its first range of 100% silk, which is woven at its mills. Primarily a wool producer, the new silks incorporate elaborate tweeds and checks in rich colours, aimed primarily at the American, Japanese and Italian markets. However, like the wools, these fabrics are intended primarily for the apparel market. The silk is spun from a heavy yarn (bourette), spun on the worsted principle; weights are 290g, and the minimum order quantity is two pieces (approximately 120 metres) per shade. Alexanders also produces linen, silk and wool mixes.

Tel: (0779) 72663

Kirkburn Mills
Weavers Lane
Peterhead AB4 6SA
Aberdeenshire
Tlx: 73111 KRKBRN
Fax: (0779) 78989
London agent:
Elliot Little
26 Knox Street
London W1
Tel: (01) 486 1119

Rosemary Atkinson

A small scale producer of woven 100% spun silk in combinations of twill weaves. The fabric has a rich and lustrous sheen which, combined with the subtle mixes of colour within the weave, can give a shot look. Designs are on a relatively large scale, including geometrics and stripes; the silk is suitable for curtaining or light upholstery. Sample lengths are woven and dyed by hand, and commissions may be taken from the address below, or through Sharon Plant at Aspects (see separate entry). The cloth, once commissioned, is manufactured in Staffordshire and Scotland. Rosemary Atkinson's work is exceptionally good; in 1985 Rosemary won the House & Garden IDDA Decorex Young Designers Scheme.

Tel: (0962) 842500 ext 137

Winchester Design Workshop
Park Avenue
Winchester
Hampshire SO23 8DL

Calzeat

Calzeat (John Bell) is primarily a wool producer, specialising in jacquard weaves and damask style designs. Calzeat also has a range of 100% woven silk; all fabrics are woven to order, and can either be taken from existing designs or jacquard cards can be cut for new designs. Twill and herringbone weaves, jacquard and plain weaves, and twill and jacquard weaves are available. Colours can also be matched. Minimum order is 120 metres.
See also under *Linen; Wool*

Tel: (0899) 20837

Thistle Mills
17 Station Road
Biggar
Scotland M12 6BS
London agent:
Texyl
3rd Floor
66 Bolsover Street
London W1P 8DA
Tel: (01) 388 7711

Manuel Canovas

See under *International*

Claridge Mills Ltd

Amongs the very best wool and silk producers in Britain, Claridge's silks are soft in fibre; often with a high lustre finish, available in weights from 230g (light weight); to 310g (fairly heavy). Claridge can weave virtually anything; designs often incorporate subtle use of colours, from dark shades to pastels. Paisleys, plains, flecked twill designs, stripes and tweed style patterns are all available. Fabrics are made to order and

minimum qualtities are half a peice (35 metres). High quality and expensive.
See also under *Wool; Linen*

Trade *Tel: (0750) 20300*

Riverside
Selkirk
Scotland TD7 5DU
Tlx: 727192 CLAMIL G
Fax: (0750) 20329

Connemara Fabrics Ltd

Producers of linens, linen/silks and linen, silk and wool mixes, Connemara specialise in highly elaborate tweeds and complex checks, using superbly rich colours, oriented towards Japanese and European markets. Fabrics are made to order and clients can choose from existing designs or choose their own design and colourway. Minimum orders are two pieces (120 metres).
See also under *Linen*

Tel: (010 353) 733 8002

Kilcar
Co Donegal
Republic of Ireland
London agent:
Elliot Little
26 Knox Street
London W1
Tel: (01) 486 1119

Crombie

Crombie is known as the world's leading producer of coating fabric using a raised, brushed surface effect; manufacturers of cloth traditionally associated with all things luxurious and very expensive, Crombie also has a range of 100% woven silk, incorporating checks, geometrics, tweeds and stripes. Colours include dark browns, blacks and greens and subtle pastels. Superbly soft with a light lustre, Crombie silk is top quality. New ranges are brought out twice a year. Minimum orders are two pieces (approximately 120 metres) per shade; weights are about 300g. Other qualities produced include 100% camelhair, cashmere and silk/wool mixes.
See also under *Wool; Speciality Fabrics*

Trade *Tel: (0224) 483201*

Grandholm Mills
Woodside
Aberdeen
Scotland AB9 2SA
Tlx: 73138 CROMBI G

Fox & Floor

Fox & Floor is developing a range of 100% woven silk suitable for cutains and upholstery; these are primarily seersuckers. Fox & Floor is best known for imaginative wool designs and cotton jacquards. Alecks, an agency operating from the

Left to right: *Van der Weyden* by Watts & Co; *Dragons & Owls* by Stuart Renaissance Textiles; *Large Falcons* by Stuart Renaissance Textiles; *The Hilliard* by Watts & Co

same address, imports and distributes Indian silks, which include plain dupions, checks, stripes and natural textured silk.
See also under *Cotton Weaves; Wool*

Trade Tel: (01) 267 1467/8

142 Royal College Street
London NW1 0TA
Tlx: 261334 SXF G

Gainsborough Silk Weaving Company Ltd

A small, privately owned company, Gainsborough Silk Weaving was founded in 1903 and weaves natural fibres, including silk. Other fibres used are cotton, cotton mixes and flax. Gainsborough specialises in specialist damasks woven on jacquard looms; and brocatelles, tabourettes, plains, quilted and woven tapestries are also made. Designs are taken from the company's archives (which date from the turn of the century) and extensive library of designs, or can be matched to customers' own designs and colours.
See also under *Cotton Weaves*

Tel: (0787) 72081

Alexandra Road
Chilton
Sudbury
Suffolk CO10 6XH
Tlx: 987562 GAINSK

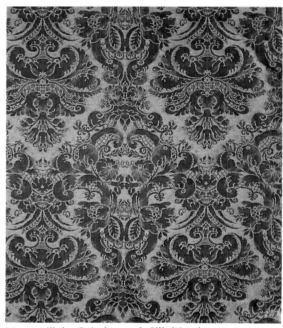

Woven silk by Gainsborough Silk Weaving

Humphries Weaving Company

Richard Humphries founded Humphries Weaving Company in 1972 on being made redundant on the closure of the last English hand weaving mill. Humphries Weaving Company at the De Vere Mill, Castle Hedingham, bought the hand looms and now produces silks and cotton using the traditional methods of weaving, and remains the only British company commercially hand weaving silk today. Of the many silks available, the most exclusive include the velvets, which demand more than two full days' weaving for the completion of one metre. Jacquards include pure silk damask, silk tissue, and brocatelle. Plains include silk lute, silk super lute,

A Brocatelle by Humphries Weaving Company

silk shot plain taffeta, satins, bombazine, and spot or plain silk velvet. Designs can be made to customer specification in any colour. Silk, cotton, wool and man-made fibres may also be woven.
See also under *Cotton Weaves*

Trade Tel: (01) 627 5566

Available through:
Pallu & Lake
London Interior Design Centre
1 Cringle Street
London SW8 5BX
Tlx: 917976 HAMON G

JAB

See under *International*

RG Neill & Son

RG Neill & Son produces superb linen, linen/silk and 100% woven silk of superb quality, woven from fine spun yarn. Minimum order is one piece (approximately 66 metres), from a huge variety of colours and designs. Weights are 240g per square metre.
See also under *Linen; Wool*

Trade Tel: (0541) 80445

Glenesk Mills
Langholm
Scotland DG13 OAL

Osborne & Little

Well-known for its sophisticated and eclectic style, Osborne & Little has a range of English silks, the most recent addition to which is the *Tamesa Silk Collection*, comprising *Colette*, in pastel colours with contrasting and self coloured stripes; *Carmen*, using richer colours with bold, vertical stripes in seersucker finish; and *Taffeta*, plains and shot effects. The firm's colours are always exciting. Osborne & Little also has showrooms in Edinburgh and Manchester.

SILK WEAVES

Falcolns & Pomegranites by Stuart Renaissance Textiles

See also under *Cotton Prints; Chintz; Cotton Weaves Weaves; Trimmings; International*

Tel: (01) 352 1456

304 Kings Road
London SW3 5UH
Tlx: 8813128
Fax: (01) 673 8254
and:
43 Conduit Street
London W1
Tel: (01) 734 5254

Pallu & Lake

See under *International*

HA Percheron

See under *International*

Silk Association of Great Britain

A useful organisation for those requiring more information on the manufacture and history of silk. Booklets, samples and journals on silk and its production, care and uses are produced.
See also under *Silk Prints; Reference*

Tel: (0625) 28362

Parkett Hayes House
Broken Cross
Macclesfield
Cheshire SK11 8TZ

Tamesa Silk Weaves by Osborne & Little

Stuart Renaissance Textiles

Stuart Renaissance Textiles is a newly formed company out of Stuart Interiors, specialising in weaving fabrics taken from Renaissance and 15th century patterns. The *Barrington Court Collection* (also available through Tissunique) is taken from original 16th and 17th century English weaves. Fabrics include wool, wool/linen and silk weaves, using Gothic-style motifs such as dragons, partridges, falcons and pomegranites. The original ten ranges, recreated on jacquard looms in Somerset, are in 100% woollens and mohair; all are suitable for upholstery, curtaining doors and windows and bed hangings and covers. Colours are rich Gothic tones: green, red, terracotta, cobalt, gold, stone, black and ivory. Fabrics can also be commissioned using the clients' choice of colour and design. Refer also to Tissunique in the *International* section.
See also under *Wool*

Trade Tel: (0460) 40349

Barrington Court
Barrington
Ilminster
Somerset TA19 ONQ

Tissunique

See under *International*

Warner & Sons Ltd

Once famous for hand loomed silk, Warner still has a collection of silks and weaves. However, the hand looms were sold in early 1970s to Richard Humphries and most of the weaves are of cotton, wool or man-made fibres. Existing silks include the collection from *Personal Choice*, *Rhapsody Silk* and *Enchantment Silk*, in pastels and stripes. Warner has, of course, a huge archive of the silks produced at the end of the 19th century which may be seen by appointment.
See also under *Chintz; Cotton Prints; Cotton Weaves; Linen Union; Wool; Lace & Sheers*

Trade Tel: (01) 439 2411

7-11 Noel Street
London W1V 4AL
Tlx: 268317

Watts & Co Ltd

Watts & Co was founded in 1874 by three church architects, George Frederick Bodley, Thomas Garner and Gilbert Scott the Younger, all pupils of Sir Gilbert Scott, one of the leaders of the

The Gothic by Watts & Co Ltd

SILK WEAVES

The Van der Weyden by Watts & Co Ltd

Gothic Revival. The partners provided embroidery, textiles and needlework, inspired in design by the late-Gothic art of Northern Europe. Watts was rivalled only by Morris & Co, and was used by leading architects and designers of the time. Sir Edwin Lutyens and Sir Robert Lorimer used its fabrics and wallpapers for their great country house restoration work; Sir Ninian Comper, Sir Giles Gilbert Scott, Temple Moore, Sir Walter Tapper and Ralph Adams Gram all used the fabrics for restoration and church decoration. Watts is now recolouring its ranges, still using the original designs, in order to achieve as authentic a look as possible. The most luxurious of its fabrics are the silk weaves, which include the *Van Der Weyden,* by Thomas Garner, woven using pure silk brocatelle in a formal design. *The Gothic,* also by Thomas Garner, is considered the hallmark of all Watts fabrics and has been in constant production since the firm began; *The Bellini,* stylised flowers by GF Bodley, inspired by Italian damasks from the 15th century and coloured according to authentic mediaeval sources; *The Hilliard,* a small scale design of birds and flowers; and *Shaftesbury,* handwoven oriental slub silk. *Shaftesbury* is available in a variety of plain colours.

See also under *Cotton Prints; Cotton Weaves; Trimmings*

Tel: (01) 222 7169

7 Tufton Street
London SW1P 3QE

LINEN

Linen is one of the oldest textile fibres known, woven from flax in Egypt over 4,000 years ago. The Irish linen industry began in the early 18th century, and some of the mills included within this section still use traditional methods of linen production. Linen is a luxury fabric in every sense of the word, expensive and time consuming to produce, the fabric itself is smooth, to a certain extent soil resistant, sleek in feel and very strong. The linen producers in this section include those who print onto linen as well as the linen mills, many of whom require large minimum orders.

From the *Kells Collection* by Ethna Brogan

Ethna Brogan Textile Design

Established about a year and a half ago, Ethna Brogan's first range is the *Kells Collection*, available on 100% linen, using modern colourways and bold patterns inspired by illuminations from the medieval illuminated Book of Kells. These fabrics are designed, woven and printed in Ireland. Brogan's designs are strong, bold and best applied to large areas; the colourings are likewise modern and striking. The three ranges are *Ethna*, *Feathers* and *Patches*.

Tel: (0238) 562278

The Pay Office
Drumaness
Ballynahinch
Co Down
Northern Ireland

Calzeat

Calzeat (John Bell) is primarily a wool producer (see under the wool section) and has a linen range based on their jacquard woven damasks, using paisley, floral and diamond designs. Plains and stripes are also available, along with polyester and linen; dacron and linen; and linen and silk mixes. Minimum orders are one piece (60 metres); linens are made and woven to order. Weight ranges are 180-400 grams
See also under *Silk Weaves; Wool*

Trade *Tel: (0899) 20837*

17 Station Road
Biggar
Scotland MK12 6BS
Tlx: 77410
London agent:
Texyl
3rd Floor
66 Bolsover Street
London W1P 8DA
Tel: (01) 388 7711

Claridge Mills Ltd

Claridge Mills are famous for their superb quality wool, linens and silk, and are considered by some amongst the best in Britain for quality and versatility. Linens are available as 100% linen, linen/silk and linen/silk/wool mixes, woven to order from a wide range of patterns and colourways, suitable for lightweight usage such as for apparel. Minimum quantities are half a piece

(35 metres). Weights are 280 - 340 grams. Plains, stripes, dobby weaves, tweeds and geometrics are available, and new qualities are being introduced all the time.
See also under *Silk Weaves; Wool*

Trade *Tel: (0750) 20300*

*Riverside
Selkirk TD7 5DU
Scotland
Tlx: 727192 CLAMIL G*

William Clark & Sons Ltd

Producers of Irish linen in plain colours since 1739, Clarke still use their 200 year old beetling machines, which provide a superbly soft finish, alongside chip controlled high speed dye jigs. Weights are 290 grams; there are no minimum orders for their house colours (of which there are 40 including white); for special colours minimum dying quantities are 400 metres. Clark produce fine, old fashioned traditional Irish linen, beautifully smooth and supple in feel.

Trade *Tel: (0648) 42214*

*Upperlands
Meghera
Co Londonderry
Northern Ireland*

Connemara Fabrics Ltd

Connemara's spring range concentrates on linen/silk and linen/wool mixes of superb quality. 100% silk is also available in one colour, suitable for apparel. The woven texture is achieved by blending the linen and silk into 2 ply yarn, giving the fabric a combination of single yarn slubby effect and the rounded effect from twisting. The linen/silk fabric is available in 200-300 gram weights (some heavier); the emphasis is on highly elaborate complex tweeds and checks in deep, rich colours. Oriented towards the Italian, Japanese and American markets, the designs are complicated tweeds and elaborate checks in rich colours. 100% linens are available in plains and stripes. As a design house, patterns and show lengths are available, and all fabrics are woven to order, generally suitable for apparel. Minimum quantities are 120 metres (two pieces).
See also under *Silk Weaves*

Trade *Tel: (010 353) 733 8002*

*Kilcar
Co Donegal
Republic of Ireland
Tlx: 40427 CFKR
London agent:
Elliot Little
26 Knox Street
London W1
Tel: (01) 486 1119*

Elizabeth Eaton

One of the best decorators in London, Elizabeth Eaton import a large range of fabrics and wallpaper. However, their own fabrics are a select printed linen collection, many of which are in one colour on a white or buff background.

Claridge Mills

Ranges are available on 100% linen, and include *Hilda*, comprising roughly drawn shell shapes; *Bubbenhal*, a diamond shape repeat with stylised sprigs; *Saighton*, comprising a thinly drawn heraldic motif on buff ground. A wide range of accessories and imported fabrics is also available.
See also under *International*

Trade *Tel: (01) 589 0118-9*

25a Basil Street
London SW3 1BB
Tlx: 22914 CCCG

John England

John England's Linens are very much in vogue, they offer a huge range, from fine shirting weights at 150 grams to heavy weaves for furnishing. There are no minimum quantities, except if special colours or designs are required. Virtually all kinds of designs, including stripes, checks, geometrics, and all colours are available either from stock or can be woven to order. Some of the most interesting qualities are the loosely woven furnishing linens. Linen/cotton and linen/polyester are also available.

Tel: (0232) 241 307

45 Charles Street South
Belfast BT12 5GA
Northern Ireland
Tlx: 747538 BELCOM JET

International Linen Promotion

The International Linen Promotion aims to increase awareness of the qualities and uses of linen, and advertises and produces information packages. Lengths of linen produced by linen manufacturers are on show at the above address. The International Confederation of the Flax and Linen industries operates an 'L' trade mark to guarantee that products are made of 100% linen (containing less than 5% other fibres). The symbol is black on clothing, brown on furnishing fabrics and blue on household textiles.
See also under *Reference*

Tel: (01) 405 7791/3

31 Great Queen Street
London WC2B 5AA

Learoyd Bros & Co

Famous for superb quality worsteds, Learoyd Brothers also produce 100% linen. Linen weights are about 200-400 grams; extensive colour ranges are available, including tweed style weaves. Different qualities are available, linen and silk, and linen and wool, or mixtures of all three. The minimum order is one piece (60 metres).
See also under *Wool*

Trade *Tel: (0484) 20377*

Kirkheaton Mills
Kirkheaton
Huddersfield HD5 0NS

Eward Liddell Ltd

Specialise in table linen but can supply apparel weights and damasks (220 grams in weight). Also produce 100% cotton and cotton/linen mix.

Tel: (0846) 692751

21 Lurgan Road
Dromore
Co Down BT25 1LL
Northern Ireland
Tlx: 74595

Lintrend Ltd

Lintrend specialise in plain linens, weights from 110-260 grams. Also available are jacquards, crepe, houndstooth and stripes. There are 16 house colours; on these there are no minimum quantities. Lintrend have developed the fibre molinease, a wood pulp viscose which helps prevent creasing, and gives an easy-care quality to the fabric. Cotton muslin and cotton/linen are also available.

Trade *Tel: (0594) 78193*

Inver Road
Larne
Co Antrim BT40 3BP
Northern Ireland

McNutt Weaving Co Ltd

Produce piece dyed linen (minimum orders are about 300 metres) and colour woven linen (minimum orders are 50 metres) in light weights, from 150 grams to 260 grams. New ranges are brought out twice a year; the designs are tweeds and tweed-styles.
See also under *Wool*

Trade *Tel: (010) 353 7455324*

Downings
Co Donegal
Republic of Ireland
Tlx: 42078 NUTT E1

RG Neill & Son

RG Neill (Neill of Langholm) produce linen and linen/silk mixes, in weights of 260, 295 and (for the latter quality) 300 grams per square metre, suitable for apparel. The minimum order is one piece (approximately 60 metres). Neil of Langholm offer a huge range of design and colours, as well as a choice of 11-12 colours in their piece dyed linen. Special colours can be produced. All linen and linen/silk fabrics are top quality, made to order.
See also under *Silk Weaves; Wool*

Tel: (0541) 80445

Glenesk Mills
Langholm DG13 0AL
Scotland

John Orr Ltd

Known for its wool upholstery fabrics, John Orr is now taking orders for linen, cotton and cotton blends are also available. Minimum orders

are 200 metres per colourway, yarn dyed. John Orr can match colours; the firm's speciality is the dobby weaves. Silk mixes are also available.
See also under *Wool*

Trade *Tel: (010 353) 46 21449*

Beechmount Industrial Estate
Navan
Co Meath
Republic of Ireland

Spence Bryson & Co Ltd

Large and well-respected producers of fine quality linens, Spence Bryson produce a range of weights, from the superbly light weight 82 grams per square metre to 300 grams. Plains, checks, suiting-style designs and stripes are available. Minimum orders are from 40 metres to 80 metres.

Trade *Tel: (0232) 226464*

41 Great Victoria Street
Belfast BT2 7AJ
Northern Ireland
Tlx: 74162
Fax: 0232 248257

Jonathan Thorpe & Sons

Knitted jersey style linen, weights ranging from roughly 286-422 grams. Minimum orders are one piece (35 metres). Jonathan Thorpe also have linen/cotton, and polyester, linen and cotton mixes.

Spence Bryson

Trade *Tel: (0484) 685415*

Valley Mills
New Mill
Huddersfield HD7 7HB
Tlx: 517120

The Ulster Weavers Co Ltd

Ulster Weavers specialise in superbly fine plain linens and weaves in a wide range of colours. The light weights are from 90 grams, to the heavier twills and crepes (up to 300 grams). Any quantity can be ordered. Ulster Weavers also have cotton, viscose and polyester mixes.

Tel: (0232) 329494

Linfield Road
Belfast BT12 5GL
Northern Ireland
Tlx: 747707

Sasha Waddell

Sasha Waddell has a library of different quality linens which she can order for customers; also a variety of interesting fabrics including cottons, and work from designers on cotton and silk; and Swedish style plain, woven, off-white natural fabrics.
See also under *Cotton Prints; Cotton Weaves; Silk Prints; Wool*

Tel: (01) 603 0474

22 North End Parade
North End Road
London W14

WOOL

This section includes producers of some of the finest tweeds, tartans, flannels, contract quality fabric and handspun cloth. Both woollens and worsteds, terms which define the method of manufacture, are included. A woollen is a fabric woven from yarns which have not been combed, which means that the fabric often has a rustic, homespun look. Woollens include fabrics with bulk and nap, such as tweeds. A worsted, by contrast, is woven from yarn which has been combed, resulting in cloth which is closely woven and fine in texture. Many wool mills require large minimum orders only.

New Images Collection by Armitage Sinclair

Ankaret Cresswell

Ankaret Cresswell is a small company producing hand woven cloth (minimum order 46 metres). Unusual effects, including subtle colour gradations, are possible, and Ankaret specialises in designs which cannot be produced on power looms. A variety of qualities of wool are used, including merino. Fabrics at retail prices are available from the below address.

Tel: (0723) 864406

Wykeham
Scarborough
North Yorkshire YO13 9QB

Armitage Sinclair

Specialises in furnishing wools and fine worsteds for the contract market, suitable for such locations as nightclubs, casinos and restaurants. Armitage Sinclair requires a minimum order of 250 metres for the domestic market; cut lengths are available for the contract market. *New Images* is their latest collection, comprising six fabric qualities including *Knightsbridge*, a plain suitable for upholstery or curtains available in 21 colourways; and ranges incorporating geometric designs, also suitable for upholstery. All fabrics can be flame retardant treated. Weights range from light worsteds for curtaining and heavy tweeds for upholstery. Armitage Sinclair also has a small printed range.

Tel: (0924) 466221

Caldervale Mills
Ravansthorpe
Dewsbury
West Yorkshire WF13 3JL
Tlx: 557552

British Furtex Fabrics Ltd

Specialists in contract furnishing fabrics woven in either 100% wool or wool/nylon mix, particularly suitable for very heavy duty upholstery; clients include British Rail and London Transport. Fabrics are woven to order to clients' specifications. Minimum orders are negotiable.

Tel: (0422) 882161

Luddendenfoot
Halifax
West Yorkshire HX2 6AQ
Tlx: 517798 FURTEX

British Replin Ltd

One of the biggest wool fabric producers in the contract furnishing market, British Replin is well known and highly respected for producing flame retardant hard wearing cloth, suitable for upholstery, screens, curtains and wall coverings. British Replin offers made-to-order services, and will work closely with clients to assess the exact fabric requirements. Fully co-ordinating ranges are available in cut lengths from stock; a minimum order of 200 metres is necessary on special orders.

Tel: (0292) 267271

Belvedere Mills
PO Box 25
Ayr
Scotland KA8 8JD
Tlx: 778974

Broadhead & Graves

Part of the Huddersfield Fine Worsteds group, Broadhead & Graves produce a superb quality flannel in a wide variety of colours and designs; 100% lambswool cloth; summer kid mohair and wool; and a wool and cashmere quality. All fabrics are suitable for apparel.

Tel: (0484) 20377

Kirkheaton Mills
Kirkheaton
Huddersfield HD5 0NS
Tlx: 517216

Bute Fabrics Ltd

Highly respected in the contract furnishing market, Bute Fabrics produces 100% wool fabric for contract furniture companies throughout the world. Their wools are suited for upholstery and office locations. Bute offer a cut length service from their standard UK collection from Unit 4 Contracts; the standard ranges comprise the three-colour checks from the *Spectrum* and *Dundee* ranges; diagonal stripes from the *Edinburgh* collection, and a wide variety of plains. Roughly 80% of their work is made to order, designed and coloured to customer specifications; Bute are able to work with clients on an individual basis and can produce special hand crafted fabrics.

Tel: (0700) 3734

4 Barone Road
Rothesay
Isle of Bute
Scotland PA20 0DP
Tlx: 778982
Distributed through:
Unit 4 Contracts
42 Great Marlborough Street
London W1V 2 EQ
Tel: (01) 437 5020/5245
Tlx: 261246 UNIFOR G

Calzeat

Specialises in made to order jacquard weaves (minimum order 120 metres). One of the most

A double cloth by Malcolm Campbell

interesting ranges is their paisley designs superimposed over tartan. Calzeat (John Bell) can produce special designs to customer specification and colours can be matched.
See also under *Silk Weaves; Linen*

Tel: (0899) 20395

17 Station Road
Biggar
Scotland ML12 6B2
Tlx: 777 410
London agent:
Texyl
3rd Floor
66 Bolsover Street
London W1P 8DA
Tel: (01) 388 7711

Malcolm Campbell

A small mill producing 100% wool and wool/silk mixes to order (minimum orders are one piece, or about 60 metres). Malcolm Campbell offers a wide range of highly inventive designs with a strong emphasis on textures, generally of light weight qualities suitable for apparel. Their furnishing fabric ranges include modern designs, checks, herringbones and tweeds, and a wool and silk fabric in a basket weave style. Malcolm Campbell also has a double cloth which has a sculptured appearance.

Tel: (0705) 20501

Shepherds Mill
Selkirk
Scotland TD7 5EA
Tlx: 72598 MALCOLM G
London agent:
Simpson Textiles
322 Golden House
39 Great Pultney Street
London W1
Tel: (01) 437 2927

Cambourne Fabrics Ltd

Major producers and wholesalers of contract furnishing fabrics, Cambourne offers a wide range of fabrics suitable for upholstery, screens and wallcoverings of 100% wool and wool mixes. Cambourne is able to take on large scale contract work, producing a range of 600 fabrics which can be adapted, for instance to incorporate a

company logo. The recent *Mirage* collection comprises an inherently flame retardant upholstery fabric of wool/viscose mix, available in five new designs and 22 plain colours.

Tel: (0924) 490491

*Hopton Mills
Hopton
West Yorkshire WF14 8HE
Tlx: 557877
Fax: (0924) 495605*

Manuel Canovas

See under *International*

Castleisland Weaving Co

Producers of wool furnishing fabric (70% wool and 30% lenzing, a fire resistant rayon). All fabrics are held in stock, with a colour dying service for which there is a minimum order of 120 metres per shade. The designs include 21 subtle flecked plains available in 21 colours and a range of fancy tweeds.

Tel: (0762) 334433

*Portadown
Craigavon
Northern Ireland BT62 1EE
Tlx: 74154*

Clansman Tweeds Company Ltd

Clansman Tweeds (comprising Stephen Burns Ltd, SA Newall Ltd, and Smiths of Stornoway

Wool and wool blend fabrics by Claridge Mills

Ltd) produces and wholesales Harris Tweed, which is hand woven by the island crofters in their own homes (see below for the official definition of this cloth). Hard wearing and durable, Harris Tweed is world famous, produced exclusively in the Outer Hebrides from 100% Scottish wool and suitable for apparels. Orders from Clansman Tweeds must be made in multiples of 80 metres.

Tel: (0851) 3065

*28 Bells Road
Stornoway
Isle of Lewis
Scotland PA87 2K
Tlx: 75161*

Claridge Mills Ltd

This small prosperous mill deals with the top end of the apparel market, dealing with internationally known clients. Claridge Mills produces top quality wool (including silk/wool; linen/wool; mohair/wool; and cashmere/wool blends) suitable for apparel and furnishing. All

fabric is made to order, and Claridge Mills has an enormous range of designs from which to choose, including checks, plains, stripes, diagonals, jacquards, and ranges using lurex yarn. Claridge Mills will also produce exclusive designs for clients; the minimum order is negotiable. Claridge Mills also has a mill shop selling small quantities of off-cuts.

See also under *Silk Weaves; Linen*

Tel: (0750) 20300

*Claridge Mills
Riverside
Selkirk
Scotland TD7 5DU
Tlx: 727192 CLAMIL G
Fax: (0750) 20329*

Cook Mills

Cook Mills produces furnishing quality wools suitable for the contract and domestic market. They have a stock controlled range available by the metre, comprising six designs, including a worsted cloth with a diamond design and co-ordinating plain. Cook Mills offers a piece dyeing service to certain specifications for which there is a minimum order of four to six metres, and a design service to produce fabrics to customer specification. Jacquard weaves in wool/silk and wool/linen mixes are also available.

Tel: (0274) 724518

*496 Leeds Road
Bradford
West Yorkshire BD3 9RF*

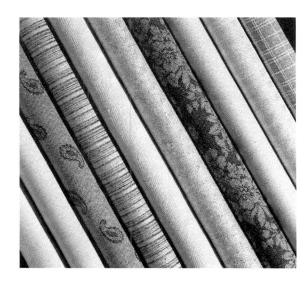

Crombie

Traditionally, Crombie is best know as the world's leading producer of coating fabric - using a raised, brushed surface effect. They are manufacturers of cloth associated with all things luxurious and very expensive, ranges including pure wool, 100% cashmere, traditional tweeds, 100% camelhair and silk/wool blends. Crombie also produces a furnishing range of fabrics, suitable for contract use; minimum orders are two pieces per colour (roughly 120 metres). Specific designs can be made and and colours can be matched to customer specification. Founded in 1805, Crombie has always produced the best quality cloth to be found at the time.

See also under *Silk Weaves; Speciality Fabrics*

Tel: (0224) 483201

*Grandholm
Woodside
Aberdeen AB9 2SA
Tlx: 73138 CROMBIE G*

History of Crombie

The history of the company traces the makings of what constitutes a quintessentially 'British' fabric. Founded by John Crombie near Aberdeen in 1805, the company produced 'Forest Cloth', a twill woollen, sold locally. Later some of the best Yorkshire mill managers were recruited. By 1830 Crombie was supplying cloth to James Locke, who tailored suits and coats for Queen Victoria and Prince Albert. It is said that one of Locke's clerks misread an order for 'tweel', reading in its place 'tweed', by which name the cloth has been known ever since. It was at this time that Locke suggested Crombie used muted, autumnal shades for their tweeds; these colours are now associated with the Scottish highlands and moors. Crombie still produces the authentic tweed. Some of the most skilled spinners in the wool trade were employed, producing fine quality yarn, with which the weavers began constructing complicated designs, including checks made fashionable by such characters as Sir Walter Scott, who often wore them. In 1851 power looms were introduced and Crombie won prizes for its cloth at the Crystal Palace Great Exhibition.

Crombie has played its part in many other major historical events. In the early 1860s, at the start of the American Civil War, Crombie won large orders for cloth for the Confederate Army uniforms, as the American textile trade was at that time in the Union-held north. It was from this cloth that the term 'rebel grey' came. Later *Crombie Beaver*, a raised woollen overcoating from finest merino wool, finished with a high gloss, became famous on the continent. During the First World War Crombie supplied millions of yards in great coating, serge, khaki, tartan and flannel. The 'British Warm' became synonymous with Crombie, who supplied one-tenth of all great coats worn by the British officers. During the Second World War Crombie was producing over 460 miles of cloth a year and, since the war, Crombie has become one of the largest producer of tweed in the UK.

Hand woven wool by Curlew Weavers

Curlew Weavers

Curlew weavers is a small versatile company, producing 100% pure wool ranges from stock and to customer specifications. Cut lengths are available from stock collections and the minimum order for specially woven wool is about 25 metres. Their own collections include *Symphony Stripes*, a muted blurred effect stripe; plains, bordered fabrics, and an effective sheer quality. Curlew Weavers offers a wide colour range, which can be adapted to different ranges, and special one-off fabrics can be woven on their hand looms. This latter service produces the traditional rough textured quality characteristic of handweaving.

Tel: (023975) 357

Troedyraur Old Rectory
Rhydlewis
Llandysull
Dyfed
Wales

Dartington Mills Ltd

Dartington Mills specialises in flat woven tweeds,

comprising attractive colourways and simple designs. Alongside their stock ranges, to which minor alterations may be made (minimum orders for which are 60 metres), Dartington offers the Studio Service, which enables clients to order special designs not available from stock (minimum order from this is 180 metres).

Tel: (0803) 864388

Shinners Bridge
Dartington
Totnes
Devon TQ9 6TL
Tlx: 42687
Fax: (0803) 26558

Donald Brothers Ltd

A fairly small company, Donald Brothers specialises in flame retardant wool for contract furnishing, ideal for hotels and offices, and large scale projects such as for shipping lines. Their stock ranges are heavy woollen fabrics, noted for their good, hard wearing contract qualities. Donald Brothers is introducing a highly flexible approach to design and is concentrating on special design services for wool made to order to customer specifications. Many of its fabrics use geometric designs and abstracts. Finer quality worsted is also being introduced.

Tel: (0382) 40309

Wallace Graigee Mills
Dundee DD4 6BB
Tlx: 76695

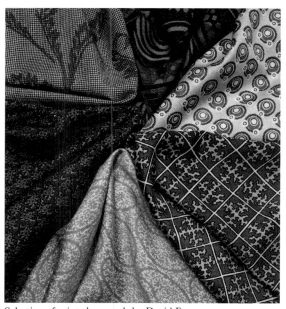

Selection of printed worsteds by David Evans

David Evans

David Evans prints onto a variety of different fabrics, including fine wools. The designs include an impressive collection of original French Gouache designs from Lyons. All designs exclusive to the client. The firm asks for a minimum order of 200 metres per colourway. See also under *Silk Prints; Speciality Fabrics*

Tel: (0322) 57521

Bourne Road
Crayford
Kent DA1 4BP
Tlx: 8956830 DECRAY G

Josiah France

Part of the Huddersfield Fine Worsteds group, Josiah France produces superfine worsteds and

kid mohair and wool; lambswool; and wool and cashmere qualities.
See also under *Huddersfield Fine Worsteds*

Tel: (0484) 20377

Kirkheaton Mills
Kirkheaton
Huddersfield HD5 0NS
Tlx: 517216

Fox & Floor

An exceptionally talented and imaginative producer of a variety of furnishing fabrics, all made to order. Fox & Floor won the 1986 Design Council Award for its 3D-effect pleated wool, designed by Fiona Greenwood, head of the design studio. As well as 'sculpted' ranges, Fox & Floor produces dobby and jacquard weaves, and has an excellent range of unusual and attractive textures - some of which use man made or natural fibre mixes with the wool.
See also under *Cotton Weaves; Silk Weaves*

Tel: (01) 267 1467

142 Royal College Street
London NW1 0TA
Tlx: 261334 SFX G

Foxford Woollen Mills Ltd

Foxford specialises in tweeds and flame retardant upholstery fabrics from 100% wool. The upholstery fabrics are available in browns, greens, and 'tweed' shades in honeycombe weave, plain or checks. Foxford also produces a plain dyed cloth suitable for curtains or soft furnishing, and will be bringing out a range of tweed styles. Foxford's apparel tweeds are *Donegal* and *Shetland*, most of which are made to order. Other styles can be made to order, and colours can be matched. Most of the wool used is Irish, carded and spun at the Foxford Mills. New ranges are brought out every autumn.

Tel: (010 353) 56104

Foxford
County Mayo
Republic of Ireland
Tlx: 40899

Glenside Fabrics Ltd

Producers of furnishing fabrics, screens and wallcoverings in a wide range of qualities, both man made and natural. Qualities include a wool lenzing range, an inherently flame resistant fabric, and a piece dyed worsted range supplied to customers' colour requirements. All fabrics are held in stock and cut lengths are supplied. Standard colours are subtle heathery shades.

Tel: (0484) 515699

12 Hillside Lane
Huddersfield
West Yorkshire HD1 6EF
Tlx: 517111 GLEFAB G

Harris Tweed

Harris Tweed has been produced in the Outer Hebrides for hundreds of years; however, it was not until the end of the last century that the Victorians seized on its commercial marketability. A meeting was held in Stornoway, Isle of Lewis, and as a result the cloth was given a trade name. Harris Tweed is now a world famous household name, and remains the only fabric with a trade mark to itself.

The definition of a Harris Tweed is that the cloth must be made from 100% pure virgin wool (ie wool that is newly sheered and processed for the first time, containing no other fibres aside from wool) produced in Scotland, dyed, spun and finished in the Outer Hebrides and hand woven by the islanders in their own homes on the islands of Lewis, Harris, Uist and Barra. The tweed must be produced according to these criteria, as it is a definition of the cloth, from which there must be no deviations. Harris Tweed is characterised by its rough durability, and has romantic associations with the Scottish highlands and moors. Since Victorian times the cloth has been used as a 'sporting' style fabric. For further information contact the Harris Tweed Association.

The Harris Tweed Association Ltd

The Harris Tweed Association is a non-profit making, non-trading body formed in 1909 to administer the certification Trade Mark known as the Orb Mark, which is given on every 3 yards of cloth and guarantees its authenticity. The association maintains the standard of Harris Tweed, and aims to promote and protect the industry.

Tel: (0463) 231270

Ballantyne House
84 Academy Street
Inverness
Scotland IV1 1LU

Arther Harrison

Arther Harrison, part of the Reuben Gaunt & Sons group, is a top quality producer of worsted, famous for its superb quality flannel, the *'2080' Flannel*, made from exceptionally fine yarn (minimum order for all cloth is 280 metres). This cloth comes in a range of greys, camel, navy blue and pinstripes. Other fabrics include a range of wool and cashmere mixes and wool and mink, mainly in check designs.

Tel: (0532) 571781

Broom Mills
Farsley
Pudsey
West Yorkshire LS28 7UT
TLx: 557454
London Agents:
Beaumont & Adams
404 Golden House
29 Great Pitney Street
London W1R 3DD
Tel: (01) 734 3406

John Hartley (Cowling) Ltd

Specialises in contract quality upholstery fabrics in wool and wool blends (the minimum order is 50 metres). Fabrics are tweeds, available from the hard wearing *Oxford* range to the more luxurious qualities; plains, available from stock; and twills, checks and herringbones. All fabrics are designed with flammability regulations in mind and fabrics can be made to order to suit customer requirements.

Tel: (0535) 33235

Acre Mill
Cowling
Keighley
West Yorkshire BD22 0BU
Tlx: 517652 JFAB G

Heild Brothers Ltd

Heild Brothers produces a 100% worsted flat woven dobby cloth suitable for upholstery. Heild Brothers has a minimum order limit of 240 metres, so enquiries should be based on bulk orders only. All cloth is woven to order in the client's choice of colour.

Tel: (0274) 571181

Briggella Mills
Little Horton Lane
Bradford BD5 0QA
Tlx: 51518

A jacquard weave by C&J Hirst

Heywood Wallcoverings

Heywood Wallcovering specialises in 100% wool wall coverings. The standard range is *Barra*, available from stock; specific designs may also be produced to customer requirements. Heywood has an extensive and prestigious client list, which includes the IWS offices, the European Parliament building in Luxembourg; the National Library, Canberra, Australia, and the Bank of England.

Tel: (061) 652 1245

Townfield House
Townfield Street
Oldham OL4 1HL
Tlx: 667579
Fax: (061) 678 0513

C & J Hirst Fabrics Ltd

C & J Hirst Fabrics Ltd, incorporating G & G Kynoch, is a joint venture between themselves and Sekers Fabrics Ltd. While remaining entirely separate companies, all C & J Hirst's fabrics are

marketed and sold through Sekers. C & J Hirst produce high quality furnishing fabrics for the contract market (minimum order is 100 metres). Qualities include 100% wool, 100% worsted and wool/worsted combinations, and dobby weaves and jacquards suitable for upholstery and curtaining. They also offer a complete design service in which patterns and colours can be matched and produced to customer specification. All fabrics measure up to flameproof standards required by office furniture and aircraft manufacturers.

Tel: (0946) 2691

Available through:
Sekers Fabrics Ltd
Whitehaven
Cumbria CA28 8TR
Tlx: 64150
Showroom:
15/19 Cavendish Place
London W1M 9DL
Tel: (01) 636 2612
Tlx: 265550

Huddersfield Fine Worsteds

Huddersfield Fine Worsteds comprises four of the oldest wool and wool blend producers in Britain: Josiah France; Learoyd Brothers & Co; Broadhead & Graves; and Martin & Sons. These companies produce a substantial proportion of the finest worsted in Britain and have speciality fabrics including exclusive fibres such as mohair, cashmere and silk, all of which are suitable for apparel. All companies within the group require a minimum order of one piece (about 60 metres) and all offer special services producing fabric to customer specification. See under individual company headings for further information.

Tel: (0484) 20377

Kirkheaton Mills
Kirkheaton
Huddersfield HD5 0NS
Tlx: 517216

International Wool Secretariat

The IWS aims to increase demand for wool worldwide; it has almost forty offices in wool-producing countries in the southern hemisphere. Wool products are also encompassed, including carpets, rugs and wall hangings. The IWS Development Centre in Yorkshire plays an essential role in the development of new products and provides the wool textile industry with a wide range of design, styling, marketing and technical services. The IWS identifies both local and global market trends and advises accordingly. More competitive uses are found and new qualities developed, such as machine washability, new colour ranges and flame resistance. The Interior Textiles Group at the IWS Centre assists manufacturers at every stage of production. It evaluates new ideas, provides design consultation and formulates a colour

forecast. The *Deep Secrets* colour forecast for 1988 can be seen at IWS branches and most major trade fairs.
See also under *Carpets & Rugs; Reference & Information*

Tel: (01) 930 7300

*Wool House
Carlton Gardens
London SW1Y 5AE
Tlx: 263926INWOOL G
and
IWS Development Centre
Valley Drive
Ilkley
West Yorkshire LS29 8PB
Tel: (0943) 601555*

The Isle Mill Ltd

Specialist producer of tartans with facilities to design to customer specifications. Isle Mills will weave any length required.

Tel: (0796) 2432

*Pitlochry PH16 5AF
Tlx: 76533 TWEEDS G*

Learoyd Brothers & Co

Part of the Huddersfield Fine Worsteds group, Learoyd produces the best quality Merino cloth (*Lumbs Golden Bale, Super 100s:*) the pick of the Australian crop). Their *Lumbs Golden Bale* is also woven with silk and summer kid mohair; wool/silk in twills and jacquards are also produced. Learoyd is known for its double plain cloth which takes on a double shadow quality.
See also under *Linen*

Tel: (0484) 20377

*Kirkheaton Mills
Kirkheaton
Huddersfield HD5 0NS
Tlx: 517216*

Peter MacArthur & Co Ltd

The worlds biggest tartan producer, Peter McArthur holds over 380 tartan designs, all of which are available as cut lengths from the mill. Standard ranges include tartans, and extra fine merino quality available in tartans or checks, and worsteds for kilting. Peter MacArthur has a special design service for customised orders. Accessories, scarves and shawls are also available.

Tel: (0698) 282544

*Clan Weaving Mill
Woodside Walk
Hamilton
Scotland ML3 7HZ
Tlx: 779154
London agent:
Barry Howell
16 Maddox Street
London W1R 9PL
Tel: (01) 499 0960*

Kenneth McKenzie Holdings Ltd

Kenneth McKenzie is the oldest and largest producer of Harris Tweed, all handwoven by island crofters in their own homes (minimum order 80 metres). Kenneth McKenzie was founded at the turn of the century when Harris Tweed was first 'discovered' as a marketable product, and was the first firm to produce Harris Tweed.

Tel: (0851) 2772

Sandwick Road
Stornoway
Isle of Lewis
Tlx: 75156 CHARTER

Kenneth MacLeod (Shawbost) Ltd

The smallest of the Harris tweed producers. All tweeds are available by the cut length.

Tel: (085171) 251

5 North Shawbost
Isle of Lewis
Tlx: 75116

McNutt Weaving Company Limited

McNutts produces wool fabrics ranging from light worsteds through to heavy tweeds, including a selection of classical weaves such as *Donegal Tweed*. McNutt produces two pattern books a year which contain over 100 designs: customers select from these and if necessary alterations and adaptions will be made. No stock is held and the minimum order is 200 metres.

Tel: (010 353 74) 55324

Downings
County Donegal
Republic of Ireland
Tlx: 42078 NUTTEI

Martin, Sons & Co Ltd

Perhaps the leading producer of fine worsted cloth among the Huddersfield Fine Worsted groups, Martin, Sons & Co are well-known for its *'Fresco' Super 100s* (an exceptional quality fine worsted cloth); *Lumbs Golden Bale Super 100s*, a cloth using the yarn form the best of Australian crop; and 100% cashmere cloth. Other fibres are crepe/wool/mohair and wool/silk/mohair, all producing superb quality fabric.
See also under *Speciality Fabrics*

Tel: (0484) 20377

Kirkheaton Mills
Kirkheaton
Huddersfield HD5 0NS
Tlx: 517216

Mourne Textiles Ltd

Hand-loom weavers producing attractive rough textured upholstery fabrics and curtaining. The firm holds stock and weaves to customer specifications. Mourne Textiles uses 100% wool and a wool and cotton mix.

Tel: (06937) 38373

Rostrevor
Newry
Northern Ireland BT34 3AE

RG Neill & Son

RG Neill produces excellent quality worsteds, all of which are made to order and are either selected from the twice yearly collections or are made up exclusively by the design team, suitable for apparel. Two of the most outstanding cloths are the lambswool/cashmere mix and the 100% wool jacketing. They aim to meet the *haute couture* market. No stocks are held and the minimum order is 60-65 metres.
See also under *Silk Weaves; Linen*

Tel: (0541) 80445

Glenesk Mills
Langholm
Scotland DG13 0LA
Tlx: 778592

Robert Noble Ltd

Robert Noble specialises in tweeds, including a quality made from British wool, giving a rough, almost Harris Tweed style texture, and softer handling jacketing of Shetland and Falkland Island wools which is suitable for apparel. All wool is made to order; wool/silk, wool/linen and combinations of all three fibres are also available. Designs tend to be classic in style and colour. Minimum orders are two pieces (approximately 135 metres). Robert Noble also produces 100% cashmere.
See under *Speciality Fabrics*

Tel: (0721) 20146

March Street Mills
Peebles
Scotland EX45 8ER
Tlx: 72367
London agent:
F Bland & Son
Langham House
308 Regent Street
London W1R 5AL
Tel: (01) 637 4135

John Orr Ltd

John Orr offers a collection specifically for contract furnishing, *Collection 200*, comprising ten designs each available in a maximum of ten colourways. John Orr is known for good quality upholstery weights, in which the firm specialises,

and offer a service producing virtually any upholstery weight wool fabric to customer specification. John Orr also produces Donegal Tweed to order and a range of wall coverings. There are no minimum quantities required, cut lengths of one metre upwards being available.

Tel: (010 353) 046 21449

Hilltop Mills
Navan
County Meath
Republic of Ireland
Tlx: 43564
Distributed through:
Helen Sheane
Daventry Road
Wildmere
Banbury
Oxon OX16 7LT
Tel: (0295) 61216
Tlx: 838878

Scottish Woollen Publicity Council

The promotional side of the Scottish Woollen Industry for virtually all Scottish weavers, spinners and accessory manufacturers, the Publicity Council can send out brochures and a product directory on Scottish wool producers. The Scottish Woollen Publicity Council also issues the Fine Woollens Woven in Scotland trademark, and work in close conjunction with

Wool, silk and linen blend by Robert Noble

the International Wool Secretariat. See also under *Reference & Information*

Tel: (031) 225 3149

45 Moray Place
Edinburgh EH3 6EQ
Scotland
Tlx: 728141 (SCOTWI)

Sekers Fabrics Ltd

Seker's wool collection includes six ranges: *Canoustie* (a plain ground with small rectangles in zig-zag pattern); *Moorland; Braemar; Kirkmuir; Inveraray* and *Lochinvar*. All designs are comtemporary, generally involving contrasting fore and backgrounds and small diamond and

flecked motifs in subtle colours. All fabrics are flame retardant treated.
See also under *Chintz; Cotton Prints; Cotton Weaves*

Tel: (01) 636 2612

15-19 Cavendish Place
London W1M 9DL
Tlx: 265550
Fax: (01) 631 5340

Skopos Design Ltd

Skopos designs and manufactures a variety of furnishing fabrics for the contract market, including cotton prints and cotton weaves; rapidly expanding, the firm is planning to move into the retail market. Their range of wool is the Hebrides tweed designed for heavy duty upholstery.
See also under *Cotton Prints; Cotton Weaves*

Tel: (0924) 465191

Providence Mills
Earlsheaton
Dewsbury
West Yorkshire WF12 8HT
Tlx: 556150

Stuart Renaissance Textiles

Stuart Renaissance Textiles is a company recently formed out of Stuart Interiors, weaving fabrics from Renaissance and 15th century designs. The *Barrington Court Collection* (also available through Tissunique) is taken from original 16th and 17th century English weaves. The fabrics comprise wool, wool/linen and silk weaves, using Gothic Style motifs, such as dragons, partridges, falcons and pomegranites. The original ten ranges, recreated on jacquard looms in Somerset, are in 100% woollen fabrics with mohair; all are suitable for upholstery, curtaining doors and windows and bed hangings and covers. Colours are rich Gothic tones: green; red; terracotta; cobalt; gold; oatmeal; stone; black and ivory. Fabrics can also be made to order, using clients' designs and colours.
See also under *Silk Weaves*

Tel: (0460) 40349

Barrington Court
Barrington
Ilminster
Somerset TA19 ONQ

Taylor & Littlewood Ltd

Producers of top quality worsteds for fashion, mens jacketings and suiting. The minimum order is four pieces (280 metres). The firm offers a variety of weights and designs, ranging from conventional subtle colour mixes to bold bright stripes.

Tel: 0523 571781

Broom Mills
Farsley
Pudsey
West Yorkshire LS28 7UT

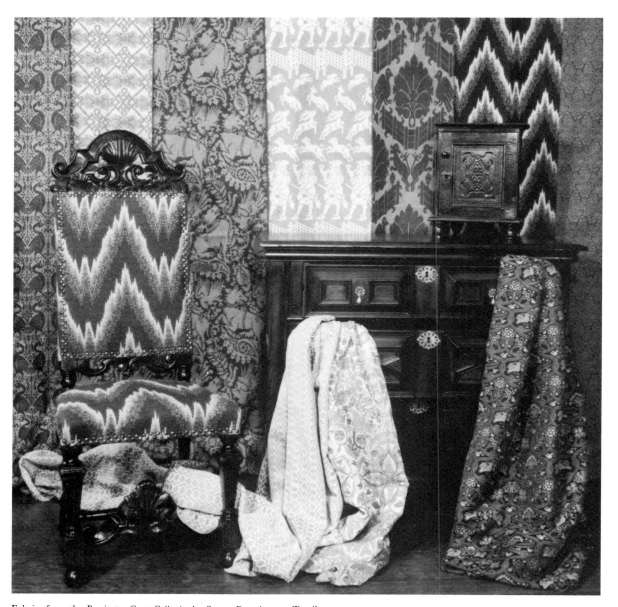

Fabrics from the *Barrington Court Collection* by Stuart Renaissance Textiles

Taylor, Livesley & Co Ltd

Taylor, Livesey & Co specialises in 100% wool woven tweeds, checks and fancy checks, and furnishing fabrics for contract and domestic markets. The upholstery weight designs include twills, herringbone, basketweaves and plains. Minimum orders are 140 metres.

Tel: 904840 652 355

Ramsden Mill
Linthwaite
Hudersfield HD7 5RA
Tlx: 51458

Tissunique

See under *International*

Viyella

Now world famous for Viyella cloth used for apparel, the company dates back to 1784 when a group of businessmen started a spinning mill in Pleasley Vale on the edge of Sherwood Forest. In 1893 a new cloth using merino wool and long staple cotton was introduced, dyed to an extraordinary depth of colour: so successful was this fabric that its name, taken from the Derbyshire valley, *Via Gellia*, was adopted by the company - 'Viyella'. Viyella's wool qualities the wool *Challis*, a plain weave fabric made from 100% lambswool known for its superb draping qualities, available in a range of traditional and fashion prints (weight 115g per square metre). *Viyella Pure Wool* is a twill-weave fabric of slightly heavier weight (180-5g), again, beautifully soft, available in checks. *Viyella Original Blend* is still the unique blend of 55% finest merino lambswool and 45% cotton, available in prints, checks and plains, 125g in weight, this quality is durable, colour-fast and beautifully soft.
See also under *Cotton Prints*

Tel: (0282) 67711

William Hollins & Co Ltd
The Viyella Mills
Pleasley Vale
Mansfield
Nottinghamshire NG19 8RL
Tlx: 377361

Sasha Waddell

Sasha Waddell carries work from a number of designers who print onto a variety of fabrics; there is also a range of wool fabrics sold through Sasha Waddell. These include a range of tartans.
See also under *Cotton Prints; Cotton Weaves; Silk Prints; Linen*

Tel: (01) 603 0474

22 North End Parade
North End Road
London W14 0SJ

Warner & Sons Ltd

Over 100 years old, Warner & Sons has a massive range of different fabrics, including an excellent range of weaves. A recent collection is the *Fiesta Wools* collection, suitable for upholstery and curtains. Ranges include *Carousel Wool*, a wool/viscose rayon mix in plain colours and a heavy textured appearance; *Fortissimo Tweed*, a tweed design, rough in texture, also a wool and viscose mix; *Virtuoso*, a wool and trevira mix and *Rondo Cord*, from 100% wool, both having a smoother texture. The imported ranges from Greeff, USA, include the *Entity* collection, wool/silk mixes in geometric designs, and tweed textures from wool, silk and polyester.
See also under *Chintz; Cotton Prints; Cotton Weaves; Linen Union; Silk Weaves; Lace & Sheers*

Tel: (01) 439 2411

7-11 Noel Street
London W1V 4AL
Tlx: 268317

WE Yates

Yates, dating back to 1871, shares the same mill as Huddersfield Fine Worsted, while remaining independent from it. Yates produces excellent quality worsteds, specialising in a twist cloth, in which the yarn has a twist creating a speckly tweedy effect (minimum orders 120 metres). Other qualities include lightweight *Panama* cloth and several attractive blends of wool/silk and wool/linen in a variety of colours including fresh blues and green, and more neutral browns. Yates is known for placing high emphasis on the design of the cloth.

Tel: (0484) 20377

Kirkheaton Mills
Kirkheaton
Huddersfield HD5 0NS
Tlx: 517216

Yorkshire Tweeds Ltd

Servicing both the contract and domestic markets, Yorkshire Tweeds Ltd is a small mill holding an extensive stock controlled range of over 100 designs in a wide range of colours, available by the metre and wholesale. Yorkshire Tweeds also has a design service producing cloth to customer specification. The minimum order for special orders is four pieces (200 metres). The firm also make wool wall coverings.

Tel: (0924) 475231

Wilton Mills
586/592 Bradford Road
Carlinghow
Batley
West Yorkshire WF17 8LP
Tlx: 51458 COMHUD G
Wholesale:
Porter Micholson
Portland House
Norlington Road
London E10 6XJ

CHILDRENS FABRICS

Both British and international producers are included within this section, and while most have ranges of cotton prints or cotton polyester mixes, there are also rug manufacturers who specialise in designs for the younger person.

Ambrose Fabrics Ltd

Produce bright, sunny prints in primary colours; these include *Hang Glider, Farmyard, Rainbow*, and the new collection with *Teddy Bear's Picnic, Frog's Frolic* and *Pink Elephants*.

Trade *Tel: (0494) 772074*

*Ambrose House
Alma Road
Bucks HP5 3HB*

Laura Ashley Home Furnishing

Not to be confused with Laura Ashley Decorator Collection, the Home Furnishing branches offer a smaller, less up-market range of fabrics. Available only through Home Furnishings is the *Boys Only* series (one colourway). A change from lambs and rabbits, the design is, in burgundy or natural ground in *toile* style, of aeroplanes and cars.
See also under *Cotton Prints; Linen Union; Lace & Sheers; Trimmings; Carpets & Rugs*

Retail *Ask for Customer Service
Tel: (0628) 39151*

*Laura Ashley Ltd
Braywick House
Braywick Road
Maidenhead
Berks SL6 1DW
Tlx: 848508
Fax: (0628) 71122*

Monsters by Boras International Ltd

Boras International (UK) Ltd

Boras International is a Swedish company, producing a large number of cotton prints. Their *Monster* range for children is a dramatic, large scale design.
See also under *International*

Tel: (0283) 41521

*Unit 4A
Boardman Industrial Estate
Hearthcote Road
Swadlingcote
Burton-on-Trent
Tlx: 341989 BORAS G*

The Coloroll Store

Wide collection of cheerful children's cotton prints, the designs range from the jolly *Jungle Crazy* and *Trains, Boats* and *Planes* to the cute *Winken-Pinken & Nod*. American in style, the choice is excellent, many designs coming with co-ordinating wallpapers.

See also under *Chintz; Cotton Prints*

Tel: (01) 434 0784

*156 Regent Street
London W1R 5TA
Tlx: 268426 CLRROL G*

Dragons of Walton Street Ltd

Dragons specialise in handpainted furniture, and have their own range of fabrics, the *Children's Chintz Collection*. The latest designs are *Clare's Bunnies* (five colourways), and *Penny's Bunnies* (3 colourways). Dragons also have their *Pooh Bear* fabrics (licensed by Walt Disney), and *Lucinda's Bows*, which co-ordinate with the *Bunnies* range. These are traditional 'nursery' fabrics, whimsical in style, available with matching wallpapers and borders.

Tel: (01) 589 3795/589 0548

*19 & 23 Walton Street
London SW3 2HX*

Horrockses Fabrics Ltd

Horrockses have the licence for *Thomas the Tank Engine and Friends* and *Peter Rabbit*. As suppliers Horrockses will give lists of their nearest stockists.

Tel: (0772) 794605

*P.O Box 65
Centenary Mill
New hall Lane
Preston PR1 5JQ*

Jungle Crazy by Coloroll

Summertree Farm by John Lewis Contract Furnishing

Habitat Designs

Habitat have children's designs which include cotton curtain for children. Designs are *Penguins, Balloons, Cats & Dogs, Cotton Tail, Robots, UFO, Tiger Rag,* and *Boboo*. All designs are available in one colourway only.

Tel: (0491) 35000

Hithercroft Road
Wallingford
Oxfordshire OX10 9EU
Tlx: 847315 HABWAL
Fax: 330 from switchboard

Lines of Pinner

Offers an exciting range of children's fabrics imported from America.

Trade *Tel: (01) 429 0939*

26 High Street
London HA5 5PW
Tlx: 8813064 LINES

Lister & Co Plc

Produce traditional hearth rugs and also a children's range, *Playmates,* with 20 different designs in a variety of colours. These are all from 100% acrylic fibres. Designs include a *Paddington Bear, Tom and Jerry,* and *Thomas the Tank Engine & Friends.* Other popular cartoon characters also feature. All rugs are washable.
See also under *Carpets & Rugs*

Trade *Tel: (0274) 494188*

Manningham Mills
Bradford
West Yorkshire
Tlx: 31658

John Lewis Contract Furnishing

John Lewis, Oxford Street, have their own fabric and furnishing name, Jonelle, which is the name of the goods made in John Lewis's own workrooms or produced for them. Jonelle comprises a wide collection of prints and weaves, available both as retail or for contract work. Jonelle also offers cotton prints for children, including *Merino Meadow* (sheep and trees); *Daisy Walk* (bold primaries); the soft coloured *Picnic Party* ; and the animals and flowers printed on white of *Summertree Farm*. Ready-made curtains are also available. John Lewis Contract Furnishing are able to take on large scale contract work, and can negotiate contract prices on their fabrics.
See also under *Chintz; Cotton Prints; Cotton Weaves; Lace & Sheers*

Tel: (01) 629 7711

278-306 Oxford Street
Pinner HA5 5PW
Tlx: 27824 JONEL LONDON

Robots by Habitat Designs

The Nursery Window

Both fabrics and accessories specifically for the nursery and children's rooms, the ranges include a *Duck Frieze* and *Bear Frieze,* printed along the length of fabric. Designs include the bold *Circus* and the softer *Rabbit Trellis.* All fabrics are cotton.

Tel: (01) 581 3358

*83 Walton Street
London SW3 2HP*

Paper Moon

All Paper Moon's children's fabrics are imported from America: the designs are imaginative, fun and include some of the best children's patterns around. The new *Rubber Ducky* edition has a mixture of abstract designs (*See Saw Stripe, Confetti*) and figurative designs (*Butterflies are Free*). These come with matching or coordinating wallpaper. Details of outlets are available from the address below.
See also under *International*

Retail *Tel: (01) 451 3655*

*Unit 2 Brent Trading Centre
390 North Circular Road
London NW10 0JF
Tlx: 297233 PAMOON*

Poppy for Children

Their designs include *Alphabet, Elephants, Clowns* and *Bears* in pastels or primary colours. These are sold with matching wallpapers and friezes.

Tel: (0642) 783892

*Poppy Ltd
44 High Street
Yarm
Cleveland TS15 9AE
Also through Harrods*

Rosine Ltd

Vanessa Burroughs and Keith Smith have designed a children's collection, *Kiddywinks*. The collection comprises four fabrics, four wallcoverings, two borders and polycotton bedlinen. Designs include aeroplanes on squiggly different coloured horizontal lines; dolls, also on the same style of background and a striking

Butterflies are Free by Papermoon

stripes and check pattern. Colours are in both primary and pastel shades.
See also under *Cotton Prints*

Trade　　　　　　　　　　　　*Tel: (01) 960 8508*

2nd Floor
Block A
124-126 Barlby Road
London W10 6BL

Trendy Tuft Designs

Hand tufted children's rugs; simply designed and brightly coloured, the best including their *Clown* design and the *Steam Train.* As the rugs can be made up to any design and colour, they are an excellent addition to the nursery or older child's room alike. An attractive aspect of the rugs is that the outline traces the design, so that the Bear rug, for instance, is in the shape of the bear itself.
See also under *Carpets & Rugs*

Trade　　　　　　　　　　　　*Tel: (0274) 869131*

Woodroyd Mills
South Parade
Cleckheaton
West Yorkshire

Verity Fabrics

Fabric and ceramic tile producers, Verity hand screen print designs to customer specifications on a variety of different fabrics, including designs

Circus by The Nursery Window

for children. A huge range of designs are available from which to choose in the show room, some of which co-ordinate with their tiles.
See also under *Chintz; Cotton Prints; Silk Prints*

Tel: (01) 245 9000

7 Jerdan Place
London SW6 1BE
Tlx: 8951770 VERPEC

Zipidi

Zipidi's sunny, Mediterranean designs are ideally suited to adaptation for children's and nursery fabrics.
See also under *Chintz; Cotton Prints; Linen Union*

Tel: (01) 491 2151

5 Deanery Mews
London W1

LACE & SHEERS

Laces within this section include traditional, 100% cotton laces using 18th-19th cenury designs, as well as contemporary patterns matching or co-ordinating with fabric ranges. Sheers cover a broad range of fine lightweight fabrics, including voiles. This section includes producers of plain sheers and voiles, sheers with designs printed onto them, sheers with a design burnt-out of the fabric, and embroidered voiles.

Laura Ashley Decorator Collection

Laura Ashley offers two laces: one a figured lace, the other a voile incorporating spotted designs. Both are 100% cotton, made on nineteenth century jaquard looms, available by the metre in ivory or white.
See also under *Chintz; Cotton Prints; Linen Union; Trimmings*

Trade *Tel: (01) 730 1771/4632*

71/73 Lower Sloane Street
London SW1W 8DA
Fax: (01) 730 3369

Laura Ashley Home Furnishing

Laura Ashley Home Furnishing is the retail side of their fabrics, offering less expensive ranges than the Decorator Collection. The above address can give addresses of branches throughout England. Laces available are their lace panels (60 inches by 90 inches) in two weights. The 12-point range is the finer of the two, incorporating a fleur-de-lys design with scalloped edges. The 8-point lace is a fairly heavy Nottingham lace in a floral swag design with scalloped edges. Lace is also available by the metre.
See also under *Cotton Prints; Linen Union; Childrens Fabrics; Trimmings; Carpets & Rugs*

Retail *Ask for Customer Service*
Tel: (0628) 39151

Head Office
Braywick House
Braywick Road
Maidenhead
Berks SL6 1DW
Tlx: 848508
Fax: (0628) 71122

Bentley & Spens

Small-scale producers who specialise in batik and richly hand painted fabrics on a variety of fabrics including sheers made of luxurious silk organza; each design is drawn in wax directly onto the fabric and painted individually. Fabrics are painted to order and samples can be viewed at the studio.
See also under *Cotton Prints; Silk Prints*

Tel: (01) 352 5685

Studio 25
90 Lots Road
London SW10 0QD

Celia Birtwell

Celia Birtwell's deceptively simple designs in the recent *Portobello Collection* are hand blocked onto a variety of fabrics including an attractive cotton muslin. The colours are either blue on white or

red on white (others, including black and gold, are available to order).

See also under *Cotton Prints; Linen Union; Silk Prints*

Tel: (01) 221 0877

71 Westbourne Park Road
London W2 5QH

Blossom (Fabrics) Ltd

Blossom Fabrics produces a wide selection of printed sheers to match their fabrics, wallpapers and borders. The sheers from their first collection are made in 100% polyester; those from the *Blossom and Stripe* range have a linen 'slub' (91% polyester, 9% linen). A wide range of designs is available on sheers from the recent collection, incuding three stripes *(Stripe, Broken Stripe* and *Fine Stripe);* an attractive bow arrangement *(Ribbon and Bows);* the all-over design, *Brushstrokes;* the simple geometric pattern, *Trellis;* and three floral designs *(Anemone, Morning Glory* and *Clematis)*. Each is available in about four colourways.
See also under *Cotton Prints*

Trade *Tel: (01) 837 5856*

24 Duncan Terrace
London N1 8BS

Boras International

See under *International*

Chelsea Green Fabrics

Chelsea Green produces two qualities of sheer fabrics. The most recent is the polyester/cotton *broderie anglais* embroidered sheer with small cut-out scalloped edgings in white. Their long-standing quality is a superb 100% cotton Swiss embroidered voile, exquisitely fine, almost an organza in weight, available in white in ten designs.
See also under *Chintz; Cotton Prints*

Trade *Tel: (01) 581 2556*

6 Cale Street
London SW3 3QU
Tlx: 268633 SABINT

Colefax & Fowler

Famous for their chintzes, Colefax & Fowler produce two printed voiles, both made from 91% polyester and 9% linen (forming an attractive slub effect). The *Berry* design is in three colourways: yellow/green, light blue/dark blue, and fawn/brown; and the *Thistle* is in light blue, pink, green and dark blue. Colefax & Fowler also produce a plain white tergal voile made from 100% tergal, and a white spot muslin.

See also under *Chintz; Cotton Prints; Cotton Weaves; Linen Union; Trimmings; Carpets & Rugs*

Tel: (01) 493 2231

*39 Brook Street
London W1 2JE
and
110 Fulham Road
London SW3 6RL
Tel: (01) 244 7427
Tlx: 8953136*

Anne Collin

A small producer, Anne Collin prints abstract designs on cotton satin and calico, and can print to order on sheers. Her prints work well on large scale areas: extremely accessible, the colours range from white and pale yellow to deep greens and soft mauves.
See also under *Cotton Prints*

*Ask for Anne Collin
Tel: (01) 607 5126*

*91 Lofting Road
London N1*

Creation Baumann

See under *International*

Danielle

Danielle's prints are available on silk, cotton and on sheer qualities. Her designs, some of which are hand printed, include pretty, feminine, ideal bedroom styles and more exotic and formal

Galadriel by Foursquare Designs

prints. All five of her books co-ordinate, giving a sense of continuity in colour throughout the collection. Accessories and tiles are also available.
See also under *Cotton Prints; Silk Prints*

Tel: (01) 584 4242/1900

*148 Walton Street
London SW3 2JJ*

Jason D'Souza

Jason D'Souza's floral and botanical designs are all hand printed onto a variety of fabrics, including sheers and voiles. His style is sumptuous and, using gold and silver metallic thread, often leaning towards glamour. Jason D'Souza designs for the boudoir and bedroom, and offers accessories such as outline quilted covers for beds and sofas; cushions and pillows are also available to order.
See also under *Cotton Prints; Silk Prints*

Trade

Tel: (01) 253 9294

*38 Graham Street
London N1 8JX
Tlx: 296716 DIESPK G*

Christian Fischbacher

See under *International*

Foursquare Designs

Foursquare has two designs on sheers: *Galadriel*, available in a green colourway; and *Tindale Fell*, available in two colourways, white on white and grey on white. The designs co-ordinate with their cotton prints.
See also under *Cotton Prints; International*

Trade *Tel: (0580) 712177*

Coursehorn Barn
Coursehorn Lane
Cranbrook
Kent NT17 3NR
Tlx: 896691 TLX1R G

Mary Fox Linton

See under *International*

Anna French Fabrics

Anna French is best known for her laces, made on Nottingham Lace machines in 100% cotton. Lace is available by the metre or as panels. The panels, available in bone colour, include such designs as *Royal Peacock*, a large scale pictorial depiction of two peacocks in a bower (150cm wide by 270cm); *Rose Medallion*, comprising a pair of small panels (60cm wide by 130cm), which feature an oval medallion in the centre of which is a flower in a pot; *Ivory Birds*, a superbly

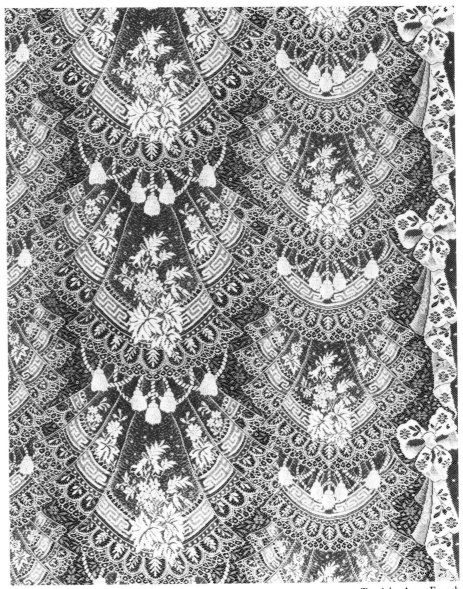

Tassels by Anna French

intricate border with birds and leaves (150cm wide by 160cm) in bone colour; and *Butterfly*, a more modern design of butterflies and birds and stylised flowers. Laces by the metre include the fine *Cornucopia*, comprising delicate flower chains in trellis shapes and intricate borders, available in natural white (173cm wide); the simple swag-like design, *Swags* (140cm wide); and the traditional bows and ribbons design in *Ascot Bows*. Some ranges, including *Rosebud* and *Napoleon* are also available stiffened as blinds.
See also under *Cotton Prints; International*

Tel: (01) 351 1126
343 Kings Road
London SW3 5ES

Susanne Garry

See under *International*

Hewetson Ltd

Hewetson produces embroidered fabrics for the trade. Buyers can either purchase 'subject to being unsold' stock in white or can commission their own work, details of minimum amounts available on request. Broderie Anglaise work is available in widths up to 60 inches.

Trade *Tel: (0625) 25571*

The Embroidery People
Augustus Mill
Buckley Street
Macclesfield
Cheshire SK11 6UH
Tlx: 666654 HEWET G

Sheer by Susan Garry

Stefan Keef Ltd

Stefan Keef has its own print works which is used to print designs onto a variety of fabrics, mainly top quality cotton and silk. Sheers are also available in the *Classic Range*.
See also under *Cotton Prints; Silk Prints*

Tel: (0634) 718871

No 7 Henley
Trident Close
Sir Thomas Longley Road
Frindsbury
Rochester
Kent ME2 4ER

Kendix Designs

See under *International*

Kinnasand UK Ltd

See under *International*

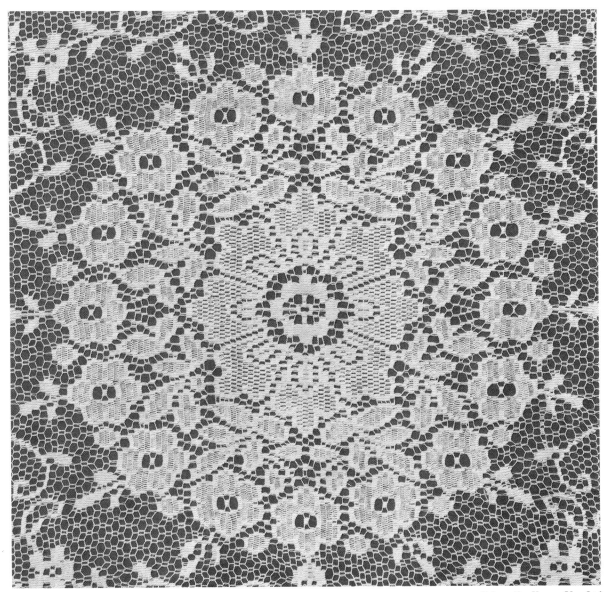

Balmoral by Krams-Ugo Ltd

Bothy Wall by Parkertex

Krams-Ugo Ltd

Krams-Ugo is a wholesale supplier of lace to the trade. They will sell lace in any quantity but prefer to sell in either 15 or 35 metre batches. The lace is made in Nottingham in 95% cotton and 5% polyester, width 59 inches. There are 6 designs: *Victoriana, Balmoral, Windsor, Blenheim, Warwick* and *Edinburgh*.

Trade *Tel: (01) 837 9262*

70-78 York Way
London N1 9AG
Tlx: 261528 KRAMS G

John Lewis Contract Furnishing

John Lewis, Oxford Street, has its own fabric and furnishing name, Jonelle, which is the name of the goods made in John Lewis' own work rooms or produced for the company. Jonelle comprises a wide collection of prints and weaves, available both as retail or for contract work. Jonelle has two ranges of sheers, on 100% polyester. These are the plain *Venice* range, and the *Karen*, available with a patterned edging. Ready made curtains are also available. John Lewis Contract Furnishing is able to take on large scale contract work, and can negotiate contract prices on their fabrics.
See also under *Chintz; Cotton Prints; Cotton Weaves; Childrens Fabrics*

Tel: (01) 629 7711

278-306 Oxford Street
London W1A 1EX
Tlx: 27824 JONEL LONDON

Ian Mankin

Specialists in natural fibres, including linen, raw silk and shirtings, Ian Mankin has a range of superb muslin in both white and cream. Ian Mankin is the only stockist in Britain of the very fine, almost silky in texture, pure Egyptian cotton muslin.
See also under *Cotton Prints; Cotton Weaves; International*

Tel: (01) 722 0997

109 Regents Park Road
Primrose Hill
London NW1 8UR
Tlx: 8951182 GECOMS G

Parkertex Fabrics Ltd

Parkertex produces a range of laces to co-ordinate with some of the ranges in the *Tatton Park Collection*. The laces are 7% polyester and 93% cotton, available in ivory, and complement the cotton prints and damask. Designs include *Bothy Wall*, a wisteria floral arrangement with a border; *My Lady's Garden*, comprising stylised peacocks and seahorse motifs to complement a damask; *The Orangery*, comprising orange motifs; and *The Fernery*, taken from the 1850 old New Zealand tree ferns house. Recent ranges are *Kuddhar* in paisley style leaves and *Hashiya*, covered in thistle like flowers. Parkertex have two sheers, *Islay*, available in four colourways designed to give a striped effect; and *Sunburgh*, available in loosely woven vertical beige and cream 'bars', made from 100% flame resistant polyester.
See also under *Chintz; Cotton Prints; Cotton Weaves; Silk Prints*

Trade *Tel: (01) 636 8412*

18 Berners Street
London W1P 4JA

Ian Sanderson Textiles Ltd

Ian Sanderson produces printed sheers available in five designs. The *Lyon Palma Terracotta*, made in 92% polyester and 8% silk, is printed with stencil type bows in a terracotta colour. The other designs are made from 90% polyester and 10% linen, and include The *Gala Meadows*, a small leaf motif available in six colourways; *Gala Ching Pai*, a tree, leaf and flower design in five colourways; *Gala Trellis*, available in white on white and in four colourways; and *Beta*, a semi-circular design available in nine colourways. Colours can be changed on large orders to meet customers' requirements.
See also under *Chintz; Cotton Prints; Cotton Weaves; International*

Trade *Tel: (01) 580 9847*

70 Cleveland Street
London W1P 5DF

Sahco Hesslein UK Ltd

See under *International*

Micheal Szell Ltd

Hand painted in exquisite colours, Micheal Szell prints designs to customer specification on a variety of fabrics, including sheer qualities. The showroom has recently displayed lengths from previous designs - mostly Oriental and Regency in feel which are subtle and very beautiful in colour. These range from the rich sumptuous use of gold and silver to pinks and French light greens. All designs can be printed in special colours at no extra charge. Michael Szell prints on his own fabrics, which are cotton, sheers, chintz, moire, velvet, light silk and heavy silk.
See also under *Chintz; Cotton Prints; Cotton Weaves; Silk Prints*

Trade *Tel: (01) 589 2634*

47 Sloane Avenue
London SW3 3DH

Bernard Thorpe

Bernard Thorpe's printed sheers (91% polyester, 9% flax) are hand screen printed to order from a massive choice of about 3000 designs. Clients can choose their own colourways.
See also under *Chintz; Cotton Prints; Cotton Weaves; Linen Union; Silk Prints*

Trade *Tel: (01) 352 5745*

6 Burnsall Street
London SW3 3SR
Tlx: 9419778 THORPE G

Turnell and Gigon Ltd

See under *International*

Warner & Sons Ltd

Warner has a select collection of laces, both Madras (fine quality) and Nottingham (heavier weight) in 100% cotton. Many of the designs are taken from traditional prints from the Warner archives: for instance, in the Madras laces *Damask Design* incorporates a traditional late 17th century design, and *Ghent* incorporates neo-classical motifs. The Nottingham lace, *Lanehurst*, is taken from a late 17th century Chinese design. Later designs include *Beauvais*, from the turn of the century. Bordered laces are also available.
See also under *Chintz; Cotton Prints; Cotton Weaves; Linen Union; Silk Weaves; Wool*

Trade *Tel: (01) 439 2411*

7-11 Noel Street
London W1V 4AL
Tlx: 268317

TRIMMINGS

Known as *passementerie*, the section includes both suppliers and manufacturers of cords, gimps, braids, tassels, tie backs and edgings. Some manufacturers can produce hand made trimmings to order from a variety of fibres, including silk, linen and cotton, as well as man made fibres. Some of the producers included within the section carry a select range of trimmings to co-ordinate with ranges of fabrics.

TRIMMINGS

Laura Ashley Decorator Collection

The Collection of trimmings and braids is being enlarged all the time, some of which co-ordinate with the Decorator ranges. A larger selection of trimmings is offered by the Home Furnishing outlets (see below).
See also under *Chintz; Cotton Prints; Linen Union; Lace & Sheers*

Trade *Tel: (01) 730 1771/4632*

71-73 Lower Sloane Street
London SW1W 8DA
Fax: (01) 730 9369

Laura Ashley Home Furnishing

Laura Ashley Home Furnishing is the retail side of their fabrics: enquire at Customer Services for addresses of branches. Home Furnishings offers a fairly wide collection of trimmings, all of which are sold to the retail market only. All ranges co-ordinate with or match their fabrics.
See also under *Cotton Prints; Linen Union; Childrens Fabrics; Lace & Sheers; Carpets & Rugs*

Retail *Ask for Customer Service*
Tel: (0628) 39151

Head Office:
Braywick House
Braywick Road
Maidenhead
Berks SL6 1DW
Tlx: 848508
Fax: (0628) 71122

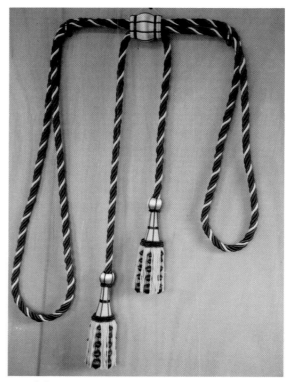

Tassels by L & E Barnett (Trimmings) Ltd

L & E Barnett (Trimmings) Ltd

Specialists in trimmings, L & E Barnett wholesale distribute and import ranges, and have a hand made service for special orders, such as for antique reproductions. Ranges are available as cut lengths or in larger quantities.

Trade *Tel: (062) 982 2251*

Unit 2B
Ravens Tor Road
Wirksworth
Derby DE4 4FY
Tlx: 665164

British Trimmings Ltd

A manufacturer of upholstery ruches and fringes, trimmings, jacquard borders, tapes, and velvet and plain ribbons, British Trimmings has a wide variety of trimmings for both furnishing and fashion. Large orders only.

Tel: (061) 480 6122/3/4

Coronation Street
Stockport SK5 7PJ
Tlx: 669785

Colefax & Fowler

Famous for their chintzes, Colefax & Fowler have a range of trimmings which co-ordinates with their fabrics; these include the latest ranges of two-tone fringes and fan edging.
See also under *Chintz; Cotton Prints; Cotton Weaves; Linen Union; Lace & Sheers; Carpets & Rugs*

Trade *Tel: (01) 493 2231*

39 Brook Street
London W1 2JE
and
110 Fulham Road
London SW3 6RL
Tel: (01) 244 7427
Tlx: 8953136

Wendy A Cushing

A specialist manufacturer of handwoven

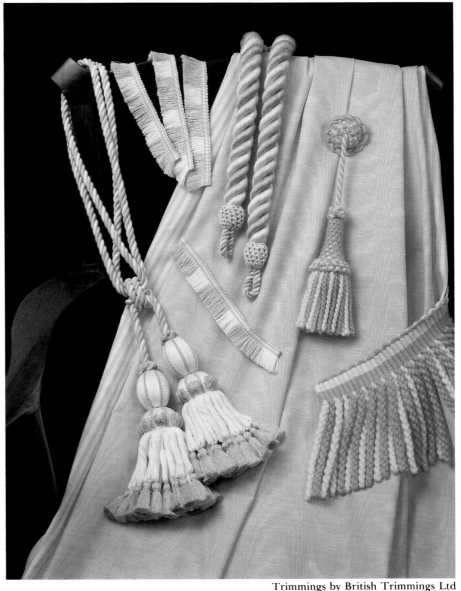

Trimmings by British Trimmings Ltd

TRIMMINGS

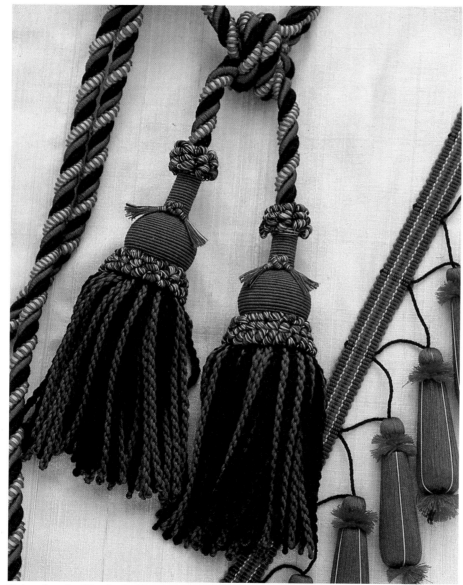

Trimmings by Wendy Cushing

trimmings, Wendy A Cushing is a small company, producing braids, gimps, fringes, tassels, cords and ropes. All items are woven to order, and a range of their own designs is available to be viewed by appointment. Any colour can be used, and most of the products are made in natural fibres, such as silks, cotton and linen.

Trade *Tel: (01) 739 5909*

Unit 410
Greenheath Business Centre
Three Colts Lane
London E2 6JP
Tlx: 888941 LCCIG CUSH

Distinctive Trimmings

One of the only retail specialists in furnishing trimmings, Distinctive Trimmings stocks virtually any and every kind of trimming. The *Designer* range offers a special hand made service, including tassels, tie backs and fringing. Most are in man-made fibres.

Retail *Tel: (01) 937 6174*

17 Kensington Church Street
London W8 4LF

Interior Selection

Small selection of trimmings, tie backs and tassels, available in 23 colours.

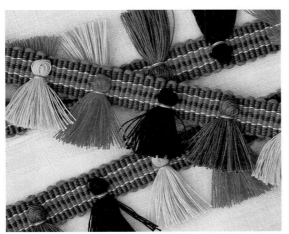

Trimmings by Wendy Cushing

See also under *Cotton Prints; Cotton Weaves*

Tel: (01) 602 7250

Springvale Terrace
London W14 OAE

Emerson Nelmes

Specialist manufacturers of hand made trimmings: all trimmings are made to order and anything can be made. Many different fibres are used, including man-mades, viscose, silk, metallic gold and metallic silver.

Trade *Tel: (01) 249 2711*

116-118 Middleton Road
London E8 4LP
Tlx: 23955 BTLBN G

Henry Newbery & Co Ltd

Considered among the best and biggest specialist trimming producers in Britain, the company's history dates back as far as 1782, when John Newbery started business as an

Tassels by Interior Selection

upholsterers' trimming manufacturer in Upper Marylebone Street. The present trading name was established by Henry Newbery in 1845. Their vast range of stock items includes tassel fringes, bullion fringes, gimps and braids, cords and tie backs. Trimmings can also be made to order from silk, linen, cotton, wool, or man made fibres. Henry Newbery also has a museum of old trimmings, dating back to Tudor times, which may be viewed by appointment.

See also under *Cotton Prints*

Trade *Tel: (01) 636 2053*

18 Newman Street
London W1
Tlx: 265830 NEWTRM G

Osborne & Little

Osborne & Little offers a wide selection of

trimmings, which co-ordinate well with its fabrics. These are made in France to Osborne & Little's specifications. Ranges include eleven different items, from narrow picot braid to double tassel tie-back. Four basic colour groups are available, shades of which can be blended and co-ordinated; all are from 100% cotton. Trimmings are sold by the metre. Osborne & Little also has showrooms in Edinburgh and Manchester.

See also under *Chinz; Cotton Prints; Cotton Weaves; Silk Weaves; International*

Tel: (01) 352 1456

304 Kings Road
London SW3 5UH
Tlx: 8813128
Fax: (01) 673 8254
and
43 Conduit Street
London WC1
Tel: (01) 734 5254

Pallu & Lake

See under *International*

HA Percheron

See under *International*

Dr Brian J Taylor

Recently opened trimmings specialist, Dr Brian J

Trimmings by Henry Newbery & Co Ltd

Taylor stocks over 5000 items, most of which are exclusive. Taylor offers several advantages, including quarter metre cut length, a policy not to discontinue ranges, and, through their huge stocks, quick service.

Trade
Tel: (061) 205 1977

Brunswick Mill
Bradford Road
Manchester M10 7EZ
Tlx: 635091 ALBION G

Tissunique

See under *International*

Turnell & Gigon

See under *International*

GJ Turner

Specialist hand made trimmings, all of which are made to order, GJ Turner can match or copy designs, whether antique or new: any yarns can

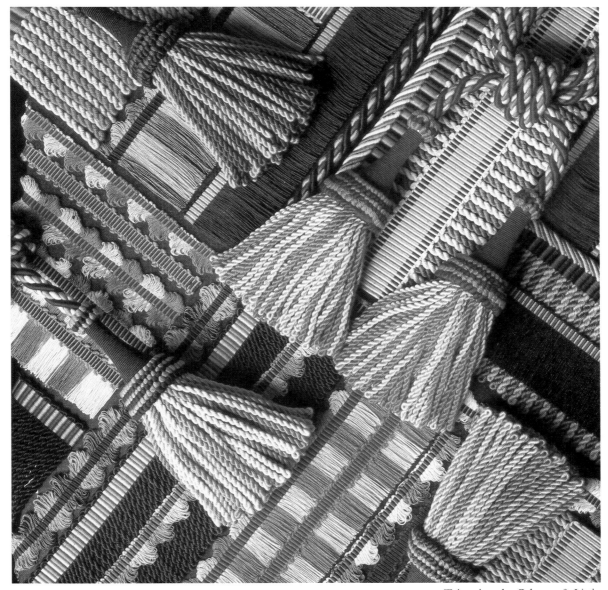

Trimmings by Osborne & Little

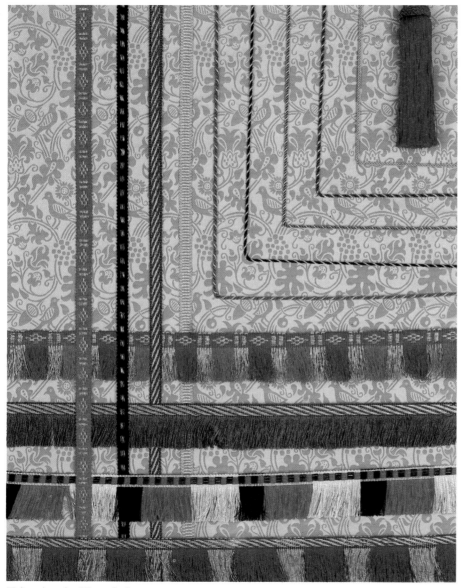

Trimmings by Watts & Co

be used and colours can be matched. GJ Turner has done work for such clients as the National Trust, for old houses and for the Church. There is also a collection of stock items of hand loomed trimmings.

Trade *Tel: (01) 247 1795*

40-42 Scrutton Street
London EC2 4PP
Fax: (010 377 5432

Watts & Co Ltd

Watts & Co was founded in 1874 by three Church architects, and still hand-weaves its own trimmings, which complement the fabrics. These are all high quality, the style dating from the nineteenth century, and include braids, fringes, and small cords; three headings are available from stock, diamond and lay, trail and diced. Colourings and designs can be individually woven using traditional techniques to customer specifications.
See also under *Cotton Prints; Cotton Weaves; Silk Weaves*

Tel: (01) 222 7169/2893

7 Tufton Street
Westminster
London SW1P 3QE

Wemyss Houles

See under *International*

SPECIALITY FABRICS

The section includes a wide range of textiles, from fabulously expensive cloth made to commission — such as 100% cashmere — to highly designed or unusual fabrics more closely associated with the decorative arts. Speciality Fabrics covers tapestries, some of which are made using the traditional French 17th century Gobelin techniques; horsehair cloth, produced by the last remaining horsehair weaver in Britain; weavers of cloth with 22 carat gold; and small scale producers of wall hangings, throws and blankets for interior decoration.

Tapestry by Helen Crosby (available through Aspects)

Aspects Applied Arts Showroom

Aspects is a gallery for decorative artists, started by Sharon Plant several years ago and now open to the public. The gallery is a house in which furniture, rugs and textiles created by contemporary artists are shown in their every day context; most items are for sale, after which Sharon Plant commissions further items to replace those sold. Aspects also has a slide index, showing examples of work by a number of artists, including a large section devoted to textiles and rugs, from which people can commission work. Comparable to the Contemporary Textile Gallery, Aspects, as a converted Victorian house, gives an excellent idea of how textile art can be used in interior design. As many of the artists represented at Aspects change, it is difficult to give an exact list of those represented. However, the following includes some of the artists who currently show work on the slide index:

Marta Rogoyska (see separate entry)
Louise Morris (sealed plastic wall hangings)
P Peahman (textured rag rugs)
Helen Crosby (tapestry and embroidered scenes of the countryside including scenes of gates, small waterfalls and fields)
Fabrics
Rosemary Atkinson (see separate entry)

Woven fabric by Jilli Blackwood (available through Aspects)

Sian Tucker (Contemporary Textile Gallery)
M Moia (printed fabrics using small repeated designs)
Anna Tilson (bold geometrics printed in superb colours: also on sale at Libertys).
There are many other artists and designers represented at Aspects, whose work can be seen by appointment with Sharon Plant.
See also under *Carpets*

Ask for Sharon Plant
Tel: (01) 354 3073

109 Highbury Hill
London N5

Jilli Blackwood

A small scale producer of embroidered and woven fabrics for the interior and fashion market. Fabrics are sold by short lengths of one metre up to five metres; throws and cushions are sold through Designers Guild, Aspects and

through the Crafts Council, or direct from her address. Jilli Blackwood's work is highly labour intensive; all fabrics and yarns are hand dyed and always of natural fibres, such as silk, linens, wools and cottons. Both embroidered and woven fabrics are in relief and textured. All her fabrics are extremely interesting, ideal for those after something special.

Ask for Jilli Blackwood
Tel: (041) 334 6180

8 Cleveden Crescent
Glasgow G12 0PB

Janet Bolton

A small scale producer of fabric pictures, using a contemporary approach to folk art tradition. The style is simple, and the techniques employed inlcude a 'painterly' eye. Currently enjoying success in the USA, commissions may be taken from her address or from fine art and craft galleries.

Ask for Janet Bolton
Tel: (01) 318 3743

40 Aislibie Road
Lee Green
London SE12 8QQ

Susan Bosence

Well-established in her field, Susan Bosence is one of the only producers of hand dyed and block

Hand block printed fabric by Susan Bosence

printed fabrics from a long established workshop. Susan Bosence cuts blocks from her own designs, assembles them, and develops the dyes using such dyestuffs as indigo, madder, iron and manganese, suitable for cotton, linen and wool. Other forms of printing used are direct painting, spraying and various forms of resist dyeing, including wax, paste and stitch. Susan Bosence works with interior designers who require special fabrics and colours; these are one-offs and not suitable for mass production orders. Her book, *Hand Block Printing & Resist Dyeing*, gives an explanation of traditional printing techniques and recipes for the dyes she uses. Her work can be seen through the Crafts Council, and may be purchased at exhibitions or ordered from her workshop address.

Tel: (062 682) 432

Sigford
Bickington
Newton Abbot
Devon TQ12 6LF

Susan Bosence

Bower Roebuck & Company Ltd

Producers of high quality worsteds and silk mixes which are suitable for apparel, Bower Roebuck can also produce to order cloth from 100% cashmere (minimum quantities 60 metres). All designs and colours are made to order; expensive and highly luxurious, the cashmere is made up to clients' specifications.

Tel: (0484) 682181

Glendale Mills
New Mill
Huddersfield HD7 7ES
London agent:
Mr MacWright
2/3 Golden Square
London W1
Tel: (01) 437 7696

Damask designs by John Boyd Textiles

John Boyd

John Boyd Textiles of Castle Cary, Somerset, is the only company manufacturing horsehair fabrics in Britain today, distributed exclusively through Pallu & Lake. John Boyd has been manufacturing horsehair textiles for the past 150 years, using genuine hair from horses' tails and fine cotton or wool yarn. The fabric, when woven, is a maximum of 76cm wide (this being the longest length of horses' hair). Exceptionally durable, the original use was for heavy usage furniture such as railway carriage seats, blinds and hard wearing upholstery. Sateens, damasks and repps are available in a large range of patterns and colours. Traditionally horsehair has never been considered a luxury item; however, designers are using horsehair in interesting new ways, not least of which includes wall covering. The glossy, sombre colours horsehair often produces are very much in keeping with the currently fashionable Victorian colouring; and, being a specialised textile, should attract those looking for an exciting and practical fabric.

Tel: (01) 627 5566

Available through:
Pallu & Lake
London Interior Designers Centre
1 Cringle Street
London SW8 5BX
Tlx: 917976

Tapestry by Joanna Buxton

Joanna Buxton

Tapestries woven in the traditional Gobelin high loom technique, Joanna Buxton uses a variety of yarns including wool, cotton, silk, rayon and linen. These are hand dyed in order to create

Tapestry by Joanna Buxton

exactly the right shades of colour. Joanna Buxton's work is representational, and a great deal of time is spent researching the images used. Commissions include those for the National Trust and Gatwick Airport and a series of works for the Government of Qatar.

Commission
Ask for Joanna Buxton
Tel: (01) 262 5773 / 253 0389

50C Westbourne Terrace
London W2 3UY

Peter Collingwood

Specialised, small scale producer of wallhangings from macrogauze: stylish and unusual, Peter Collingwood also weaves rugs from mixes of wool, mohair and linen. His work may also be seen at the Contemporary Textile Gallery.
See also under *Carpets*

Commission *Tel: (0206) 262 401*

Old School
Nayland
Colchester CO6 4JH

The Contemporary Textile Gallery

The Contemporary Textile Gallery (CTG) is a division of the Vigo Carpet Gallery, one of the longest established Oriental Rug galleries in Britain. The CTG deals with modern, mainly British hand-tufted rugs, hand woven tapestries and silk prints, and other specialised textiles. The Gallery is an excellent showroom for modern fabrics and carpet producers and as such is useful for those interested in unusual fabrics. As well as stocking rugs from artists represented at the Gallery, the CTG's in-house design team will take commissions for rugs designed to clients' specifications. The gallery will also organise commission work on behalf of the artists.
See also under *Cotton Prints; Silk Prints; Carpets*

Tel: (01) 439 9070 / 1

10 Golden Square
London W1R 3AF

Tapestry by Bobbie Cox

Tapestry by Joanna Buxton

Bobbie Cox

Produces tapestries, woven exclusively in wool. Bobbie Cox exploits the texture of wool to the fullest and spins her own yarn from fleeces

chosen according to their qualitites of lustre, texture or length of staple. She dyes all wool herself; low reliefs and tactile qualities are the hallmarks of her work. Bobbie Cox's recent exhibition, Indian Journey, contains some stunning work, including abstracts in suberb colours. Tapestries are sold direct from the work shop, or commissions may be taken for particular sites.

Ask for Bobbie Cox
Tel: (082 281) 305

Higher Manor
Cudlipptown
Peter Tavy
Tavistock
Devon PL19 9LZ

Crafts Council

The Crafts Council operates two registers of 'craft' artists, selected on the basis of quality and interest. Background information and a slide index are also available on the artists' work. The Crafts Council will also send out information on specific subjects, including textiles and rugs, and is useful for those searching for hand crafted and unusual decorative items.
See also under *Reference*

Ask for Information Desk
Tel: (01) 930 4811

8 Waterloo Place
London SW1Y 4AT

Tapestry by Bobbie Cox

SPECIALITY FABRICS

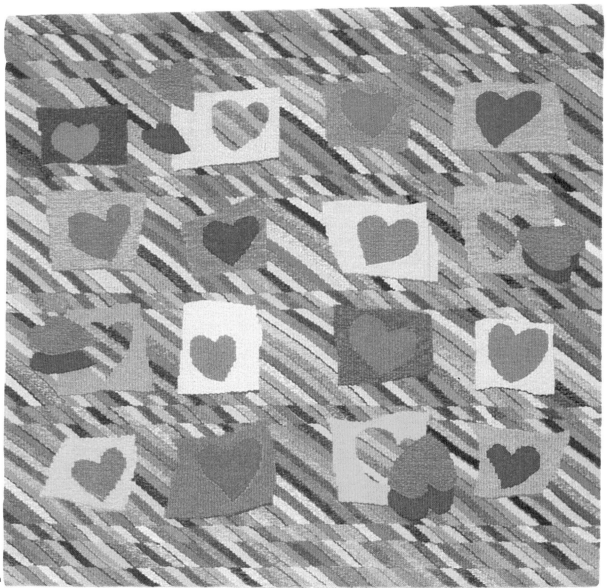

Valentine by Grace Erickson

Maintenance by Grace Erickson

Crombie

Crombie is known as the world's leading producer of coating fabric using a raised, brushed surface effect; manufacturers of cloth traditionally associated with all things luxurious and very expensive, Crombie also has a range of 100% cashmere and camelwool (minimum order 60 metres). Crombie also has a range of 100% woven silk and silk mixes, incorporating checks, geometrics, tweeds and stripes. New ranges are brought out twice a year, all of which are suitable for apparel.
See also under *Silk Weaves; Wool*

Trade *Tel: (0224) 483201*

Grandholm Mills
Woodside
Aberdeen
Scotland AB9 2SA
Tlx: 73138 CROMBI G

Double Weave

Double Weave is a design and production partnership involving Wendy Jones and Lesley Butenshaw, who design and produce individual handwoven furnishings and rugs both from stock and to commission. Exclusive co-ordinating furnishings ranges are also available for individual companies. Only the best natural fibres are used, mainly worsted wool; mixes and blends are used to order. The partners have access to power looms for larger orders. Their colours remain fashionable, and recently coloured warps are being used, producing rich, deep colours.

Ask for Wendy Jones/Lesley Butenshaw
Tel: (0732) 810420 or (0732) 883812

Cage House
Long Mill Lane
Plaxtol
Kent TN15 ORA

Grace Erickson

A small producer of highly textured woven tapestries, using wool on a linen warp, Grace Erickson's work incorporates simplified figures and/or abstract designs in subjectively based 'observations of life'. The best of Erickson's work involves lyrical, often classically composed forms; the tapestries may also employ over-painting onto the wool, applique or figures in relief, and

Open Space by Sue Lawty

Landscape Sketch by Sue Lawty

always in recessed, subtle colours. Tapestries are never duplicated.

Commission *Tel: (0752) 261788*

334 Old Laira Road
Plymouth PL3 6AQ

David Evans

A subsidiary of Sekers International, and known as the 'last of the old London textile printers' David Evans print mainly onto silk, and will also print onto 100% cashmere and mohair, using their extensive archive documents. All fabrics are printed to order, minimum quantities are 44 metres. These include designs taken from traditional Lyons silk blocks from the 18th century.
See also under *Silk Prints; Wool*

Trade *Tel: (0322) 57521*

Bourne Road
Crayford
Kent DA1 4BP
Tlx: 8956830 DECRAY G

Independent Designers Federation (IDF)

A newly established cooperative of young designers' work, the IDF offers an exciting range of fabrics, wallhangings and furnishings using new designs and unusual treatment. All items at the IDF are exclusive and original.
See also under *Silk Prints*

 Tel: (01) 485 4555

30 Bruges Place
Randolph Street
London NW1

Johnstons of Elgin

Specialist producers of 100% cashmere cloth, all of which is made to order and is suitable for apparel (minimum quantity is 70 metres). Cashmere/wool is available. Made up items (scarves and ties) are also available.

Trade *Tel: (0343) 7821*

Newmill
Elgin
Moray IV30 2AF
London showroom:
15 Golden Square
London W1R 3AG
Tel: (01) 439 6013
Tlx: 298212

Sue Lawty

Tapestries woven on a high warp loom using traditional techniques. Sue Lawty's work ranges from miniatures to large scale wall murals of land and seascapes, using fine silk threads and linen; other fibres are cotton, linen and wool. Her style is spontaneous and retains the sketch quality of the original drawings. Commissions are taken

from the above address; designs are drawn up in close consultation with the client. Also seen at the Contemporary Textile Gallery.

Commission *Tel: (0422) 844934*

The Coach House
Cross Lanes
Hebden Bridge
West Yorkshire HX7 7EW

Martin & Sons

Producers of some of the finest quality worsted wools in the Huddersfield Fine Worsteds group (of which they are part), Martin & Son also have a superb quality 100% cashmere, suitable for light weight usage such as for men's suitings and apparel. Martin & Sons require large minimum orders. They also use a blend of wool and 40% cashmere and 60% summer kid mohair.
See also under *Wool*

Tel: (0484) 540344

Kirkheaton Mills
Kirkheaton
Huddersfield HD5 0NS
Tlx: 517216

Jennie Moncur

A small scale producer of tapestries for upholstery, some of which are inspired by the Middle Ages and French Renaissance worked in the kelim-style, Jennie Moncur is enjoying a high profile in the design world for her linoleum flooring (recently the ICA commissioned her work for the staircase linking the lower and upper galleries). Her designs are translated onto flooring by using a new lazer cutting tool. Jennie Moncur also produces painted banners; her work can be seen at the Contemporary Textile Gallery, or can be commissioned from her address.

Commission *Tel: (01) 439 9070/1*
(Contemporary Textile Gallery)

Home address:
154 Sinclair Road
London W14

Alison Morton

Hand woven rugs, wallhangings and throws, Alison Morton produces three types of rugs. The flat woven range is available in a variety of colours, suitable for the floor; the tufted rugs, which are more suited as wallhangings, are flat woven with added tufts in simple geometric patterns giving a highly textured surface. The hangings use a mixture of flat and tufted techniques in a range of colours. Her throws are handwoven, using handspun yarn to give each an individual handle and texture. These are available with wide patterned borders and are finished with decorative tassels.

Commission *Ask for Alison Morton*
Tel: (Home) (065) 473 629

1 Bron-y-Gan
Corris
Machynlleth
Powys S720 9TN

SPECIALITY FABRICS

Stone Age by Penny Beard (IDF);
print by Jasia Szerszynska

Tapestry by Marta Rogoyska (available through Aspects)

Moxon Huddersfield

The most expensive and exotic fibres available are produced to order; a wool worsted producer for the apparel market, Moxon Huddersfield also make up cloth from 100% cashmere and mohair; others available are ermine, mink, vicuna, beaver and arctic fox. Moxon can also use 22 carat gold stripes in their cloth. Minimum orders start from 60 metres and, with fibres as expensive as these, all goods are made in close association with the client, and will remain exclusive to the client, worldwide, for a year.

Tel: (0484) 602622

Southfield Mills
Kirkburton
Huddersfield HD8 0QJ

Judith Perry

Wall hangings, pictures and boxes made from textiles; Judith Perry is a marvellous colourist and has a terrific eye for design. Judith worked initially from her landscape drawings, then progressed to combine them with decorative patterned borders. Many of her wall hangings and fabric pictures are abstract, taken from Indian, African and Japanese textiles. She also uses the 'serti' technique - drawing the design onto silk with a gum, then colouring the fabric with dyes - after which some of the pieces are quilted. Hand painted and quilted silks are also available, and commissions are undertaken from her address.

Tel: (0926) 23847

20 & 21 Offchurch Village
Leamington Spa
Warks CV33 9AP

Marta Rogoyska

Tapestries using strong designs and colours woven using the classical Gobelin techniques; Marta Rogoyska's work can be see at Aspects. All tapestries are made to commission.

Commission *Tel: (01) 241 6739*

61B Downs Park Road
London E8 2HY

Pallu & Lake

See under *International*

Geraldine St Aubyn Hubbard

Handwoven cloth in silk, cashmere and wool, using combinations of any of the three. At present cloth can be supplied by the yard or as soft furnishings; power looms are used for larger

orders. However, her work is primarily for small quantities. Hand block printing onto cotton and silk is also available.

Commission

Tel: (0903) 814204
or (01) 930 4811 (Crafts Council)

Home address:
2 Charlton Court
Mouse Lane
Steyning
West Sussex BN4 3DF

The Coral Stephens Collection

See under *International*

Ann Sutton Textiles

A well-established and highly respected producer of woven fabrics, Ann Sutton is currently specialising in wool bedcovers and throws. The *Small Patch* range is woven in double cloth to give a quilt-like appearance; colourways available are primary colours and a mix of primary and secondary colours on white ground. Throws are machine woven with hand woven edging, one of which is an attractive loose shell weave. All are made from 100% wool. Ann Sutton also weaves using a variety of other fibres; commissions are taken from the below address; she has also written a number of books on textiles.

Ask for Ann Sutton
Tel: (0903) 883445

40 Tarrant Street
Arundel
West Sussex BN18 9DN

Jasia Szerszynska

Jasia Szerszynska

A small scale producer, Jasia Szerszynska is a young designer who hand screen prints onto a variety of fabrics, including cotton woven with silk, hand loomed in India. Jasia's prints are modern, abstract in style, using hieroglyphic-based motifs. Some of her most striking work incorporates gold metallic paint on a rich velvets or cotton muslin. Other fabrics include hessian and taffetas. Jasia's work can be seen at the Contemporary Textile Gallery.

Ask for Jasia Szerszynska
Tel: (01) 481 3273/608 0647

144 Haberdasher Street
London N1

Taylor & Lodge

Producers of worsted wool suitable for apparel, Taylor & Lodge also have superb ranges of 100% cashmere made to order. Other fibres used with wool are small proportions of chinchilla and vicuna.

Tel: (0484) 23231

Raashcliffe Mills
Albert Street
Huddersfield
West Yorkshire HD1 3PE

CARPETS & RUGS

There are two main types of woven carpets, Axminster and Wilton; while these names orginally referred to the place of their origin, they are now used to denote the method of their manufacture. The pile in an Axminster is inserted while the carpet is woven, a row of tufts at a time; the pile in a Wilton carpet runs continuously into the carpet, and form a more integral part of the weaving process. The method of Axminster weaving allows for an infinite number of colours to be used, while a Wilton can have no more than five. Tufted carpets are made by inserting the pile into a 'primary' backing material, anchored by an adhesive. A secondary backing is then attached. This section includes some of the finest, most luxurious Axminster, Wilton and hand tufted carpet and rug manufacturers, as well as manufacturers of carpets suitable for offices, hotels or large scale contract work.

Abingdon Carpets Ltd

Tufted, mainly plain, carpets; colours can be matched to customer specification with large enough orders. Berbers, cut and loop, cord, saxony, velvets and velours are available.

Trade *Tel: (0495) 243000*

Pen-Y-Fan Park
Crumlin
Gwent NP1 4EF
Tlx: 498148

Adam Contract Carpets

Tufted carpets in 80/20 or 50/50 wool/nylon mixes, produced to any size and colour according to customer specification. Adam Carpets offers in-house dyeing facilities, a choice of plain and textured ranges, computer generated designs, a range of backings, and carpets of both broadloom width and tiles.

Retail *Tel: (0562) 2247*
Trade

Greenhill Works
Birmingham Road
Kidderminster
Worcestershire DY10 2SH
Tlx: BIRCOM 338024 ADAM

Afia Carpets

Do not manufacture carpets themselves, but will take on customers' orders and organise the design of the carpet or rug using the best manufacturer for the job. As retailers producing custom design work, Afia are ideal for domestic qualities.

Trade *Tel: (01) 935 0414*

60 Baker Street
London W1M 1DJ

Shyam Ahuja

See under *International Fabrics*

Anker Contract Carpets

Part of Skopos Design, along with Skopos Fabrics; Anker specialise in heavy contract ranges from 100% man made fibres, with 50 standard ranges. Ideal for leisure centres, offices, hotels, airport foyers, and any design can be incorporated. Anker are a major supplier for hospitals and are DHSS approved.

Tel: (0924) 465191

Providence Mills
Earlsheaton
Dewsbury
West Yorkshire WF12 8HT
and
87 York Street
London W1
Tel: (01) 402 5532

Laura Ashley Home Furnishing

Laura Ashley Home Furnishing is the retail side of their fabrics, offering less expensive ranges

Rug by Mary Farmer (Aspects)

than the Decorator Collection. The addresses of branches throughout England can be obtained from the address given below. Home Furnishings have a range of Indian-made dhurries, designed to Laura Ashley's specifications, and a range of Brussels weave rugs.
See also under *Chintz; Cotton Prints; Linen Union; Children's Fabrics*

Retail *Ask for Customer Service*
Tel: (0628) 39151

Laura Ashley Ltd
Braywick House
Braywick Road
Maidenhead
Berkshire SL6 1DW
Tlx: 848508
Fax: (0628) 71122

Aspects Applied Arts Showroom

Aspects is a gallery for decorative artists, founded by Sharon Plant several years ago and now open to the public. The gallery is a converted Victorian house in which furniture, rugs and textiles created by contemporary artists are shown in their every day context; most items are for sale, after which Sharon Plant commissions further items to replace those sold. Aspects also has a slide index, showing examples of work by a number of artists, including a large section devoted to textiles and rugs, from which people can commission work. Comparable to the Contemporary Textile Gallery, Aspects gives an excellent idea of how modern textile art can be

Rug by Lynne Dorrien (available through Aspects)

used in interior design. As many of the artists represented at Aspects change, it is difficult to give an exact list of those represented. However, the following includes some of the rug makers currently showing work on the slide index:
Liz Kitching see separate entry & at CTG
Caroline Slinger see separate entry & CTG
Helen Yardley see separate entry & CTG
Lynne Dorrien also at the CTG
Mary Farmer see separate entry
Peter Podmore also at CTG
Allen Wilding also at CTG
Celia Harrington see separate entry & CTG
See also under *Speciality Fabrics*

Ask for Sharon Plant
Tel: (01) 354 3073

109 Highbury Hill
London N5

Avena Carpets Ltd

Weavers of fine Brussels Wiltons, Avena's carpets are designed by such people as David Hicks, Susan Kingsfor, Ulla Holland and Margo Cholmondeley. Plain and banded borders can also be supplied. Their excellent designs are available in qualities which include Brussels Super/de Luxe, Velvet de Luxe, Harden Oakworth, Haworth and Keelham. The latter two are limited to a maximum of three colours.

Trade
Tel: (0422) 44096

Bankfield Mill
Haley Hill
Halifax HX3 6ED

Chirvan by Axminster

Axminster Carpets Ltd

Axminster Carpets Ltd manufacture superb quality Axminster carpets, using 100% wool unless otherwise specified. Axminster Carpets Ltd are based in the town where the Axminster method of weaving carpets was first practised. The present company has remained at the top end of the market, using traditional craft methods of manufacture, and producing carpets that continue the belief that their manufacture is an art form. Axminster also has its own spinning facility and wool buyer. Custom made carpets and standard ranges are available, with a vast range of styles from which to choose. The top quality carpets for very heavy wear include the Royal Collection and Exeter.

Trade
Tel: (0297) 33533

Axminster
Devon EX13 5PQ
Tlx: 42931 AXCARP

History of Axminster Carpets Ltd

Axminster Carpets Ltd was founded in 1937. However, the Axminster carpet tradition, based on a particular method of weaving carpets, dates back well over 200 years. In 1754 Thomas Whitty, a cloth weaver from Axminster, became fascinated by the seamless method of construction of a Turkey Carpet which measured 86 feet by 12 feet, rumoured to be the best and largest in England. The breadth of the pattern woven without interruption inspired Whitty to attempt his own carpets in this style. However, early samples, made on a horizontal loom, were too labour intensive to be profitable. The answer came on

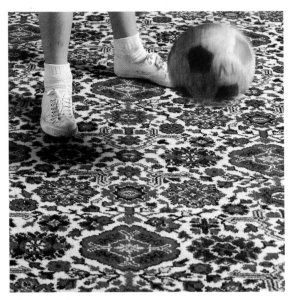

Beker by Axminster

Axminster

inspection of the work of a carpet company in Fulham, set up by the former French priest, Parisot, who, along with other Hugenot weavers brought with him the French skills of fine carpet production. Parisot's carpets were extremely expensive, and Whitty decided to weave carpets at a price people could afford. In 1755 Whitty's first piece of 'Axminster carpet', woven with pile made in the oriental style, was completed. By chance a steward to the Earl of Shaftesbury saw it, and, impressed, described it to Lady Shaftesbury. Known for her patronage to the arts, Lady Shaftesbury requested that she might have it, as an example of the first piece of English carpet she had seen woven in this style. Subsequently Lord and Lady Shaftesbury were to become amongst Whitty's best customers.

Thomas Whitty's success in Axminster coincided with the huge success of the hand knotting industry in England. Thomas Moor opened a company at Moorfield in Exeter, producing hand knotted carpets and tapstries; and Jesser started up shop in Frome. The trend was encouraged by the Royal Society of Arts, which offered prizes for the best produced carpet over 15 feet by 12 feet in size. Whitty won this prize three times, not least because of the reasonable price of his carpets. Whitty also worked with the Adam brothers, weaving carpets to match the designs on ceilings, at that time very much in fashion. Despite these successes, the company was forced to close in 1835. The Earl of Pembroke, patron to the Wilton carpet weaving tradition, bought the entire factory, and moved the looms and some of the Axminster weavers to Wilton.

Years later, Harry Dutfield took advantage of the name and tradition to found Axminster Carpets Ltd. The first loom was unloaded in Axminster in 1937. Aside from an interruption during the war, during which time Axminster exported carpets only and was otherwise used to produce stirrup pumps, the company continues to produce traditional Axminster woven carpets, using only the best materials, design and colour.

BMK Ltd

BMK is a highly respected carpet manufacturer with huge resources, offering virtually any and every kind of carpet. Contract Wilton, Axminsters and tufted ranges from 100% wool or wool mixes are available to customer

Oakleaves by Bosanquet Ives Ltd

Marigold by Bosanquet Ives

specification. Highly recommended for large scale quality contract work.

Trade *Tel: (01) 408 2220*

23 Maddox Street
London W1
Tlx: 28378

Bosanquet Ives Ltd

Offers a comprehensive service, which includes the *Bosanquet Ives Collection* of carpets, quality Wilton rugs and the Bosanquet Ives Custom-Made Carpet Service. Wilton rugs are available in Brussels weave or cut pile, manufactured in three sizes to individual colour and design requirements. Bosanquet Ives Ltd also produce an exclusive range of Brussels weave rugs for Laura Ashley.

Trade *Tel: (01) 730 6241*

3 Court Lodge
48 Sloane Square
London SW1W 8AT

Brintons Carpets Ltd

Over 200 years old, Brintons has a huge range of facilities for contract work and a wealth of resources based on traditional Wilton carpet manufacturing methods. Recommended for large scale contract work. Brintons has offices throughout the USA, Paris and Germany. Axminster ranges are also excellent: their best include the *Palau Palace Velvet* design.

Trade *Tel: (01) 937 3765*

British Carpet Trade Centre
99 Kensington High Street
London W8 5TB
Tel: (01) 937 3765

The British Carpet Manufacturers Association Ltd

The BCMA has a list of members and brief descriptions of their products, and can advise on specific details regarding carpets.
See also under *Reference*

Tel: (01) 734 9853

Royalty House
72 Dean Street
London WV 5HB

Brockway Carpets

Axminsters and tufted carpets in 80/20 wool/nylon mix. Custom made carpet service is also available with designs and colours made up to clients' specifications.

Trade *Tel: (0562) 824737*

Hoobrook
Kidderminster
Worcestershire DY10 1XW
Tlx: 337218

Bronte Carpets Ltd

The contract ranges are the hard twist carpets *Rochester* and *Hightown*, both 80/20 wool/nylon mixes. Other carpets and rugs are from 100% wool, including hard wearing heavier saxonies. Also available are shag pile tufted carpets.

Trade *Tel: (0282) 862736*

Unit 4 Bankfield Mill
Greenfield Road
Colne
Lancashire BB8 9PD

Carpets of Worth Ltd

Contract Axminster ranges from 80/20 wool/nylon mix. Colour can be matched and designs made to customer specification. Most often used in pubs clubs and restaurants.

Trade *Tel: (02993) 4122*

Severn Valley Mills
Severn Road
Stourport on Severn
Worcestershire DY13 9HA
Tlx: 338324

Carrington Carpets

See under *CV Carpets*

Cathy and Eve Designs

Small scale producers of one-off rugs and fitted carpets to customer specifications; Cathy and Eve also produce wall hangings. Their work may be seen, and commissions made if required, at the Contemporary Textile Gallery.

Tel: (0532) 458205
10 Dovereign Street
Leeds LS1 3BJ

CARPETS & RUGS

Checkmate Carpets Ltd

Tufted carpets and carpet tiles for contract use. All carpet tiles are suitable for heavy and very heavy wear; qualities associated with Checkmate are the *Masterpiece* and *Heathland* ranges, available in twin tone hard twist yarn and loop pile tiles respectively. The Berlin wool/nylon 80/20 mix can be made to order in any colour over 500 metres.

Trade　　　　　　　　　　　*Tel: (0787) 477272*

Bridge House
Bridge Street
Colchester CO9 1HT
Tlx: 987161

Clandeboye Carpets Ltd

Axminsters and tufted in both domestic and contract qualities. Tufted qualities include plain and those with small patterns. The best quality carpet is a 42 oz twist.

Trade　　　　　　　　　　　*Tel: (0247) 813995*

Glenford Way
Newtownards
Co Down DT23 4BX
Northern Ireland

Alice Clark

Small scale producer of warp face rugs using a plain rib weave with interchanging colours; Alice Clark rugs are for modern interiors, or for those looking for strong geometric or assymetric lines. Alice Clark has experience working with interior designers, and supplies retail outlets in England. Her work is also available through the Contemporary Textile Gallery.

Tel: (0232) 662485

49 Eglantine Avenue
Belfast BT9 6EW
Northern Ireland

Colefax & Fowler

Famous for their chintzes, Colefax & Fowler have a range of over thirty carpets made exclusively for them. Carpets are available as Brussels loop pile or cut pile, woven in any colour combination. A range of borders is also available.
See also under *Chintz; Cotton Prints; Cotton Weaves; Linen Union; Laces & Sheers; Trimmings*

Tel: (01) 493 2231

39 Brook Street
London W1
and
110 Fulham Road
London SW3
Tel: (01) 244 7427

Peter Collingwood

Peter Collingwood has been producing rugs on a small scale for many years; he also specializes in

wallhangings from macrogauze. Rugs are woven from quality fibres including mixes of wool, mohair and linen.
See also under *Speciality Fabrics*

Trade　　　　　　　　　　　*Tel: (0206) 262 401*

Old School
Nayland
Colchester
Essex CO6 4JH

The Contemporary Textile Gallery

The Contemporary Textile Gallery is a division of the Vigo Carpet Gallery, one of the longest established oriental rug galleries in Britain. The Contemporary Textile Gallery deals with modern, mainly British, hand-tufted rugs, hand woven tapestries and silk prints, and other specialized textiles. The Gallery is an excellent showroom for modern fabric and carpet producers, and as such is highly recommended for those interested in unusual, highly individual fabrics. As well as stocking rugs from designers, the Contemporary Textile Gallery has facilities for making limited editions of selected rugs from the in-house rug designers.
Rug makers on show at the Gallery include:
Cathy & Eve Designs see separate entry
Alice Clark see separate entry
Tom Collins
Lynne Dorrien
Sandy Ennis
John French see separate entry

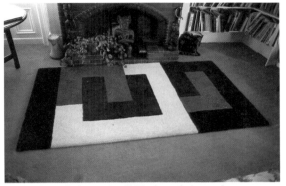
Rug by Peter Podmore (available through Aspects)

Leslie & Robin Greaves see separate entry
Gill Hewitt
Ian Henon
Sally Hampson see separate entry
Celia Harrington see separate entry
Anne Kelly
Liz Kitching also at Aspects
Jennie Moncur see separate entry
Fiona Nealon
Morgan & Oates see separate entry
Ron Nixon
Peter Podmore also at Aspects
Sara Parnell
John Scott
Malcolm Temple see separate entry
Allen Wilding also at Aspects
Helen Yardley see under separate entry, also at Aspects
Rosalind Zialourad
See also under *Cotton Prints; Silk Prints; Speciality Fabrics*

Tel: (01) 439 9070/1

10 Golden Square
London W1R 3AF

Bourbon by Craigie Stockwell

CP Carpets

Geared to small production runs, CP Carpets make custom designed carpets, with an in-house design team to assist the client in the selection of colour and designs from their library, or for their own design matching. Yarn is dyed to order, either 100% wool or 80-20 wool/nylon mix. CP Carpets specialise in Wilton carpets on Boucher looms.

Trade

Tel: (01) 240 1096
1 Goodwins Court
55/56 St Martin's Lane
London WC2 4LL
Tlx: 338278
Fax: (01) 379 4182

Craigie Stockwell Carpets Ltd

Considered by many to produce among the very best quality custom made hand crafted carpets, rugs and wall hangings in Britain, Craigie Stockwell's carpets are exceptionally beautiful, available in a wide range of styles and designs. Most notable are the Victorian ranges; hand-woven needlepoint rugs with Victorian Rose borders; and adaptations of Victorian rugs incorporating floral motifs. Also available are rugs in Art Nouveau designs; varied pile heights and wallhangings using varying textures with silk and lurex highlights; superb designs including the butterfly motifs from the Border Collection; Savonnerie style carpets designed by Robert

Brighton Pavilion by Craigie Stockwell

Homes; and carpets designed for Adam town houses reflecting the pattern on the ceiling. All ranges are hand tufted using 100% wool.

Trade

Tel: (01) 580 5935
67a Great Titchfield Street
London W1P 7FL
Tlx: 299247
Fax: (01) 580 7070

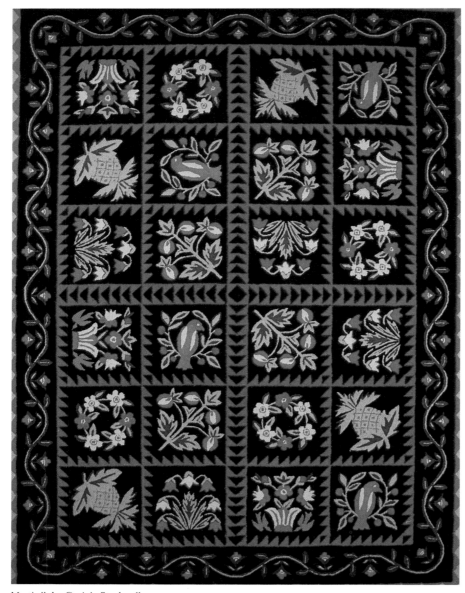

Monticello by Craigie Stockwell

Crowthers Contract Carpets

Crowthers incorporates several companies and as a result has huge resources. Under Crowthers is Crossley, which produces superb quality Axminsters, Wiltons and tufted carpets; the best of which are the *Crescendo* and *York* 100% wool Wiltons and the *Sultana* 100% wool Axminster. Gilt Edge Carpets (which now operates under the name Crowthers) also has Axminster, Wiltons and Tufted carpets; 50% of their work is custom designed services. Crowthers also has a wide traditional domestic range. Other companies within the group are Kosset and Weaver Craft & Carpets International, all trading under the name of Crowthers.

Trade
Tel: (0484) 715500
PO Box 10
Brookfoot
Brighouse
West Yorkshire
HD6 2RD
Tlx: 51565

CV Carpets

Part of the Coats Viyella group, CV Carpets now includes Lancaster Carpets, Tudor Rose, Carrington Carpets and Donaghedee Carpets. Set up to deal with all major contract work, offices, hotels and banks. CV Carpets best qualities include 100% wool loop and heavy wear Wiltons; contract and heavy contract tufted ranges (grades 4-5); and three standard

Rug by Designer Choice

Rug by Designer Choice

Axminster ranges. CV Carpets has a broad range, incorporating the best of Lancaster Carpets and Carrington.

Trade Tel: (0282) 67766

Brunswick St
Nelson
Lancashire BB9 08Y
Tlx: 63408
and (Showroom):
28 Savile Row
London W1
Tel: (01) 734 4030
Tlx: 21232

Designer Choice

Machine tufted and hand tufted rugs and carpets; a unique technique resulting in all rugs, carpets and wall hangings comprising one piece with one primary backing. All products are hand sheared. Started in 1984, Designer Choice offers in-house designers and superb quality commissions, up to 180 oz per sq yard; colours and designs can be made to order.

Trade Tel: (0483) 811050

The Old Pottery
Watts Gallery
Down Lane
Compton
Guildford
Surrey GU3 1DQ
Tlx: 859850

Designers Guild

The range of carpets is manufactured exclusively for Designers Guild by Tomkinsons Carpets of Kidderminster; carpets are *Twill*, a soil resistant Axminster carpet using fine pencil line designs available in 80/20 wool/nylon mix and colourways; *Plainline*, also a soil resistant Axminster in 80/20 wool/nylon mix in eight colourways; and *Ultra Plain*, a tufted deep pile carpet made from 100% Antron Ultra Plus, wet

stain resistant and anti-static, available in twelve colourways.
See also under *Chintz; Cotton Prints; Cotton Weaves; Linen Union*

Tel: (01) 351 5775

277 Kings Road
London SW3 5EN
Tlx: 916121
Fax: (01) 352 7258

De Mont & Wright Designers

Small scale producers of attractive weft-faced rugs in natural black and white wool, woven on flax warp with twined and knotted fringe. Four variations of design are available and the size is approximately 32 inches by 68 inches.
See also under *Cotton Weaves*

Tel: (0686) 24652/24341

Unit 29
Vastre Ind Estate
Kerry Road
Newton
Powys SY16 1DZ
Tlx: 35851 CYMEX

Mary Fox Linton

See under *International*

Firth Carpets

Comprehensive range of traditional Axminsters, Wilton and tufted carpets, Firth Carpets was established in 1867 and is still on its original site at Bailiff Bridge. Firth boasts one of the most sophisticated production plants in Europe. Computer aided pattern effects are available in the tufted ranges; the in-house design team can make up designs to order with hand-made trial samples for approval. Colours can be matched. Contract qualities available in 80/20 wool/nylon mix.

Trade

Tel: (0484) 713371

Head office and factory:
PO Box 17
Clifton Mills
Brighouse
West Yorkshire HD6 4EJ
Showroom:
The Business Design Centre
52 Upper Street
Islington
London N1 0QH
Tel: (01) 288 6015

Birkby Moor by Firth Carpets

Rug by Celia Harrington

Rug by John French Atelier Ltd

John French

Modern and highly influential, John French is a small scale producer of hand tufted rugs, wall hangings and carpets. Through his innovative and experimental work, John French has influenced a generation of modern hand tufted carpet makers. Colours can be matched and designs worked through with clients. Also available through the Contemporary Textile Gallery.

Tel: (01) 631 4750

19-30 Alfred Place
London WC1E 7EA
Tlx: 295877

Georgian Goodacre Ltd

Excellent quality tufted carpets, the majority of which are plain; chunky pile; velvet pile; twist pile; plush pile and two-tone twist tufted styles. Two ranges have small geometric patterns. The best quality is the *G Major* range, 80/20 wool/nylon mix for very heavy wear; other good qualities are the *Manor*, from 100% wool, and *Georgian Suede* and *Georgian Velvet*.

Trade *Tel: (0562) 820800)*

Clensmore Mills
Clensmore Street
Kidderminster
Worcestershire DY10 2LH
Tlx: 337198

Gilt Edge Carpets

See under *Crowther Contract Carpets*

Goodacre Carpets Ltd

Excellent quality traditional Axminster carpets; one of the best qualities is the *Royal Kendal* in 100% wool, suitable for very heavy wear. All

other patterned Axminsters are in 80/20 wool/nylon mixes. Goodacre is a sister company to Georgian Goodacre Ltd.

Trade Tel: (0539) 23601

Castle Mills
Aynham Road
Kendal
Cumbria LA9 7DF
Tlx: 65299
Fax: (0539) 32442

Gaskell Broadloom Ltd

Gaskell Broadloom have five qualities of contract Axminster and roughly twenty tufted carpets, suitable for medium and heavy contract use. The Axminster qualities are woven in both body and broadloom; borders are also available. They have facilities to design and colour carpets to customer specifications. 100% wool pile is available in the tufted qualities.

Trade Tel: (0254) 885566

Wheatfield Mill
Parker Street
Rishton
Blackburn
Lancashire BB1 4NU
Tlx: 63480

Juliet Goodden

Hand knotted rugs made from 100% wool on a cotton warp; 48 knots to the square inch. Juliet

Rug by Lister & Co Ltd

Rug by Celia Harrington

Goodden designs her rugs and has them made up in the Indian Subcontinent by Tibetans; all rugs are made to order to suit customer specifications, and colours can be matched. A wide variety of designs is available, ranging from geometrics to figuratives.

Tel: (01) 635 8422

231 Bellenden Road
London SE15 4DQ

Alex Gossley

Small producers of hand tufted rugs, all of which are custom designed. Alex Gossley work within Hebble Rugs Ltd (see separate entry), specialising in the hand crafted work. Standard ranges are also available.

Tel: (0422) 68759

Lewis Street
Halifax
West Yorkshire HX1 5DJ

Leslie Greaves

A husband and wife team, the Greaves's rugs are hand tufted, offering a range of designs often with carved, sculpted effects. Patterns are decorative and geometric in style. Rugs can be made to any size, colour and shape. Also

available through the Contemporary Textile Gallery.

Tel: (0663) 42784

*Shudehill
Hayfield
Via Stockport P.O.
Derbyshire SK12 5EP*

Sally Hampson

A small scale producer, Sally Hampson's work incorporates woven rugs, flat weaves, kilims and tapestries in quiet, accessible colours. Also available through the Contemporary Textile Gallery.

Tel: (01) 739 4988

*Charlotte Road
London EC2*

Celia Harrington

A small scale producer of hand tufted rugs, Celia's designs make use of the broad brush strokes of her painting style. Her rugs are colourful, busy and full of movement, influenced in style by Trinidadian culture. Celia Harrington's rugs are also available through the Contemporary Textile Gallery and Aspects.

Tel: (01) 769 6214

*Unit 203
16-48 Great Guildford Street
London SE1 OES*

Rug by Sally Hampson

Hebble Rugs Ltd

Hebble Rugs produce tufted carpets and rugs, some of which are made from 100% wool. Rugs and carpets can be made to order or taken from a standard range. Designs include plains and stippled effects.

Trade Tel: (0422) 68759

Lewis Street Mill
Halifax
West Yorkshire HX1 5DJ

Heckmondwike Carpets Ltd

Specialise in custom made Wiltons and Axminsters; carpets are made according to customers' designs and colours or can be made from their standard ranges. Most are from 80/20 wool/nylon mixes; Heckmondwike Carpets also have a 100% Brussels loop pile Wilton, and can make 100% wool carpet to order. Their sister company is Heckmondwike Fibre Bonded Carpets, producing fibre bonded qualities.

Trade Tel: (0924) 456271

Mill Street West
Dewsbury
West Yorkshire WS12 9AE
Tlx: 557263

Twill blankets by Wendy Jones

Wendy Jones

A small producer of hand woven rugs on a countermarch rug loom, who uses a linen or worsted warp and a single two-ply weft in a double weave technique, based in either double plain or twill weaves. The results are exceptionally hard wearing rugs, with a reversible design. Rugs are available through exhibitions, direct from the designer, the British Craft Centre or the Independent Design Federation (see separate entry).

Tel: (0732) 810420

Gage House
Long Mill
Plaxtol
Kent TN15 ORA

International Wool Secretariat (IWS)

The IWS aims to increase demand for wool worldwide; it has almost forty offices in wool-producing countries in the Southern Hemisphere. Wool products are also encompassed, including carpets, rugs and wall hangings. The IWS Development Centre in Yorkshire plays an essential role in the development of new products and provides the wool textile industry with a wide range of design,

styling, marketing and technical services. The IWS identifies both local and global market trends and advises accordingly. More competitive uses are found and new qualitites developed, such as machine washability, wide ranges of colours and flame resistance. The Interior Textiles Group at the IWS Centre assists manufacturers at every stage of production. It evaluates new ideas, provides design consultation and formulates a colour forecast. The *Deep Secrets* colour forecast for 1988 can be seen at IWS branches and most major trade fairs.
See also under *Wool; Reference*

Tel: (01) 930 7300

Wool House
Carlton Gardens
London SW1Y 5AE
and
IWS Development Centre
Valley Drive
Ilkley
West Yorkshire LS29 8PB
Tel: (0943) 601555

Kinnasand UK Ltd

See under *International*

Elizabeth Kitching

A small scale producer of hand tufted rugs and wall hangings. Originally inspired by the works of Miro, the rugs are strong in design and often

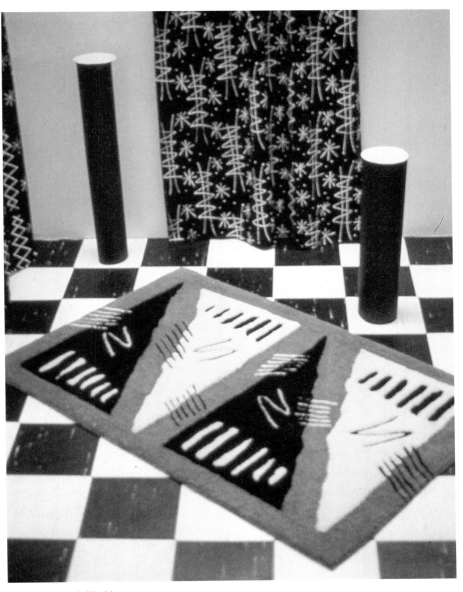

Rug by Elizabeth Kitching

subtle in colour. (See separate entries under Aspects & CTG)

Retail *Tel: (01) 671 4993*

22 Rastell Avenue
London SW2 4XP

Lister & Co Plc

Produce traditional hearth rugs from 100% wool, and bathroom carpets. Lister also produce a children's range.
See also under *Children's Fabrics*

Trade *Tel: (0274) 494188*

Manningham Mills
Bradford
West Yorkshire BD9 5SH
Tlx: 51658

Lyle Carpets Ltd

Tufted carpets from 80/20 wool/nylon mix for contract and domestic.

Trade *Tel: (023 67) 25551*

42 Toll Park Road
Ward Park East
Cumbernauld GV8 0LW
Scotland
Tlx: 77530

Hugh Mackay Plc

A large and highly respected company, Hugh Mackay has a wide range of output. Contract quality Wiltons, Axminsters and tufted carpets are available; Mackay has experience in all markets, from traditional based designs to special qualities including Wiltons woven in fluorescent yarn, ideal for discotheques.

Trade *Tel: (091) 386 4444*

PO Box No 1
Dragon Lane
Durham City
County Durham DH1 2RX
Tlx: 53327
Fax: (091) 384 0530

McMurray Connemara

One of the best producers of hand tufted custom made carpets, rugs and wall hangings, the quality of wool and craftsmanship is second to none. Among the most interesting rugs and wall hangings is the wall hanging for the Irish Institute of Research and Standards, Dublin. A section of this wall hanging comprises a stylised representation of a factory machine, together with a large wheel and pistons. Carpets include a commission for the panoramic Sitting Area, Royal Palace, Jeddah, and rugs for hotels and reception areas in New York, San Diego, Bahrain and London. McMurray Connemara are marketed through Munster Carpets.

Trade *Tel: (010 353) 95 41010*

Moyard
County Galway
Republic of Ireland
Fax: (095) 41083

Agent:
4B Strathfield Gardens
Barking
Essex IE11 9UL
Tel: (01) 591 0631
Tlx: 893126

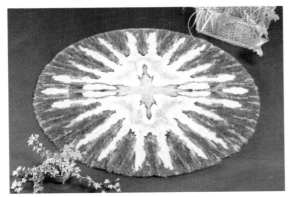

Rug by Morgan & Oates

Macroom Carpets

Hand woven carpets with good selection of colour, texture and size, these use natural colours or soft, pastel and tweed tones. Designs include stripes, herringbone style patterns and flecks. All are from 100% wool.

Trade *Tel: (010 353) 26 41140*

*Macroom
Co Cork
Republic of Ireland
Tlx: 76093*

Manx Carpets

Specialise in twist pile tufted carpets, all plains, in twenty four standard colours. Thirteen ranges are available, the best quality being the Super Berber Twist, very hardwearing and suitable for contract use.

Trade *Tel: (0254) 583330*

*Syke Mill
Belthorn
Blackburn
Lancashire BB1 2NN
Tlx: 635625*

Mercia Weavers

Top quality customized Wilton carpets, Mercia also has a large range of standard colour and patterns. All are carpets woven to order.

Trade *Tel: (09285) 64050*

*57 Brindley Road
Runcorn
Cheshire WA7 1PS
Tlx: 629805
and
38-40 Eastcastle Street
London W1
Tel: (01) 631 4421*

Merino Carpets Ltd

Specialise in plain tufted carpets, all of which are made to order. 100% wool and 80/20 mix available; Merino are geared to the domestic market but do have contract heavy duty weights and qualities.

Trade *Tel: (0747) 860059*

*Quarry Fields
Mere
Wiltshire BA12 6LA*

Morgan & Oates

Among the best of contemporary rug designers,

CARPETS & RUGS

Morgan and Oates are small producers of hand woven and tufted rugs, made individually to order. Abstract and modern in design, Morgan and Oates are well-respected for their designs. Their work is also available through the Contemporary Textile Gallery.

Tel: (0531) 2718

Church Lane
Ledbury
Herefordshire HR8 1DW
Tlx: 35405 M/OTEX

Munster Carpets Ltd

Manufacturers of quality plain and patterned single-frame Wilton carpets and custom designed Wiltons using 100% wool and wool mixes. Munster Carpets also market the superb MacMurray Connemara rugs and carpets.

Trade *Tel: (0001) 613167*

Stephen House
7/8 Upper Man Street
Dublin
Republic of Ireland
Tlx: 93489
Fax: (0001) 612829

Agent:
4B Strathfield Gardens
Barking
Essex IE11 9UL
Tel: (01) 591 0631/594 2033

Newhey Carpet NFG Co Ltd

Axminster carpets, available in 80/20 wool mix; the best quality is the *Newmarket Special*, grade five very heavy wear. Newhey are geared for domestic and contract markets, and carpets can be made to order to customer specifications.

Trade *Tel: (0706) 846375*

Station Yard
Gordon Street
Newhey OL16 3SL
Fax: (0706) 842979

Next Interiors

Next Interiors have three ranges of carpets made exclusively for them by Tomkinsons of Kidderminster. These are *Plain* (five colourways); *Mosaic* (six colourways); and *Colourpoint* (six colourways). All carpets are stain resistant.
See also under Cotton Prints; Cotton Weaves; Linen Union

Ask for Customer Services
Tel: (0533) 866411

Head Office:
Desford Road
Enderby
Leicestershire LE9 5AT
Tlx: 34415 NEXT G
Fax: (0533) 848998

Pendle Carpets Ltd

Tufted carpets in 80/20 wool mix, plains and modern geometric ranges available. Designs can be made order.

Trade *Tel: (0200) 27321*

Riverside Mill
West Bradford
Clitheroe
Lancashire BB7 4TT
Tlx: 635747

Pennine Fullwool Carpets

Provide custom made tufted carpets in any width and length, in a standard range of colours or can dye to customer specification. Office and heavy wear range are the twist piles, from 80/20 wool/nylon mix. All others are from 100% wool; velvets (40-100oz); twist (34-90oz); and saxonies and shag piles (up to 12 oz) are available. Pennine Fullwool also have a hand tufting service, for rugs and borders to customer design, again from 100% wool.

Trade *Tel: (0282) 861400*

Pave Sheds
Trawden
Lancashire BB8 9QT

Penthouse Carpets Ltd

Tufted carpets; their best qualities in 100% wool

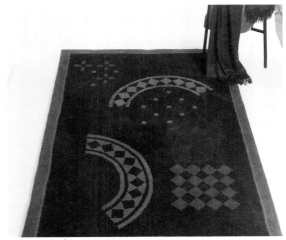
Rug by Morgan & Oates

are the shag pile range, *New Studio; Supreme* and *Supreme Delux* ; these can also be made into rugs, and all the above ranges can be dyed to suit customer requirements. Other ranges available for heavier use, including the 80/20 wool/nylon mix in the twist tufted ranges.

Trade *Tel: (0706) 341231*

Buckley Carpet Mill
Buckley Road
Rochdale L12 9DY

Vanessa Robertson

A small scale producer of warp dyed woven rugs in soft, abstract one-off designs using worsted wool and excellent colour combinations; Vanessa Robertson has recently enjoyed a great deal of success in Britain and abroad. Customers can choose designs and colourways from a catalogue, or Vanessa can visit the house and assess the requirements and design appropriate to the space and decor. Some of her most successful work has come out of her own interpretation of

the customer's interiors, as she has an exceptional eye for colour and design.

Tel: (0803) 865027

Apple Barn
Week Dartington
Totnes
Devon

Ryalux Ltd

Tufted carpets for domestic and contract; the best qualities are the 100% wool available in Ryalux Shag pile and New Ryavelvet Royale; heavy duty weights are avaialable in the Ryatwist Royale, grade 6; carpets and plains of berbers and colours can be made up to customer specifications.

Trade *Tel: (0706) 54211*

Ensor Mill
Queensway
Castleton
Rochdale
Lancashire OL11 2NU
Tlx: 635365

Arthur Sanderson & Son Carpets

Tufted carpets; 100% wool in the *Deep Velvet* and *Deep Velvet Hostess* ranges; 80/20 wool/nylon blends available in their twist pile *Super Hostess*. Patterns available to a limited extent. *Whisper* range is 100% nylon, primarily

Rug by Caroline Slinger

for the bedroom, with minimum quantities of 12,000 square yards. Special designs and colours can be made up.
See also under *Chintz; Cotton Prints; Cotton Weaves; Linen Union*

Tel: (01) 636 7800

52 Berners Street
London W1

Shaw Carpets

Available to the domestic market through retail outlets, Shaw Carpets produce 100% nylon tufted carpets, from light weight loop to high quality cut pile qualities. Shaw Carpets etch designs into the carpet, producing a sculpted effect. Carpets are printed.

Tel: (0226) 390390

P.O. Box 4
Darton
Nr Barnsley
South Yorkshire S75 5NH
Tlx: 54365

Rug by Caroline Slinger

Shelley Textiles Ltd

Scatter rugs, washable bathroom rugs and traditional hearthside rugs, from a range of fibres, including 100% wool, mohair, nylon mixes. Also rugs in cotton.

Trade　　　　　　　　　　　*Tel: (0484) 604336*

Woodhouse Mills
Shelley
Huddersfield
West Yorkshire HD8 8LU
Tlx: PRIMA G51418
Fax: (0484) 538186

Signature Rugs

Produce hand tufted rugs in superb designs and colours.

Tel: (0422) 845075

Croft Yard Mill
Hebden Bridge
West Yorkshire HX7 8AS

Caroline Slinger

Small scale producer of carpets and wall hangings from 100% wool. Caroline Slinger specialises in sculpted pile carved to achieve as much three dimensional effect as possible. Roughly half of her work is wallhangings, the most prestigious commission was for the Queen Elizabeth II Conference Centre, completed last Year. The carpets are designed specifically to order Generally speaking, the largest size available is 10ft square.

Trade　　　　　　　　　　　*Tel: (0244) 390766*

Canal Warehouse
Whipcord Lane
Chester CH1 4DE

Steeles Carpets

Steeles produce excellent quality carpets, with facilities to make virtually anything to order. Steeles are particularly well known for their designs. Ranges in the Wilton carpets include the standard carpets and facilities to design to order. Both 100% wool Brussels Wilton and 80/20 wool/nylon blends are available in a choice of 80 colourways, suitable for heavy contract use (grade five). Steeles' Axminster ranges include *Country Border* and the *Voysey Range*. The latter is based on the archive Voysey designs, dating from the turn of the century; Steeles have chosen Voysey's finest and most influential work, which can be re-coloured to meet designers' individual requirements. The Axminsters are suitable for heavy contract usage (grade five). The tufted ranges include *Royal Court*, *Motel* and *Motel Delux*,

in 60/40 wool/nylon blends, for medium contract such as offices. Steeles also have a 100% man made fibre range, *Mar de Gras*.

Trade Tel: (01) 288 6138

Business Design Centre
52 Upper Street
London N1
and
The Carpet Mill
Barford Road
Bloxham
Oxfordshire OX15 4HA
Tel: (0295) 720556
Tlx: 837664

Stockwell Riley Hooley Ltd

Stockwell carpets date back to the 18th century; Stockwell Riley Hooley also produce wall hangings. Their *Country House* collection of designs is a fine Brussels weave Wilton in 100% pure new worsted wool, available in standard ranges or special colours and borders. Stockwell Riley Hooley are known for their excellent designs.

Trade Tel: (01) 580 5935

67a Great Titchfield Street
London W1P 7FL
Tlx: 299247

Stoddard Carpets Ltd

Ideal for office and contract work, Stoddard Carpets produce Axminster and Wilton carpets,

Carpet by Tankard Carpets Ltd

Carpet by Stoddard Carpets Ltd

and the Design concept carpet tiles, which are velvet pile bonded carpet tiles for heavy contract areas. Their *Design Concept* carpet tiles won the 1986 Contract Fabrics and Furnishing section of the Design Council Award. Special colours and designs can be supplied to order. Stoddard also have a versatile Axminster service, offering a made to order custom designed and coloured carpet facility; any quality and weight can be made. Axminsters are available in 80/20 nylon/wool mix or 100% Tactess. Wiltons either from 100% wool or 80/20 wool/nylon mix, available as plains only.

Trade Tel: (0505) 27100

Glenpatric Road
Elderslie
Johnston
Renfrewshire PA5 9UJ
Scotland
Tlx: 77237
Fax: (0505) 35528
and
Business Design Centre
52 Upper Street
Islington
London N1 OQH
Tel: (01) 288 6142/6143
Fax: (01) 359 4601

The Coral Stephens Collection

See under *International*

Tankard Carpets Ltd

Tankard Carpets specialise in Wiltons, available from standard ranges and can be made to customer specifications. Carpets are from 80/20 wool/nylon mix, and suitable for heavy contract work. Tankard also have a small Axminster range made to order.

Trade *Tel: (0274) 495646*

York Mills
York Street
Fairweather Green
Bradford
West Yorkshire BD8 OHR
Tlx: 517881G
Fax: (0274) 370543 - Relay BSB UK

Malcolm Temple Design Ltd

Unmistakable in colour and design, Malcolm Temple is a small scale producer of bright, primary coloured hand tufted carpets using modern, abstract designs. His work is also available through the Contemporary Textile Gallery.

Tel: (01) 373 6122

36c Trebovir Road
London SW5 9NJ

Rug by Malcolm Temple Design Ltd

Rug by Malcolm Temple Design Ltd

Blue Brocade by Tompkinson Carpets Ltd

Tintawn Ltd

Tufted carpets; 12 ranges available in different colourways. Their best qualities are the Wool *Velvet* and *Spice*, both 100% wool (the latter is designed to contrast specifically with Osborne & Little fabrics). *Lattice Weave*, a patterned carpet, is also excellent, from 50/50 wool/acrylic blends. Heavy contract use carpets also available in other ranges.

Trade	Tel: (01) 847 3671

142 Clocktower Road
Isleworth
Middlesex TW7 6DT
Tlx: 9413163

Tomkinsons Carpets Ltd

Tomkinsons offers domestic quality carpets, and manufactures exclusive ranges for Designers Guild, Habitat and Next Interiors. Standard ranges are Axminster carpets from 80/20 wool/nylon mix and tufted carpets of 60/40 wool and man made fibres, and 100% meraklon, also a man made fibre. Contract work is carried out by the sister company, Steeles Carpets.

Trade	Tel: (0562) 745771

PO Box 11
Kidderminster
Worcestershire DY10 2JR

Trafford Carpets Ltd

Axminster and Wilton carpets from 80/20 wool/nylon mix. The Axminster carpets are available either in their standard ranges or from their Customer Design Service. Superb qualities are available, up to grade 6-7, suitable for hotels, airports and very heavy contract uses. Wiltons are available in velour and velvet piles, twist and hard twist.

Trade	Tel: (061) 872 1665

Mosley Road
Trafford Park
Manchester M17 1PX
Tlx: 666851

Ulster Carpet Mills Ltd

Axminster carpets in twenty standard qualities, from modern geometric to traditional designs in 80/20 wool/nylon mix. Their Custom Plan range can incorporate customers' own designs and colourways with minimum quantities of 100 square yards of 36 feet body width. Ulster Carpets also produce Wiltons in twist and velvet plain ranges. All carpets are suitable for the contract carpet sector. The Castleisland

Lattice Weave by Tintawn Ltd

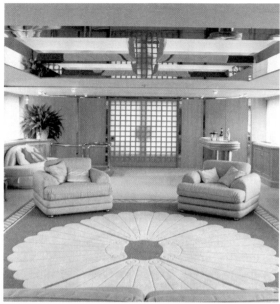

Rug by V'Soske-Joyce

Weaving Company is a subsidiary of Ulster Carpet Mills (see under *Wool*).

Trade *Tel: (0762) 334433*

Ulster Carpet Mills Ltd
Castleisland Factory
Portadown
Craigavon BT62 1EE
Northern Ireland
Tlx: 74154 CARPET G

Victoria Carpets Ltd

Victoria produce the *Super Wyndham* grade A, top quality Wilton carpet, in plain colours; also available is a selection of three standard ranges of Axminster carpets or custom design service. All grades, designs and colours can be catered for. Tufted carpets in plains or berbers, twists and velours also available. Axminsters and Wilton ranges are in 80/20 wool/nylon mixes; the tufted ranges are in a variety of blends.

Trade *Tel: (0562) 823400*

Green Street
Kidderminster
Worcestershire DY10 1HL
Tlx: 336221
Fax: (0562) 822679

V' Soske-Joyce

Considered by many to be among the very best carpet and rug producers in Britain, V' Soske-Joyce specialises in custom designed hand-tufted carpets, rugs and wall hangings. Colours can be matched; hand dyeing takes place in Oughterard, West Ireland; borders and central designs are tufted into the carpets as one piece of shearing and incision work takes place in the hands of some of the best craftsmen in Britain. V'Soske Joyce is also able to produce a range of semi-machine made carpets allowing clients to have a plain carpet produced to any shade up to 10 metres wide in room shapes without seams. An infinite variation of finishes is available, including loop, partial shear, velvet, one level or more carving embossing.

Trade *Tel: (01) 724 0182*

54 Linhope Street
London NW1 5HL
Tlx: 335269 COMET G

Trellis by Wilton Royal

Wilton Royal

Wilton Royal has woven carpets on the same site since 1655. Wilton Royal produces magnificent Wiltons (a *Wilton* carpet denotes the type of weave rather than the town: not every Wilton carpet comes from the Wilton Royal factory) and Axminster carpets; there are also facilities for tufted carpets and tiles, and a huge range of fibres for all contract and heavy wear usage. Their Wiltons and Axminsters are a by-word for luxury; however, the tufted carpet ranges account for 85% of their production. The well established tufted ranges, available in plains, berbers, textures and patterns are: *Charter*, *Crest*, *Guild*, *Crystal*, *Merit* and *Professional*.

Trade Tel: (0722) 742441

The Wilton Royal Carpet Factory Ltd
King Street
Wilton
Salisbury
Wiltshire SO2 0AY
Tlx: 47534

History of Wilton Royal

Probably the oldest carpet factory in the world Wilton Royal's fortunes have been linked closely with the family of the Earl of Pembroke, whose family seat is Wilton. The factory was built in 1655 as an assembly room for the weavers who, as in the silk weaving business in Spitalfields, worked from home. At this time, carpets were rare, valuable objects, used as wall hangings, and were either Oriental or English imitations of Oriental carpets. Carpets were, generally speaking, tapestries, or made from 'Turkey work', a knotting technique popular throughout the 16th and early 17th centuries. Later embroidered carpets were seen in larger houses. Hand knotting was laborious, time consuming and unprofitable; the quality of English manufacture was also poor compared to the French and Oriental work. This was noted by the Earl of Pembroke, who, at the end of the 17th century, smuggled two master weavers from France to Wilton - Anthony Dufosse and Peter Jemaule - in wine barrels. Dufosse and Jemaule revolutionised the carpet industry, developing the manufacture of Wilton cut pile on a loom. Carpets could be produced faster, and cheaper, than ever before. A fire in 1769 stopped trading for a time; this proved no long term hardship, and in 1835 the Earl of Pembroke bough out the Axminster factory in Devon. Their looms, ancilliary equipment and many of the weavers all arrived at Wilton, leaving Wilton Royal the Axminster carpet

CARPETS & RUGS

Wilton Royal

legacy. Surprising - because the carpets produced were all hand woven, superbly thick and appearing in glowing colours - the company alternated between boom and depression. In 1905 Yates and Co (as Wilton Royal was then known) went bankrupt; the current Earl of Pembroke again saved the factory. A consortium was formed by him and others, controlling the company until 1944, when it was bought by the Solent Carpet Company. In 1968 the Wilton Royal Carpet Factory Ltd was formed.

Woodward Grosvenor & Co Ltd

Woodward Grosvenor was founded in 1970 by Benjamin Grosvenor, and is famous for producing some of the best quality worsted Wiltons in Britain. Equally well-known is the superb design definition; standard ranges are available, together with facilities to meet customers' specific styling requirements either from their library of designs, or from the customers' own. Woodward Grosvenor's archives date from their library established in 1790, and include particularly comprehensive documents of the whole of the 19th century, from grand Victorian designs to Art Decor and modern schemes of this century. 216 standard colours are available; precise matching can be achieved through their dyehouse. High quality Axminsters are also available, including their new *Designer Spectrum* scheme, a stock Axminster range woven in the Gresham quality (grade B). A range of eight small scale designs is available together with a series of eight interchangeable borders. The *Gresham '87* contract Axminster range is suitable for pubs and clubs. Their *Heritage Collection* is a range of authentic period designs, many signed and dated by the original creator, taken from the company's archives.

Trade *Tel: (0562) 745271*

Stourvale Mills
Kidderminster
Worcestershire DY10 1AT
Tlx: 335433

Hand tufted rug Helen Yardley

Helen Yardley

A small scale producer of hand tufted rugs, Helen Yardly is extremely well respected and takes on a wide variety of commissions. Her designs were originally based on calligraphic motifs, and include modern abstract designs. Also available through the Contemporary Textile Gallery.

Tel: (01) 403 7114

A-Z Studios
3-5 Hardwidge Street
London SE1 3SY

ANTIQUE FABRICS

For those interested in authentic laces, silks, curtains, wall hangings, paisleys, samplers, tapestries, aubusson and trimmings, both specialist antique fabric dealers and those with occasional pieces are included within this section.

Meg Andrews

Offers a wide variety of fabrics, including hangings dating from the 18th-19th centuries and Chinese decorative textiles. By appointment only.

Tel: (0582) 460107

20 Holly Bush Lane
Harpenden
Herts AL5 4AT

The Antique Textile Company

Specialise in large, single pieces of antique fabrics, including chintzes and Toiles de Jouy from the mid-18th century; cotton prints of the early 19th century; and, when available, Spitalfields silks and damasks. Other items include caddow work covers, bedspreads, curtains, decorative pieces (such as screens) and linen.

Tel: (01) 221 7730

100 Portland Road
London W11

Geoffrey Bennison

Antique needlework; crewel work; silk and curtain fabric.

Tel: (01) 730 3370

91 Pimlico Road
London SW1W 8PH

Bernadout & Bernadout

Primarily carpets, antique Oriental; however, Bernadout and Bernadout do have a small selection of needlework and tapestry.

Tel: (01) 584 7658

7 Thurloe Place
London SW7 2RX

Joanna Booth

Tapestries, needlework, silks and damasks from the 16th-17th centuries; also tassels.

Tel: (01) 352 8998

247 Kings Road
London SW3 5EL

British Antique Dealers Association

Trade association; their lists of members may help those on the hunt for antique textiles. See also under *Reference*

Tel: (01) 589 4128

20 Rutland Gate
London SW7 1BD

Christina Chance

Silk pictures, embroideries, cushions, samplers. Strictly by appointment only.

Tel: (0244) 300 442

Windsor Lodge
Mickle Trafford
Chester CH2 4EA

17th century tapestry available through Joanna Booth

Celia Charlottes

Offer lace, linen, textiles, samplers, period costume, christening gowns, tapestries, veils and wedding accessories, oriental items and heavy guilts.

Tel: (0273) 473303

7 Malling Street
Lewes
East Sussex BN7 2RA

Christie's

Christie's have several sales throughout the year for all kinds of fabrics. Approximately four times a year they have sales for patchwork quilts; once a month there are sales for laces, linens, samplers and embroidered pictures; three times a year there are sales of Oriental and Islamic fabrics, including those from the Middle East and Central Asia; four times a year there are sales for fans; and four times a year there are sales of fine costume and needlework from the 17th-18th centuries, including exceptionally good quality fabrics, and, when available, Fortuny dresses.

Tel: (01) 581 2231

85 Old Brompton Road
London SW7 3LD
Tlx: 922061
Fax: (01) 584 0431

Close Antiques

Specialise in samplers, mainly English, from the 17th century to about 1840, and offer patchwork quilts and paisley shawls.

Tel: (096 273) 3131

32 East Street
Alresford
Hampshire SO23 9HA

Julie Collino

Interesting and unusual pieces of furniture, fabrics, ceramics and general decorative items, shawls, samples, tapestry pictures, patchwork quilts, cushions, embroideries. Also a good selection of paintings, watercolours and etchings.

Tel: (01) 584 4733

15 Glendower Place
South Kensignton
London SW7

Alistair Colvin

Offer mainly Victorian textiles and trimmings.

Tel: (01) 370 3025

116 Fulham Road
London SW3

Belinda Coote

Belinda Coote has antique chenilles, paisleys and shawls from the 19th century. There is also a wonderful range of reproduction French tapestries, woven in exquisite colours in traditional designs.

Tel: (01) 937 3924

French Tapestries & Antiques
29 Holland Street
London W8 4NA

Pamela Elsom Antiques

While not specialising in antique fabrics, Pamela Elsom sometimes carries the occasional antique bedspread, Victorian linen or paisley.

Tel: (0335) 43468

5 Church Street
Ashbourne
Derby

Joan Eyles Antiques

Textiles up to 1930 - bedspreads, patch works, white wear, shawls, curtains and cushion materials.

Tel: (090 12) 3357/2487)

The Stone Yard
Fishergate
Boroughbridge
York YO5 9AL

556 Antiques

Specialise in plaid shawls and cushions made of 18th century tapestries; other pieces include 19th century quilts from the USA, England and Wales; paisley, 19th century wool shawls and a few silk paisleys; needlepoint and beadwork cushions and antique fire screens.

Tel: (01) 731 2016

556 Kings Road
London SW6 2DZ

S Franses Ltd

Tapestries, carpets, needleworks and embroideries; some date back to the 16th century (some earlier). The majority of the textiles are from the 17th-18th centuries.

Tel: (01) 235 1888

82 Jermyn Street
London SW1Y 6JD

Victor Franses Gallery

Carpets, rugs and tapestries from 19th century

(some earlier) from China, East Turkestan and Europe. Victor Franses also carries some English needlework.

Tel: (01) 629 1144

57 Jermyn Street
London SW1Y 6LX

Gallery of Antique Costumes & Textiles

One of the best shops for decorative accessories and fabrics. The Gallery of Antique Costumes & Textiles carries virtually every kind of accessory possible, and well worth visiting. Dating from 17th century, the collection includes trimmings, tapestries, wall hangings, woven fabrics and patchwork quilts.

Tel: (01) 723 9981

2 Church Street
London NW8

Great Malvern Antiques

Offer a cross section of decorative antiques up to 1930, including quilts, bed covers, pelmets, tapestries, tapestry pictures, beadwork and 19th century upholstery fabrics.

Tel: (06845) 5490

6 Abbey Road
Malvern
Worcestershire WR14 3HG

Linda Gumb

European textiles and decorative objects, including aubussons, needlework, paisley shawls, cushions and curtains from the 18th-19th centuries.

Tel: (01) 354 1184

19 The Mall
359 Upper Street
Camden Passage
London N1

B B Harris Antiques

Oddments, including aubussons, curtains, tapestries and cushions dating from the 17th century.

Tel: (0488) 83382

The Sale Room
Church Street
Hungerford
Berks RG17 0JG

Heraz

Antique fabrics dating from the 16th century from all over the world, including tapestries and cushions.

Tel: (01) 245 9497

25 Motcombe Street
London SW1

Heskia

Oriental antiques, carpets and tapestries.

Tel: (01) 629 1483

19 Mount Street
London W1Y 5RA

Paul Hughes

Offers fabrics from 3rd century Greek and Roman to fabrics from the 1950's. Fascinating collection, and well worth visiting. Phone for an appointment.

Tel: (01) 229 1927

Antique & Ancient Textiles
3a Pembridge Square
London W2 4EN

Huntington Antiques Ltd

Occasionally offer a small collection of wall hangings and tapestries.

Tel: (0451) 30842

The Old Forge
Church Street
Stow-on-the-Wold
Cheltenham
Gloucestershire GL54 1BE

Paul Jones

Excellent collection of antique textiles. Fabrics range from 17th century silk curtains to William Morris collections; also tapestries, needlework and trimmings.

Tel: (01) 351 2005

183 Kings Road
London SW3

H Keil Ltd

Continental and English tapestries of all sizes from 17th-18th centuries. Also carpets and rugs.

Tel: (0386) 852408

Tudor House
Broadway
Hereford and Worcester WR12 7DP

Leonard Lassalle (Antiques) Ltd

Specialise in 17th century antiques, which include fabrics, tapestries and needlework. The main interest of the company is in interior decorating of a highly specialised nature, including fresco painting.

Tel: (0892) 31645

21 The Pantiles
Tunbridge Wells
Kent TN2 5TD

London and Provincial Antique Dealers

Has lists of members and can assist and advise on those who produce antique fabrics.

See also under *Reference*

Tel: (01) 584 7911
3 Cheval Place
London SW7 1EW

Loot

19th century quilts, curtains, needlework and hangings.

Tel: (01) 730 8097
767 Pimlico Road
London SW1W 8PR

Lots Road Galleries

Auctions held every Monday evening; catalogue and viewing every morning and all day Monday.

Tel: (01) 351 7771
71 Lots Road
London SW10 0RN

Lunn Antiques

Offer mainly lace and linen, paisley shawls, oriental textiles and patchwork, also English marcella bedcovers.

Tel: (01) 736 4638
86 New Kings Road
Parsons Green
London SW6 4LU

McKinney Kidston

A recently opened shop offering all things to do with curtains, both antique and modern. Curtain fabrics, trimmings, poles, pelmets and gesso mouldings are available. Cath Kidston or Shona McKinney will visit the home and suggest ideas, sketches and styles for those requiring advice or help. Phone before visiting.

Tel: (01) 225 0039
First Floor
184 Walton Street
London SW3

Market Place Antiques

A large shop, selling 19th century quilts, linens and shawls.

Tel: (0491) 572 387
35 Market Place
Henley on Thames RG9 2AA

Mayorcas Ltd

A marvellous collection of European textiles and carpets from the 18th century and earlier. These include Elizabethan embroideries and silks from the Spitalfields silk industries of the 18th century.

Tel: (01) 629 4195
38 Jermyn Street
London SW1Y 6DN

Philips

Hold auction sales once a month for antique textiles, including embroideries, Oriental fabrics, laces and linens. Viewing two days before the sale.

Tel: (01) 629 6602
7 Blenheim Street
London W1

Punch Antiques

Offer antique quilts from 1850, paisley shawls, chintz curtains (when available), cushions, beadwork, crewel work and tapestries. Punch also has a bedroom shop with such items as bedspreads.

Tel: (01) 359 5863

31 Georgian Village
Camden Passage
London N1

Peta Smyth Antique Textiles

Offers needlework, hangings, tapestry cushions and country furniture.

Tel: (01) 630 9898

42 Moreton Street
London SW1

A Stitch In Time

Samplers and needlework from 17th century until the 1880s.

Ask for Elizabeth Bradley
Tel: (0248) 81055

1 West End
Beaumaris
Anglesey
N Wales LL58 8BD

The Textile Gallery

Deal in extremely rare textiles, by appointment only. The range of textiles include early European fabrics from the 14th-15th centuries; classical carpets from 15th-16th centuries; 10th century Peruvian work; a variety of textiles from 4th, 5th and 6th centuries; Ottoman pieces from the 16th-17th centuries and, when available, English pieces. The Textile Gallery sell all over the world and, obviously, not all their stock is at their London address.

Tel: (01) 286 1747

No 4 Castellian Road
London W9

Thornborough Galleries

Mainly offer carpets and rugs; Thornborough Galleries often have kilim flat woven items and the odd fabric.

Tel: (0285) 2055

28 Gloucester Street
Cirencester
Gloucestershire GL7 2DH

Vigo Carpet Gallery

As well as dealing in Oriental rugs and carpets, Vigo Carpet Gallery also has a strong emphasis on antique European carpets; they will also take on the occassional fabric if they consider it of interest. Vigo will effect reproductions of antique fabrics to match a specific carpet.

Tel: (01) 439 6971

6a Vigo Street
London W1X 1AH

Virginia Antiques

Specialises in lace curtains, bedspreads and pillowcases. Also curtains and a few trimmings.

Tel: (01) 727 9908

98 Portland Road
London W11

INTERNATIONAL

The International section lists major companies from abroad represented in Britain, both agents and manufacturers. British companies with books from companies from overseas are also included.

Fabric and cushion by Shyam Ahuja

Shyam Ahuja

Famous for exquisite silks, cottons and dhurries imported from India, Shyam Ahuja's colours are, typically, subtle and pale shades. Qualities include upholstery weights, cotton and silks in seersucker, ikats and plains; others are embroidered or hand painted. The handwoven dhurries and handknotted carpets are reputedly made by some 18,000 expert weavers in remote hamlets across India, using wool, cotton, silk and linen. Shuttle dhurries are available in wool and cotton: rag rugs, chenille rugs and bath rugs are made in a variety of colour schemes. Tufted carpets are also available. Designs include traditional motifs such as lotus flowers, conch shells and peacocks; others are geometrical, often intricate lines and circles. The *Zaminda dhurries* employ a fine weave, using intricate designs in strong colours. These fabrics have become a byword for cool elegance and expensive understatement.

Tel: (01) 622 9372

Available through:
Brooke London Ltd
5 Sleaford Street
London SW8 5AB
Tlx: 925025 BROOKE G

Boras International (UK) Ltd

Boras International is a Swedish company, working in association with its sister company, Aurora Fabrics (see under separate entry in the British section). Boras produces primarily domestic, non-flame retardant fabrics. Cotton prints include a range of small print floral designs; a range of bright, primary designs and colours; modern geometrics on cotton satins; and a large collection of plains. Boras also has a small collection of Pyrovatex flame treated cottons. Sheers are available using modern designs, including the effective *Rapid* range, with a mass of loosely drawn lines on the cloth. Chintzes using modern floral, fruit (as in the *Tutti Frutti* range) and geometric designs are also produced.

One of the firm's ranges is the *Monster* design for children.
See also under *Childrens Fabrics*

Tel: (0283) 41521

Unit 4A
Boardman Industrial Estate
Hearthcote Road
Swadlingcote
Burton-on-Trent
Tlx: 341989

Cole & Son

Cole & Son, a British company famous for its own chintzes and wallpapers taken from document prints, also has fabrics of Pierre Balmain.
See also under *Chintz*

Tel: (01) 580 1066

18 Mortimer Street
London W1A 4BU

Creation Baumann

Creation Baumann is by tradition a weaving and dyeing company, whose origins date back to the 17th century as linen producers on the River Langete in Switzerland. Creation Baumann is a subsidiary of Baumann Weavers and Dyers of Langenthal. Baumann uses highly innovative techniques as part of its fabric production, and offers an enormous range of fabrics. One of its specialities is a knitted quality. Sheers are

Tutti Frutti by Boras International (UK) Ltd

embroidered, knitted, printed or have a burnt-out design. A wide variety of plains in over 80 colours is available. Cotton prints include a range which is sewn over to give a diagonal pleat, a ten-screen print with an all-over pattern, and ethnic style prints. Cotton and cotton mix weaves include jacquards, thick twills, pocket weaves, warp knitted fabrics, double weaves are inherently flame retardant fabrics. A small range of silk blends is also available. One of the more striking ranges includes the graphic *Traffic* design, and the new *Sherlock Holmes and*

Florito by Creation Baumann

Watson complex woven geometric check pattern. Special colours may be produced on request. All the Creation Baumann collections are entirely contemporary in design.

Trade *Tel: (01) 637 0253*

*41-42 Berners Street
London W1P 3AA*

Manuel Canovas

Offers a wide range of weaves, cotton prints and chintzes on superb quality cloth using Manuel Canovas' distinctive and idiomatic designs. Manuel Canovas is also characterised by subtle and daring colour combinations. Chintzes include the well-known *Bienaimee*, a large scale design of flowers in blue and white china vases, exquisitely drawn and almost surreal in detail. Many of the designs work on a large scale, using as many as 39 screens for one print. Florals, masculine stripes, geometrics and checks are also available. Canovas also has ranges of document prints including *Toiles de Jouy* prints, paisleys, and *Toiles de Nante*. Other designs are adapted from document prints, recoloured to jewel-like intensity in astonishing precision of graphic detail. Weaves include a range of 64 woven damasks (most of which are cotton and cotton/viscose mix); crewell style weaves; and weaves incorporating simplified floral designs. Wool and wool mixes include superb quality flannels and 100% wool satins are available; there is a huge range of plains in velvet, herringbone and moires from linen and viscose. Canovas also has a 'natural' look ranging from creams and fawns, and 'rustic' rough textured fabrics. The silk ranges, including the stunning 100% silk velvet, use wonderful colours.

Trade *Tel: (01) 225 2298*

*2 North Terrace
Brompton Road
London SW3 2BA*

Elizabeth Eaton

Elizabeth Eaton, a British company and one of the best decorators in London, produces its own ranges of fabric; Elizabeth Eaton is also the sole UK importers for Schumacher-Williamsburg fabrics and Folk Art collections,

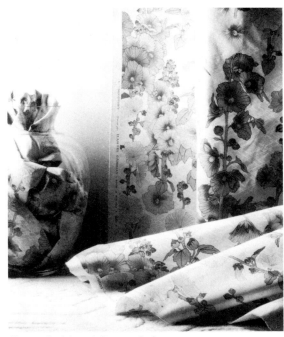

Sigourney by Manuel Canovas Ltd

Diament wallpapers and fabrics, Clarence House fabrics, Alan Campbell wallpaper and fabrics and Jones & Erwin wallpaper and fabrics.
See also under *Linen*

Trade *Tel: (01) 589 0118-9*

25a Basil Street
London SW3 1BB
Tlx: 22914 CCCG

Christian Fischbacher

A Swiss company, Christian Fischbacher is not a company for the faint at heart; modern and very bold, it carries its own ranges and several from invited designers. Fischbacher's own sheers and voiles include the delicate *Farfalla Butterflies*

Limelight by Christian Fischbacher

which appear as applique in white or pink. The new *Limelight* collection includes pearlised plastic coated cotton, giving the impression of 1970s style wet look. Fischbacher also has a collection of upholstery weight cotton weaves. Ranges from designers are the *I Relievi di Gianni Versace*, a strong, 'masculine' style collection. Some of the more stunning fabrics include the chrome threaded cotton; others are Italianate and *outre* in colour and design, ideal for city style decoration. Carl Dawson has a range of cotton

prints using marble-effects. The collections from the English design teams Collier Campbell and Munro & Tutty are listed under *Cotton Prints*.

Trade *Tel: (01) 580 8937*

42 Clipstone Street
London W1P 8AL
Tel: (01) 580 8937

Foursquare Designs

Foursquare is a British company with its own range of fabrics; it also has upholstery weight fabrics from Svartdal (Gvbrandsdalen of Norway) and cotton prints and sheers from Carlos Lepetre of France.
See also under *Cotton Prints; Lace & Sheers*

Tel: (0580) 712177

Corsehorne Barn
Corsehorn Lane
Cranbrook
Kent TN17 3NE
Tlx: 896691 TLMIR

Mary Fox Linton

As head of an extremely stylish company, top interior designer, Mary Fox Linton, imports exclusively top quality fabrics from various parts of the world. The wonderful Jim Thompson silks, imported from Thailand, are all hand woven and hand dyed, and are available in a number of different qualities. Swiss cotton, voiles and chintzes are imported from Itair, a

Rug by Toulemonde Bouchart available through Mary Fox Linton

German/Swiss company. Traditional chintz methods are used, and specialities include seersucker effects, and the graphite finishes. From Itoni come the Indian silks, some of which are brocaded. Fox Linton also has hand tufted rugs from Tisca and Toulemonde Bouchart, and designs dhurries herself.

Trade *Tel: (01) 351 0273*

249 Fulham Road
London SW3 6HY
Tel: (01) 351 0273

Anna French Fabrics

Anna French, a British company marketed through Margo International and famous for superb laces and fabrics, also has a wide range of Missoni fabrics.
See also under *Cotton Prints; Lace & Sheers*

Tel: (01) 351 1126

343 Kings Road
London SW3 5ES

Susanne Garry Ltd

Sole distributors of the Interieur/Elvo ranges of fabrics and based in Germany and Holland, Susanne Garry offers sheers, voiles, chintzes, upholstery weights, and cotton prints. The sheers and voiles are from Elvo, many of which have burnt-out designs matching the chintzes. Ranges include the original houndstooth check voile in white on white, and a choice of geometric designs, Interieur offers white cotton with four stencilled flower designs, available in primary colours and co-ordinating with the firm's plain chintzes. Chintzes include the *Glittering Perspectives* collection, comprising geometric waves of gold and silver lacquered over in a choice of six colourways. These are matched with a neutral voile, *Carrara*, which repeats the pattern. Softer in style is the *Garden Chintz Collection*, including the bold *Tulip & Poppy* design in blues and yellows on brush stroke backgrounds. Also available are furnishing weight fabrics and a heavy tapestry comprising rich colours, which is suitable as a hanging or table covering. Susanne Garry also offers a collection of screens and custom made shower curtains and bathroom blinds.

Trade
Tel: (01) 584 1091
152A Walton Street
London SW3

JAB International Furnishings

A Company producing large collections of cotton prints and polyester mixes to suit all tastes. Print designs include geometric patterns, florals and moire designs, some over printed with metallic coloured paint. Moires and moire stripes; upholstery weights; tapestries; checks and chenilles are also available. A subsidiary of the West German company, JAB has showrooms throughout Europe, supplying roughly four million metres of curtain and upholstery fabrics. JAB has a comprehensive silk collection from India; along with these are the Kashmir embroidery and other weaves. What JAB is best known for is undoubtably the plains, some of which are available in 200 colours.

Trade
Tel: (01) 636 1343
and (01) 631 0176
15-19 Cavendish Place
London W1M 9DL

Kendix Designs

Kendix, a Dutch company, shares the same showroom as Creation Baumann; yet the

company is completely separate, serving the domestic market to a much greater extent. Some flame retardant materials are available. Baumann and Kendix do however use similar innovative approaches to fabric production, and both have in-house designers. Kendix offers a large range of voiles and sheers; cotton prints include room high panels, in which the design occupies the entire drop length of the fabric. These include *Mare*, a stylised palm tree arrangement; *Delta*, comprising darkened rushes in the foreground looking over a stretch of water; *Duna*, a colourful sandscape using crayon-like grass designs; and the striking *Serres*, an extremely effective architecturally inspired view down a white tiled corridor with palm trees extended along its length. Other fabrics available include jacquards, cotton weaves and pocket weaves, and a vast number of plains.

Trade *Tel: (01) 637 0253*

41/42 Berners Street
London W1P 3AA

Kinnasand UK Ltd

A Swedish company, marketed by Ploeg (see below) Kinnasand produces fabrics with a distinct Scandinavian feel; the design team is constantly producing new ranges using geometric, modern motifs. Collections include its sheers and semi-sheers (such as the geometric squares and stripes of *Dolomit*, *Klitter* and *Dover*); cotton prints; upholstery weights and polyester Trevira CS. All fabrics co-ordinate in colour with their existing ranges. Kinnasand also produces an exclusive collection of 100% wool hand knotted rugs in modern, geometric designs in primary and pastel colours.

Trade *Tel: (01) 636 7402*

45-46 Berners Street
London W1P 3AD

Ian Mankin

Ian Mankin is a British company producing a range of their own fabrics, and stocks a selection of superb quality cottons imported from India and Egypt.
See also under *Cotton Prints; Cotton Weaves; Lace & Sheers*

Tel: (01) 722 0997

109 Regents Park Road
Primrose Hill
London NW1 8UR

Marvic Textiles

Marvic produces a stunning collection of jacquards, damasks, dobby weaves and printed moires, as well as cotton prints and chintzes. Its recent moire designs include *Cascade*, a printed linen moire based on an Ikat theme, in which the pattern appears to cascade down the length of the fabric. The Italian broad striped moire design of *Alexander* is an example of the

wonderful colours Marvic uses; a soft background with olive greens and navy. Weaves include their plain fabric, *Rani,* which co-ordinates with the jaspe stripe, *Raja* (available in 44 colourways). The *Studio Collection* comprises subtle geometric designs woven into the fabric; four ranges are available using diagonal and raised patterns. *Albany* is a woven repp with a two colour dot, which co-ordinates with *Vermont,* a self-coloured geometric. Cotton prints are available, and include *Ombrage* and *Omega,* co-ordinating floral art nouveau designs; Marvic also has a range of chintzes from Waverley Schumaker in the USA. Its English range of four *Toiles* is listed under the British section. See also under *Chintz; Cotton Prints; Cotton Weaves*

Trade Tel: (01) 580 7951

12-14 Mortimer Street
London W1N 7DR
Tlx: 2331 MARVIC G

Nobilis-Fontan

Collections range from traditional provencale styles and classical French prints to more modern stripes and weaves. The *Agnes* range in linen unions with brambley prints, berries and sprigs on off-white are delightful, and very 'French'; *Toiles de Jouy* on cotton satin and chinoiserie patterns are also available. Nobilis' latest collection, *Garden Party,* comprises chintzes; of these *Pre Catelan,* a floral pattern, and *Varennes,* a wavy stripey pattern, are particularly effective.

The chintzes come with co-ordinates and weaves. The *Parade* collection comprises plains, moires and stripes; the grey and the cream backgrounds of the latter are superb. Wallpapers are also available. Nobilis-Fontan are also agents to the Italian company, Valentino.

Trade Tel: (01) 351 7878 / 352 3870

1 & 2 Cedar Studios
45 Glebe Place
London SW3 5JE

Osborne & Little

Osborne & Little is a British company, well known for its wide range of designs. Osborne & Little also has a range of fabrics produced by Etamine of France.
See also under *Chintz; Cotton Prints; Cotton Weaves; Silk Weaves; Trimmings*

Tel: (01) 352 1456

304 Kings Road
London SW3 5UH
Tlx: 881 3128
Fax: (01) 673 8254

Paper Moon

A retail company with several outlets, Paper Moon import the Waverly collection from North America, which includes the *Country Roads* and *Flower Show* collection in cotton prints; Imperial Wallcoverings and SM Hexter, also from North

America; and International Wallcoverings from Canada. Paper Moon offers French-style floral prints and classical rural effects. Some of the most interesting ranges come from Imperial Wallcoverings. Paper Moon also has its famous collection of Childrens fabrics, details of which can be given at the address below.
See also under *Childrens Fabrics*

Tel: (01) 451 3655

Unit 2
Brent Trading Centre
390 North Circular Road
London NW10 0JF

Pallu & Lake

Now sharing a showroom with Charles Hammond at the London Interior Design Centre, Pallu & Lake are agents for a wide range of companies from The USA and Europe, producing exceptionally exotic and unusual fabrics as well as traditional chintzes and cotton prints. The LIDC is an excellent venue for the interior designer, styled as 'Europe's only one-stop resource centre, the showroom provides a day's worth of browsing for ideas. Companies represented include the superb weaves from Etro, an Italian company, offering paisleys woven in wool and silk, using rich reds and golds, and exclusive damasks and jacquards available in glorious designs and colours. Gretchen Bellinger, from the USA, offers unusual and often stunning interpretations of natural fibres.

La Dame du Lac available through HA Percheron

Wool fabrics include *Martinique*, an exquisitely fine merino cloth. Mohair fabrics include the superb *La Scala*, 100% mohair plush; silks include sheers dotted with rhinestones; *Mazurka*, a silk cloque; the fine pleated *Isadora* and scrumpled-effect *Sylphide*. Linens include *Pasha*, a 100% linen pile velvet. *Rupli*, from France, specialises in braids and trimmings. Those from England are John Boyd Textiles, Edith de Lisle and Humphries Weaving, all mentioned separately. Many other companies are represented at the LIDC, and can be seen at the showroom.

Trade

Tel: (01) 627 5566

London Interior Design Centre
1 Cringle Street
London SW8 5BX
Tlx: 917976
Fax: (01) 622 4785

HA Percheron

Importers of some of the most fabulous silks from France and Italy to be seen anywhere. Lavish and extremely expensive - the most costly being *Les Doges,* a figured handloomed velvet, from the famous Venetian Rubelli house - styles are both traditional and contemporary. Aside from the Rubelli silks, Percheron offers the silks from Tassinari & Chatel, known for its reproduction work for Versailles and Fontainebleau, who, along with Prelle & Cie (imported by Tissunique) is one of the last remaining hand-weaving silk companies in France. Tassinari & Chatel also has ranges available from stock, including a range of lampas, damasks, and silk velvets. Hamot & Burger produces fine traditional brocades and silks, and percales with traditional French prints. Silk taffetas and satins, plains, traditional boucles and lampas are also available from the two companies Veraseta and Edmond Petit. Contemporary upholstery jacquards, plains and semi-plains and traditional chintzes are available from Maurice Lauer; and printed and plain voiles, silks and linen from Bisson Bruneel. Trimmings are from the Lyons house of Reymondon, offering a wide variety of items, and can provide special colouring and designs to order.

Trade *Tel: (01) 580 5156*

97-99 Cleveland Street
London W1P 5PN

Silk by Rubelli and tie back, *Bahia*, available through H A Percheron

Ploeg

Ploeg, a Dutch company, uses mainly natural fibres for all but the inherently flame proof fabrics. Sheers, cotton prints (floral and stripes), weaves and a collection of upholstery weights are all available, co-ordinating in colour with each other. On larger orders only, Ploeg can design and colour fabrics to customer specification.

Trade *Tel: (01) 636 7402*

45-46 Berners Street
London W1P 3AD
Tlx: 261119

Rich & Smith

Rich & Smith, a British company with a select range of its own fabrics, distributes exclusive ranges from Waverly Schumacher.
See also under *Cotton Prints*

Tel: (0935) 824 696

North Street Farm
Stoke Sum Hamdon
Somerset TA14 6QR

Sahco Hesslein UK Ltd

A German company, Sahco Hesslein's fabrics are characteristically, masculine in style, using textured cloth with sombre, heavy tonals. Ranges include *Valance* and the similarly produced *Karo Holiday*, where warp printed cotton polyester with a jacquard weave give a damask style pattern and chequered pattern respectively. Other fabrics include the *Nobless* stripes, textured with a damask weave behind the stripes. *Rigoletto* is an example of the kind of heavy weaves Sahco Hesslein produces, where a cotton and viscose mix give a diamond lattice effect over the stripes, Chintzes and voiles are also available, along with traditional unions and plain cotton in a huge range of colours, and a large selection of moires.

Tel: (01) 636 3552

58-59 Margaret Street
London W1N 7FG
Tlx: 22767 SAHCO G

St Leger Fabrics

A British company with its own range of fabrics, St Leger also has several imported fabrics, including the *Candie Cotton Collection*, comprising twenty seven plains and five designs hand woven in India. These are *Ticking Stripe, Herringhone, Tweed, Two-tone,* and *Checks.*
See also under *Cotton Prints; Cotton Weaves*

Tel: (01) 736 4370

68 Maltings Place
Bagleys Lane
London SW6 2BY

Serpentina and *Danza* by St Leger Fabrics

Rug by The Coral Stephens Collection

Ian Sanderson (Textiles) Ltd

Ian Sanderson is British, producing its own ranges of fabrics and carrying chintz ranges from the German company Johnnes Wellmann.
See also under *Chintz; Cotton Prints; Cotton Weaves; Lace & Sheers*

Tel: (01) 636 7800

*52 Berners Street
London W1P 3AD*

The Coral Stephens Collection

The Coral Stephens collection comprises fabrics, carpets and rugs imported from Swaziland. All these fabrics are hand carded and spun from mohair from the Angora goat (native to Lesotho), and dyed with aniline dyes. The cloth is woven by Swazi women in their own homes, many of whom have worked for Coral Stephens for many years. The range includes a wide variety of texture, colour, weave and designs; each piece is unique, and clients may choose from a range of designs at the above address, or fabrics and carpets can be woven to individual specifications. Carpets and rugs are hand sheared or available as shag pile; others are hand knotted. These unusual fabrics are ideal for those looking for natural, ethnic sytle material in combination with luxurious lustre and soft texture.

*Ask for Ruth Schlapobersky
Tel: (01) 435 1609*

*Entabeni
107 Hillfield Court
Belsize Avenue
London NW3*

Tissunique

Importers of expensive fabrics from France, Tissunique carries silks, trimmings, traditional and modern cotton prints and chintzes. Tissunique also has its own ranges, which include the *Historic Prints Collection* which comprises seven chintzes and cotton prints, taken from Lord Byron's original decorations of Castletown House in Kildare; the *Marlborough* woven fabrics; and well-known *Ceres*, comprising diamond-shape designed upholstery weaves. The *National Trust Collection* has been recreated by Tissunique and hand block printed by Prelle & Cie in Lyons. The designs are taken from six original documents found in British houses, dating from the late 18th and early 19th centuries. The colouring of the chintzes was undertaken by the English designer and decorator, David Mlinaric. The collection includes the *Erddig* range, dating from 1720, found in a house in North Wales, the design of which are exquisitely drawn sprigs of flowers interspersed with moths, insects and butterflies;

Thorpe Hall, based on a document dating from 1835; *Stamford & Stamford Borders*, taken from Dunham Massey in Cheshire; the small scale trellis pattern of *Dunham Massey*, from the property of the same name; *Castle Coole*, an elaborate chinoiserie design from James Wyatt's neo-classical mansion in Northern Ireland; and a companion fabric, *Royal Oak*, produced by Tissunique, comprising a small scale oak leaf repeat in four colourways. Tissunique also distributes the *Barrington Court Collection* from Stuart Renaissance Textiles. Trimmings include hand woven trimmings made to order; *La Passementerie Nouvelle*, in Paris, offers superb colours and blends, from rich, burning colours of *Cleopatra*, to the cool, very 'French' shades of green in the *Lauzun* range. Prelle & Cie, one of the last remaining hand weaving companies in France (along with Tassinari and Chatel, imported by Percheron), specialise in pure silk brocades and cut velvets, many made to order. Vincent Hamelin produces borders, some embroidered by hand, using ribbons, lace and silk. Chintzes and cotton prints are available from Pierre Frey.

Trade *Tel: (01) 491 3386*

10 Princes Street
London W1R 7RD

Turnell & Gigon Ltd

Agents for a select number of companies from India, the Continent and Canada, Turnell &

Weaves from Sahco Hesslein

Gigon has a distinct style, expensive, understated and sophisticated. The Italian firm, Cesari, offers damasks, lampas and exquisite figured velvets. A new range of chintzes is available in three designs; floral, paisley and a colourful damask design. Gundle Karie's chintzes are the *Hampton House* range, available in sixteen designs; others include hand-loomed cottons and silk plaids from Anne Beetz, including silk with metallic thread; silk and wool voiles; linen and viscose designs which resemble horsehair; and the traditional French cotton prints from the collection *Les Olivades*. An extensive range of trimmings from Passementeries de L Ile de France, all manufactured by traditional methods, and offering a sophisticated collection of traditional and more original designs, are available in a wide colour range. Special designs may be woven to order.

Trade *Tel: (01) 351 5142/3*

Room G/04
250 Kings Road
London SW3 5UE

Wemyss Houles

Specialists in trimmings, Wemyss originally distributed Houle trimmings from France; Wemyss Houle has since opened a showroom in the West End of London, where its extensive range of bullion fringes, cords, tie-backs, fringes and braids can be seen. All items are from stock; minimum lengths supplied are one metre (ten metres for cord).

Trade *Tel: (01) 255 3305*

40 Newman Street
London W1 4AB
Tlx: 1918205

Brian Yates

Brian Yates, a British company with its own range of fabrics, is also the sole distributor of Omexco and Arte fabrics from Belgium, and Duro fabrics from Sweden.
See also under *Chintz*

Tel: (0524) 35035

3 Riverside Park
Katon Road
Lancaster LA1 3PE
Tlx: 65264 YATES

Zoffany

Zoffany is a British company with a range of its own fabric. Also available through Zoffany are the Pierre Balmain collection of cotton sateens and chintzes, and the American Van Luit collection.
See also under *Chintz; Cotton Prints; Silk Weaves*

Tel: (01) 235 5295/7241

27a Motcomb Street
London SW1X 8JU
Tlx: 291120
Fax: (01) 259 6549

REFERENCE & INFORMATION

Useful addresses for those in the interior design or decorating trade who require more information on fabric usage and care and for those seeking North American sources for fabrics are listed in this section.

ASSOCIATIONS IN THE UNITED STATES

American Textiles Manufacturers Institute
1101 Connecticut Ave., N.W.
Suite 300
Washington, D.C. 20036
Tel: (202) 862-0500

CRI Carpet and Rug Institute
Box 2048
Dalton, GA 30722
Tel: (404) 278-3176

Decorative Fabrics Association
c/o Phillip Puschell
Schumacher & Co.
79 Madison Ave.
New York, NY 10016
Tel: (212) 213-7900

International Linen Promotion
200 Lexington Ave.
New York, NY 10016
Tel: (212) 685-0424

Mohair Council of America
499 Seventh Ave.
1606 North Tower
New York, NY 10018
Tel: (212) 736-1898

National Antique and Art Dealers Association of America
15 E. 57th St.
New York, NY 10022
Tel: (212) 826-9707

Textile Import Corporation
135 W. 50th St.
New York, NY 10020
Tel: (212) 581-2840

The Wool Bureau Inc.
360 Lexington Ave.
New York, NY 10017-6572
Tel: (212) 986-6222

North American Sources

Many of the fabrics listed in this book are available through U.S. and Canadian distributors. To locate a particular fabric producer, you can either call the British phone number to get the name of the North American distributor closest to you or you can ask the British Trade Development Office for assistance. Its address is:

British Trade Development Office
845 Third Avenue
New York, New York 10022
Tel: (212) 593-2258

The following is a listing of North American sources for many of the fabrics in the book.

Armitage Sinclair: *Lee Jofa*
Laura Ashley Decorator Collection: *Laura Ashley*
Laura Ashley Home Furnishing: *Laura Ashley*
GP & J Baker: *Bailey and Griffin; Lee Jofa; Rose Cumming*
John Boyd: *Lee Jofa*
Manuel Canovas: *Manuel Canovas*
Claridge Mills Ltd: *Clarence House*
Cole & Son: *Clarence House*
Colefax & Fowler: *Clarence House*
Cook Mills: *Clarence House*
Wendy A Cushing: *Clarence House*
The Design Archives: *Clarence House; Lee Jofa*
Designers Guild: *Osborne & Little*
Donald Brothers Ltd: *Hinson & Company*
John England: *Lee Jofa*
Fox & Floor: *Clarence House*
Foxford Woollen Mills Ltd: *Lee Jofa*
Anna French Fabrics: *Lee Jofa*
The Gainsborough Silk Weaving Company Ltd: *Lee Jofa*
Charles Hammond: *Bailey and Griffin; Clarence House; Lee Jofa; Rose Cumming*
Hill & Knowles: *Clarence House*
Humphries Weaving Company: *Lee Jofa*
John Lewis Contract Furnishings: *Lee Jofa*
Liberty of London Prints: *Liberty of London*
Peter MacArthur & Co Ltd: *Lee Jofa*
Marvic Textiles: *Clarence House*
Henry Newbery & Co Ltd: *Lee Jofa*

John Orr Ltd: *Clarence House; Lee Jofa*
Osborne & Little: *Clarence House; Osborne & Little*
Pallu & Lake: *Bailey and Griffin; Lee Jofa; Rose Cumming*
Parkettex Fabrics: *Bailey and Griffin; Lee Jofa*
Ramm, Son & Crocker Ltd: *Bailey and Griffin; Hinson & Company; Lee Jofa; Rose Cumming*
Zandra Rhodes: *Osborne & Little*
Arthur Sanderson & Son: *Arthur Sanderson & Son*
Sekers Fabrics Ltd: *Clarence House, Hinson & Company; Lee Jofa*
Textra Ltd: *Clarence House*
Titley & Marr: *Clarence House; Hinson & Company*
Warner & Sons Ltd: *Bailey and Griffin; Clarence House; Lee Jofa; Rose Cumming*

Carpets produced by the majority of the British carpet mills listed in this book are available from Stark Carpet Corporation, 979 Third Avenue, New York, New York 10022 (212-752-9000). All designs are custom Stark designs executed by the mills at Stark's direction.

Laura Ashley Decorator Collection
New York, NY 10022: *Laura Ashley Decorator Collection, 979 Third Ave. (212) 223-0220*

Laura Ashley Inc. also has retail stores in the following locations:
Alabama: *Birmingham*
Arizona: *Phoenix*
Arkansas: *Little Rock*
California: *Beverly Center, Los Angeles; Carmel Plaza, Carmel-by-the-Sea; Century City, Los Angeles; Corte Madera; Costa Mesa; Glendale; La Jolla; Palm Springs; Palo Alto; Bullock's, Pasadena; Redondo Beach; Sacramento; San Diego; Union Street, San Francisco; Sutter Street, San Francisco; San Jose/Santa Clara; Santa Ana; Santa Barbara; University Towne Center, San Diego; Walnut Creek; Bullock's, Westwood; Woodland Hills*
Colorado: *Colorado Springs; Denver*
Connecticut: *Danbury; Greenwich; Hartford/Farmington; New Haven; Stamford; Westport*

Florida: *Boca Raton; Fort Lauderdale; Jacksonville; Miami; Orlando/Winter Park; Palm Beach; Tampa*
Georgia: *Lenox Square, Atlanta; Perimeter Mall, Atlanta*
Hawaii: *Honolulu*
Illinois: *Chicago; Northbrook; Oakbrook; Old Orchard/Skokie; Woodfield/Schaumburg*
Indiana: *Indianapolis*
Iowa: *Des Moines*
Kentucky: *Lexington; Louisville*
Louisiana: *Kenner; New Orleans*
Maine: *Freeport*
Maryland: *Annapolis; Baltimore; Owings Mills; White Flint/Kensington*
Massachusetts: *Boston; Cambridge; Chestnut Hill*
Michigan: *Ann Arbor; Detroit/Novi; Grand Rapids; Troy*
Minnesota: *Edina; Minneapolis; Ridgedale/Minnetonka*
Mississippi: *Jackson/Ridgeland*
Missouri: *Kansas City; Plaza Frontenac, St. Louis; St. Louis Centre, St. Louis*
New Jersey: *Hackensack; Paramus; Princeton; Short Hills*
New York: *Albany; Manhasset; Madison Avenue, New York City; Columbus Avenue, New York City; South Street Seaport, New York City; Southampton; Stony Brook; Vernon Hills/Scarsdale; Woodbury Common/Woodbury*
North Carolina: *Charlotte; Raleigh; Winston-Salem*
Ohio: *Beachwood; Cincinnati; Worthington*
Oklahoma: *Tulsa*
Oregon: *Portland*
Pennsylvania: *Ardmore; Philadelphia; Ross Park Mall, Pittsburgh; Station Square, Pittsburgh; Reading/Wyomissing*
Rhode Island: *Providence*
South Carolina: *Charleston*
Tennessee: *Chattanooga; Memphis/Germantown; Nashville*
Texas: *Austin; Galleria, Dallas; North Park Center, Dallas; Fort Worth; Galleria, Houston; West Oaks Mall, Houston; Plano; San Antonio*
Utah: *Salt Lake City*
Vermont: *Burlington*
Virginia: *Fair Oaks/Fairfax; Regency Square, Richmond; Cary Street, Richmond; Tysons Corner/McLean; Williamsburg*
Washington: *Seattle*
Washington, D.C.: *Georgetown*
Wisconsin: *Milwaukee*
Canada: *Bayview/Willowdale, Ontario; Montreal, Quebec; Ottawa; Toronto/Etobicoke, Ontario; Hazelton Ave., Toronto, Ontario; Wilfred Laurier Ste-Foy, Quebec; Vancouver, British Colombia*

Bailey and Griffin, Inc.
Atlanta, GA 30305: *Curran Associates, 351 Peachtree Hill Ave., N.E.* (404) 233-1725
Boston, MA 02210-2340: *Fortune, Inc., One Design Center Place* (617) 350-6526
Chicago, IL 60654: *Hensel Associates, 6-120 Merchandise Mart* (312) 644-6640
Dallas, TX 75207: *Jim Barrett Associates, 620 Dallas Design Center* (214) 744-5665
Denver, CO 80202: *Kneedler-Fauchere, 1801 Wynkoop St.* (303) 292-5353
High Point, NC 27260: *Curran Associates, 1410 Danmar Ave.* (919) 889-2818
Los Angeles, CA 90069: *C.W. Stockwell, 8687 Melrose Ave.* (213) 659-9500
Miami, FL 33137: *Design West, Inc., 4141 N.E. 2nd Ave.* (305) 576-8922
New York, NY 10022: *Bailey & Griffin, Inc., 979 Third Ave.* (212) 371-4333
Philadelphia, PA 19103: *Duncan Huggins Perez, 2400 Market St.* (215) 567-3573
San Francisco, CA 94103: *Kneedler-Fauchere, 101 Henry Adams St.* (415) 861-1011
Seattle, WA 98121: *Mattoon & Associates, 1000 Lenora St.* (206) 641-5193

Manuel Canovas
Atlanta, GA 30305: *Curran Associates, 351 Peachtree Hills Ave., N.E.* (404) 233-1725
Birmingham, MI 48010: *Nancy Miklos Mason, 30215 Stelamar* (313) 540-6846
Boston, MA 02210: *Shecter Martin Ltd., One Design Center Place* (617) 951-2526
Chicago, IL 60654: *Donghia Showrooms Inc., Merchandise Mart* (312) 822-0766
Cleveland, OH 44122: *Donghia Showrooms Inc., 23533 Mercantile Rd.* (216) 831-7797
Dallas, TX 75207: *David Sutherland Inc.,*

1707 Oak Lawn (214) 742-6501
Dania, FL 33004: *Donghia Showrooms Inc., 1855 Griffin Rd.* (305) 920-7077
Denver, CO 80209: *Shears & Window, 595 South Broadway* (303) 744-1676
High Point, NC 27260: *Curran Associates, 1410 Danmar Ave.* (919) 889-2818
Houston, TX 77056: *David Sutherland Inc., 5120 Woodway* (713) 961-7886
Los Angeles, CA 90069: *Manuel Canovas Inc., 8687 Melrose Ave.* (213) 657-0587
New York, NY 10022: *Manuel Canovas Inc., 979 Third Ave.* (212) 752-9588
Philadelphia, PA 19103: *Matches Inc., 2400 Market St.* (215) 567-7830
San Francisco, CA 94103: *Donghia Showrooms Inc., 200 Kansas St.* (415) 861-7717
Seattle, WA 98108: *James Goldman & Associates, 5701 6th Ave. S.* (206) 762-2323
Washington, D.C. 20024: *Donghia Showrooms Inc., 300 D St., S.W.* (202) 479-2724
Canada: *Telio & Cie, 1390 Ouest rue, Sherbrooke, Montreal, Quebec H3G1J9* (514) 842-9116

Clarence House
Atlanta, GA 30305: *Jerry Pair & Associates, 351 Peachtree Hills Ave., N.E.* (404) 261-6337
Boston, MA 02210: *Davison's, One Design Center Place* (617) 348-2870
Chicago, IL 60654: *Rozmallin, Merchandise Mart* (312) 467-6860
Dallas, TX 75207: *Walter Lee Culp Associates, 1505 Oak Lawn* (214) 651-0510
Denver, CO 80202: *Kneedler-Fauchere, 1801 Wynkoop St.* (303) 292-5353
Houston, TX 77056: *Walter Lee Culp Associates, 5120 Woodway* (713) 623-4670
Los Angeles, CA 90069: *Kneedler-Fauchere, 8687 Melrose Ave.* (213) 855-1313
Miami, FL 33137: *Jerry Pair & Associates, 155 N.E. 38th St.* (305) 576-1938
New York, NY 10022: *Clarence House, 211 E. 58th St.* (212) 752-2890
Philadelphia, PA 19103: *Croce, 2400 Market St.* (215) 561-6160
Portland, OR 97209: *Wayne Martin, Inc., 210 N.W. 21st Ave.* (503) 221-1555
San Francisco, CA 94103: *Kneedler-Fauchere, 101 Henry Adams St.* (415) 861-1011
Seattle, WA 98108: *Wayne Martin, Inc., 5701 6th Ave. S.* (206) 763-1990
Troy, MI 48084: *Rozmallin, 1700 Stutz Drive* (313) 643-8828

Hinson & Company
Atlanta, GA 30305: *Jerry Pair & Associates, 351 Peachtree Hills Ave., N.E.* (404) 261-6337
Boston, MA 02210: *Devon Service, Inc., One Design Center Place* (617) 451-7787
Chicago, IL 60654: *Hinson & Company, 6-117 Merchandise Mart* (312) 787-5300
Dallas, TX 75207: *Walter Lee Culp Associates, 1505 Oak Lawn* (214) 651-0510
Denver, CO 80209: *Regency House, 595 South Broadway* (303) 733-6484
Houston, TX 77056: *Walter Lee Culp Associates, 5120 Woodway* (713) 623-4670
Laguna Niguel, CA 92677: *Shears & Window, 23811 Aliso Creek Rd.* (714) 643-3025
Los Angeles, CA 90069: *Hinson & Company, 8687 Melrose Ave.* (213) 659-1400
Miami, FL 33137: *Jerry Pair & Associates, 155 N.E. 38th St.* (305) 576-1938
New York, NY 10022: *Hinson & Company, 979 Third Ave.* (212) 475-4100
Philadelphia, PA 19103: *Duncan Huggins Perez, 2400 Market St.* (215) 567-3573
Phoenix, AZ 85014: *Brandt's Ltd., 4717 N. 7th St.* (602) 264-4246
San Francisco, CA 94103: *Regency House, 151 Vermont St.* (415) 626-0553
Seattle, WA 98108: *Designers Showroom, 500 S. Findlay* (206) 767-4454
Washington, D.C. 20024: *Duncan Huggins Perez, 300 D Street, S.W.* (202) 484-4466
Midwest & Central Outside Sales: *James H. Trueman & Associates, 23600 Mercantile Road, Beachwood, OH 44122* (216) 831-5038

Lee Jofa
Atlanta, GA 30305: *Curran Associates, 351 Peachtree Hills Ave., N.E.* (404) 233-1725
Boston, MA 02210-2340: *Fortune, Inc., One Design Center Place* (617) 350-6526

Chicago, IL 60654: *Lee Jofa, 1270 Merchandise Mart* (312) 644-2965
Dallas, TX 75207: *Lee Jofa, 440 Decorative Center* (214) 741-2755
Dania, FL 33004: *Lee Jofa, 1855 Griffin Rd.* (305) 925-2424
Denver, CO 80202: *Howard Mathew, Ltd., 1801 Wynkoop St.* (303) 295-7718
Detroit, MI 48070: *Kress/Tennant Associates, 26339 Woodward Ave.* (313) 548-3632
High Point, NC 27260: *Curran Associates, 1410 Danmar Ave.* (919) 889-2818
Honolulu, HI 96825: *The Fibre Gallery, 250 Kawaihae #6E* (808) 955-5468
Houston, TX 77056: *Lee Jofa, 5120 Woodway* (713) 629-5453
Laguna Niguel, CA 92656: *Lee Jofa, 23811 Aliso Creek Rd.* (714) 831-9797
Los Angeles, CA 90069: *Lee Jofa, 8687 Melrose Ave.* (213) 659-7777
New York, NY 10022: *Lee Jofa, 979 Third Ave.* (212) 688-0444
Philadelphia, PA 19103: *Duncan Huggins Perez, 2400 Market St.* (215) 567-3573
Providence, RI 02903: *Verlaine, Inc., 128 N. Main St.* (401) 274-1130
San Francisco, CA 94103: *Lee Jofa, 200 Kansas St.* (415) 626-6921
Seattle, WA 98108: *James Goldman & Associates, 5701 6th Ave. S.* (206) 762-2323
Washington, D.C. 20024: *Duncan Huggins Perez, 300 D St., S.W.* (202) 484-4466
Canada: *Craig Johnson & Associates, Inc., 462 Wellington St. W., Toronto, Ontario M5V 1E3* (416) 597-0733

Liberty of London, Inc.
New York, NY 10018: *Liberty of London, Inc., 108 W. 39th St.* (212) 391-2150

Liberty of London also has retail stores in the following locations:
Illinois: *Chicago*
New York: *229 E. 60th St., New York City*
Pennsylvania: *Ardmore*
Washington, D.C.: *Georgetown Park*

Osborne & Little
Atlanta, GA 30305: *Ainsworth-Noah and Associates, 351 Peachtree Hills Ave., N.E.* (404) 231-8787
Chicago, IL 60654: *Designers Choice, Inc., 6-119 Merchandise Mart* (312) 944-1088
Dallas, TX 75207: *Boyd Levinson & Company, 1400-C HiLine Drive* (214) 698-0226
Denver, CO 80202: *Kneedler-Fauchere, 1801 Wynkoop St.* (303) 292-5353
Houston, TX 77056: *Boyd Levinson & Company, 5120 Woodway* (713) 961-4937
Los Angeles, CA 90069: *Kneedler-Fauchere, 8687 Melrose Ave.* (213) 855-1313
Miami, FL 33137: *Design West, Inc., 4141 N.E. 2nd Ave.* (305) 576-8922
New York, NY 10022: *Osborne & Little, 979 Third Ave.* (212) 751-3333
Philadelphia, PA 19103: *Darr-Luck Associates, Inc., 2400 Market St.* (215) 567-3275
Portland, OR 97209: *Wayne Martin, Inc., 210 N.W. 21st Ave.* (503) 221-1555
San Francisco, CA 94013: *Kneedler-Fauchere, 101 Henry Adams St.* (415) 861-1011
Seattle, WA 98108: *Wayne Martin, Inc., 5701 6th Ave. S.* (206) 763-1990
Stamford, CT 06902: *Osborne & Little, 65 Commerce Rd.* (203) 359-1500
Washington, D.C. 20024: *Darr-Luck Associates, Inc., 300 D. St., S.W.* (202) 646-0260
Canada: *Habert Associates Limited, 321 Davenport Rd., Toronto, Ontario M5R 1K5* (416) 960-5323

Rose Cumming Chintzes, Ltd.
Atlanta, GA 30305: *Ainsworth-Noah and Associates, 351 Peachtree Hills Ave., N.E.* (404) 231-8787
Boston, MA 02210: *Devon Service, Inc., One Design Center Place* (617) 451-7787
Chicago, IL 60654: *Holly Hunt Ltd., Merchandise Mart* (312) 661-1900
Dallas, TX 75207: *Walter Lee Culp Associates, 1505 Oak Lawn* (214) 651-0510
Houston, TX 77056: *Walter Lee Culp Associates, 5120 Woodway* (713) 623-4670
Los Angeles, CA 90069: *Keith McCoy & Associates, 8710 Melrose Ave.* (213) 657-7150
Miami, FL 33137: *Charles Gelfond Associates, 4141 N.E. 2nd Ave.* (305) 573-0880
Minneapolis, MN 55405: *Holly Hunt Ltd., 275 Market St.* (612) 332-1900
New York, NY 10022: *Rose Cumming Chintzes,*

Ltd., 232 E. 59th St. (212) 758-0844
Philadelphia, PA 19103: *Duncan Huggins Perez*, 2400 Market St. (215) 567-3573
San Francisco, CA 94103: *Keith McCoy & Associates*, 151 Vermont St. (415) 861-4848
Washington, D.C. 20024: *Duncan Huggins Perez*, 300 D St., S.W. (202) 484-4466

Arthur Sanderson & Sons
Atlanta, GA 30305: *Marion Kent, Ltd.*, 351 Peachtree Hills Ave., N.E. (404) 237-9000
Boston, MA 02210: *Walls Unlimited*, One Design Center Place (617) 423-4333
Chicago, IL 60654: *Holly Hunt Ltd.*, Merchandise Mart (312) 661-1900
Dallas, TX 75207: *Hargett Associates*, 1700 Oak Lawn (214) 747-9600
Denver, CO 80209: *Shears & Window*, 595 South Broadway (303) 744-1676
High Point, NC 27260: *Marion Kent, Ltd.*, 401 W. High Ave. (919) 889-8000
Houston, TX 77056: *Hargett Associates*, 5120 Woodway (713) 626-3100
Laguna Niguel, CA 92656: *J. Robert Scott & Associates*, 23811 Aliso Creek Rd. (714) 643-8727
Los Angeles, CA 90069: *J. Robert Scott & Associates*, 8727 Melrose Ave. (213) 659-4910
Minneapolis, MN 55405: *Holly Hunt Ltd.*, 275 Market St. (612) 332-1900
New York, NY 10022: *Arthur Sanderson & Sons*, 979 Third Ave. (212) 319-7220
San Francisco, CA 94103: *Shears & Window*, 101 Henry Adams St. (415) 621-0911
Seattle, WA 98108: *Collins & Draheim*, 5701 6th Ave. S. (206) 763-4100
Washington, D.C. 20024: *Marion Kent, Ltd.*, 300 D St., S.W. (202) 863-1300

Stark Carpet Corporation
New York, NY 10022: *Stark Carpet Corporation*, 979 Third Ave. (212) 752-9000

Alphabetical Listing

556 Antiques *Antique Fabrics*
Abingdon Carpets Ltd *Carpets & Rugs*
Adam Contract Carpets *Carpets & Rugs*
Afia Carpets *Carpets & Rugs*
Shyam Ahuja *International*
Alexanders *Silk Weaves*
Ambrose Fabrics Ltd *Childrens Fabrics*
Meg Andrews *Antique Fabrics*
Ankaret Cresswell *Wool*
Anker Contract Carpets *Carpets & Rugs*
The Antique Textile Company *Antique Fabrics*
Armitage Sinclair *Wool*
Laura Ashley Decorator Collection *Chintz; Cotton Prints; Linen Union; Lace & Sheers; Trimmings*
Laura Ashley Home Furnishing *Cotton Prints; Linen Union; Lace & Sheers; Trimmings; Childrens Fabrics; Carpets & Rugs*
Aspects Applied Arts Showhouse *Speciality Fabrics; Carpets & Rugs*
Rosemary Atkinson *Silk Weaves*
Aurora Fabrics Ltd *Cotton Prints*
Avena Carpets Ltd *Carpets & Rugs*
Axminster Carpets Ltd *Carpets & Rugs*
BMK Ltd *Carpets & Rugs*
GP & J Baker *Chintz; Cotton Prints; Linen Union*
L & E Barnett (Trimmings) Ltd *Trimmings*
Geoffrey Bennison *Antique Fabrics*
Bentley & Spens *Cotton Prints; Silk Prints; Lace & Sheers*
Bernadout & Bernadout *Antique Fabrics*
Celia Birtwell *Cotton Prints; Line Union; Silk Prints; Lace & Sheers*
Jilli Blackwood *Speciality Fabrics*
Blossom (Fabrics) Ltd *Cotton Prints; Lace & Sheers*
Gabrielle Bolton *Cotton Prints; Silk Prints*
Janet Bolton *Speciality Fabrics*
Joanna Booth *Antique Fabrics*
Boras International (UK) Ltd *Childrens Fabrics; International*
Bosanquet Ives Ltd *Carpets & Rugs*
Susan Bosence *Speciality Fabrics*
Bower Roebuck & Company Ltd *Speciality Fabrics*
Bowland Prints Ltd *Cotton Prints*
John Boyd *Speciality Fabrics*
Brintons Carpets Ltd *Carpets & Rugs*
British Antique Dealers Association *Antique Fabrics; Reference*
The British Carpet Manufacturers Association Ltd *Carpets & Rugs; Reference*
The British Contract Furnishing Association *Reference*
British Furtex Fabrics Ltd *Wool*
British Replin Ltd *Wool*
British Trimmings Ltd *Trimmings*
Broadhead & Graves *Wool*
Brockway Carpets *Carpets & Rugs*
Ethna Brogan Textile Design *Linen*
Bronte Carpets Ltd *Carpets & Rugs*
J Brooke Fairbairn & Company *Cotton Weaves*
Linda Bruce Studio *Cotton Prints*
Bute Fabrics Ltd *Wool*
Joanna Buxton *Speciality Fabrics*
C&J Hirst Fabrics Ltd *Wool*
CP Carpets *Carpets & Rugs*
CV Carpets *Carpets & Rugs*
Calzeat *Silk Weaves; Linen; Wool*
Cambourne Fabrics Ltd *Wool*
Malcolm Campbell *Chintz; Linen Union*
Nina Campbell Ltd *Chintz; Linen Union*
Manuel Canovas *International*
Carpets of Worth Ltd *Carpets & Rugs*
Carrington Carpets *Carpets & Rugs*
Castleisland Weaving *Wool*
Cathy & Eve Designs *Carpets & Rugs*
Christina Chance *Antique Fabrics*
Celia Charlottes *Antique Fabrics*
Checkmate Carpets *Carpets & Rugs*
Chelsea Green Fabrics *Chintz; Cotton Prints; Lace & Sheers*
Christie's *Antique Fabrics*
Jane Churchill Ltd *Chintz; Cotton Weaves*
Clandeboye Carpets Ltd *Carpets & Rugs*
Clansman Tweeds Company Ltd *Wool*
Claridge Mills Ltd *Silk Weaves; Linen; Wool*
Alice Clark *Carpets & Rugs*
William Clark & Sons Ltd *Linen*
Close Antiques *Antique Fabrics*
Cole & Son *Chintz; International*
Colefax & Fowler *Chintz; Cotton Prints; Cotton Weaves; Linen Union; Lace & Sheers; Trimmings; Carpets & Rugs*
Collier Campbell *Cotton Prints*
Anne Collin *Cotton Prints; Lace & Sheers*
Peter Collingwood *Carpets & Rugs; Speciality Fabrics*
Julie Collino *Antique Fabrics*
Sarah Collins *Cotton Prints; Silk Prints*
Collins & Hayes Ltd *Cotton Weaves*
The Colouroll Store *Cotton Prints; Childrens Fabrics*
Colour Counsellors Ltd *Chintz; Cotton Prints*
Alistair Colvin *Antique Fabrics*
Connemara Fabrics Ltd *Silk Weaves; Linen*
The Contemporary Textile Gallery (CTG) *Cotton Prints; Silk Prints; Speciality Fabrics; Carpets & Rugs*
Sian Tucker (Contemporary Textile Gallery) *Speciality Fabrics*
Contract Design Association *Reference*
Cook Mills *Wool*
Belina Coote *Antique Fabrics*
Corney & Company *Cotton Prints; Silk Prints*
Bobbie Cox *Speciality Fabrics*
Crafts Council *Speciality Fabrics; Reference*
Craigie Stockwell Carpets Ltd *Carpets & Rugs*
Creation Baumann *International*
Crombie *Silk Weaves; Wool; Speciality Fabrics*
Crowthers Contract Carpets *Carpets & Rugs*
Curlew Weavers *Wool*
Wendy A Cushing *Trimmings*
Jason D'Souza Designs *Cotton Prints; Silk Prints; Lace & Sheers*
Danielle *Cotton Prints; Silk Prints; Lace & Sheers*
Dartington Mills Ltd *Wool*
De Mont & Wright Designers *Cotton Weaves; Carpet & Rugs*
The Design Archives *Chintz; Cotton Prints; Silk Prints*
The Design Council *Reference*
The Design Group of Great Britain *Reference*
Designer Choice *Carpets & Rugs*
Designer Style *Cotton Prints; Cotton Weaves*
Designers Guild *Chintz; Cotton Prints; Cotton Weaves; Linen Union; Carpets & Rugs*
Distinctive Trimmings *Trimmings*
Annie Doherty *Silk Prints*
Donald Brothers Ltd *Wool*
Lynne Dorrien *Carpets & Rugs*
Double Weave *Speciality Fabrics*
Dovedale Fabrics Ltd *Chintz; Cotton Prints; Cotton Weaves*
Dragons of Walton Street Ltd *Childrens Fabrics*
Elizabeth Eaton *Linen; International*
Edinburgh Weavers *Cotton Prints; Cotton Weaves*

Philip Edwards *Chintz; Cotton Prints*
Pamela Elsom Antiques *Antique Fabrics*
John England *Linen*
English Eccentrics *Cotton Prints*
Grace Erickson *Speciality Fabrics*
David Evans *Silk Prints; Wool; Speciality Fabrics*
Edward Liddell Ltd *Linen*
Joan Eyles Antiques *Antique Fabrics*
Firth Carpets *Carpets & Rugs*
Christian Fischbacher *International*
Foursquare Designs *Cotton Prints; Lace & Sheers; International*
Fox & Floor *Cotton Weaves; Silk Weaves; Wool*
Mary Fox Linton *International*
Foxford Woollen Mills Ltd *Wool*
Josiah France *Wool*
Victor Franses Gallery *Antique Fabrics*
S Franses Ltd *Antique Fabrics*
John French *Carpets & Rugs*
Anna French Fabrics *Cotton Prints; Lace & Sheers, International*
The Gainsborough Silk Weaving Company Ltd *Cotton Weaves; Silk Weaves*
Gallery of Antique Costumes & Textiles *Antique Fabrics*
Susanne Garry Ltd *International*
Gaskell Broadloom Ltd *Carpets & Rugs*
Georgian Goodacre Ltd *Carpets & Rugs*
Gilt Edge Carpets *Carpets & Rugs*
Glenside Fabrics Ltd *Wool*
Goodacre Carpets Ltd *Carpets & Rugs*
Juliet Goodden *Carpets & Rugs*
Alex Gossley *Carpets & Rugs*
Graham & Green *Cotton Prints*
Great Malvern Antiques *Antique Fabrics*
Leslie Greaves *Carpets & Rugs*
Linda Gumb *Antique Fabrics*
Habitat Designs *Childrens Fabrics*
Charles Hammond *Chintz; Cotton Prints; Linen Union*
Sally Hampson *Carpets & Rugs*
Celia Harrington *Carpets & Rugs*
BB Harris Antiques *Antique Fabrics*
Harris Tweed *Wool*
The Harris Tweed Association Ltd *Wool; Reference*
Arthur Harrison *Wool*
John Hartley (Cowley) Ltd *Wool*

Nicholas Haslam Decoration *Chintz*
Hebble Rugs Ltd *Carpets & Rugs*
Heckmondwike Carpets Ltd *Carpets & Rugs*
Heild Brothers Ltd *Wool*
Heraz *Antique Fabrics*
Heskia *Antique Fabrics*
Hewetson Ltd *Lace & Sheers*
Heywood Wallcoverings *Wool*
David Hicks *Chintz; Cotton Prints; Cotton Weaves*
Hill & Knowles *Chintz; Cotton Prints*
The Home & Contract Furnishing Textiles Association *Reference*
Horrockses Fabrics Ltd *Childrens Fabrics*
Huddersfield Fine Worsteds *Wool*
Paul Hughes *Antique Fabrics*
Humphries Weaving Company *Cotton Weaves; Silk Weaves*
Huntington Antiques Ltd *Antiques Fabrics*
Ian & Marcel *Silk Prints*
Independent Designers Federation (IDF) *Silk Prints; Speciality Fabrics*
Interior Decorators & Designers Association *Reference*
Interior Selection *Cotton Prints; Cotton Weaves; Trimmings*
International Linen Promotion *Linen; Reference*
International Mohair Association *Reference*
International Wool Secretariat *Wool, Carpets & Rugs, Reference*
Irish Export Board *Reference*
The Isle Mill Ltd *Wool*
David Ison Designs Ltd *Cotton Prints*
JAB International *Cotton Weaves; International*
Jamasque Ltd *Cotton Weaves*
Johnstons of Elgin *Speciality Fabrics*
Paul Jones *Antique Fabrics*
Wendy Jones *Carpets & Rugs*
K&K Designs *Cotton Prints*
Stefan Keef Ltd *Cotton Prints, Silk Prints, Lace & Sheers*
H Keil Ltd *Antique Fabrics*
Kendix Designs *International*
Kenneth Macleod (Shawbost) Ltd *Wool*
Kinnasand UK Ltd *International*
Elizabeth Kitching *Carpets & Rugs*
Krams-Ugo Ltd *Lace & Sheers*
Alexandra Lacey *Silk Prints*

Tessa Lambert *Silk Prints*
Leonard Lassalle (Antiques) Ltd *Antique Fabrics*
Christopher Lawrence *Cotton Prints*
Sue Lawty *Speciality Fabrics*
Learoyd Bros & Co *Linen; Wool*
John Lewis Contract Furnishings *Chintz; Cotton Prints; Cotton Weaves; Lace & Sheers; Childrens Fabrics*
Liberty of London Prints *Chintz; Cotton Prints; Linen Union*
Shirley Liger Designs *Chintz; Cotton Prints; Silk Prints; Linen Union*
Lines of Pinner *Childrens Fabrics*
Lintrend Ltd *Linen*
Edith de Lisle Designs *Cotton Prints*
Lister & Co PLC *Childrens Fabrics; Carpets and Rugs*
London & Provincial Antique Dealers *Antique Fabrics; Reference*
Loot *Antique Fabrics*
Lots Road Galleries *Antique Fabrics*
Lunn Antiques *Antique Fabrics*
Lyle Carpets Ltd *Carpets & Rugs*
Peter MacArthur & Co Ltd *Wool*
Hugh Mackay PLC *Carpets & Rugs*
Macroom Carpets *Carpets & Rugs*
Malcolm Temple Design Ltd *Carpets & Rugs*
Ian Mankin *Cotton Prints; Cotton Weaves; Lace & Sheers; International*
Manx Carpets *Carpets & Rugs*
Market Place Antiques *Antique Fabrics*
Martin, Sons & Co Ltd *Wool; Speciality Fabrics*
Marvic Textiles *Cotton Prints; International*
Mayorcas Ltd *Antique Fabrics*
Kenneth McKenzie Holdings Ltd *Wool*
McKinney Kidston *Antique Fabrics*
McMurray Connemara *Carpets & Rugs*
McNutt Weaving Co Ltd *Linen; Wool*
Mercia Weavers *Carpets & Rugs*
Merino Carpets Ltd *Carpets & Rugs*
Janet Milner *Cotton Prints*
Jennie Moncur *Speciality Fabrics*
Monkwell Fabrics *Chintz; Cotton Prints; Cotton Weaves, Linen Union*
Mrs Monro *Chintz*
Morgan & Oates *Carpets & Rugs*
Alison Morton *Speciality Fabrics*
Mourne Textiles Ltd *Wool*

Moxon Huddersfield *Speciality Fabrics*
Moygashel *Cotton Prints; Linen Union*
Munro & Tutty *Cotton Prints*
Munster Carpets Ltd *Carpets & Rugs*
RG Neill & Son *Silk Weaves; Linen; Wool*
Emerson Nelmes *Trimmings*
Henry Newbery & Co Ltd *Cotton Prints; Trimmings*
Newhey Carpets Co Ltd *Carpets & Rugs*
Next Interiors *Cotton Prints; Cotton Weaves; Linen Union; Carpets & Rugs*
Nobilis-Fontan *International*
Robert Noble *Wool*
The Nursery Window *Childrens Fabrics*
John Orr Ltd *Linen; Wool*
Osborne & Little *Chintz; Cotton Prints; Cotton Weaves; Silk Weaves; Trimmings; International*
Pallu & Lake *International*
Palmer-Phipps Design Associates *Cotton Prints*
Paper Moon *Childrens Fabrics; International*
Parkettex Fabrics *Chintz; Cotton Prints; Cotton Weaves; Silk Prints; Lace & Sheers*
Pendle Carpets Ltd *Carpets & Rugs*
Penine Fullwool Carpets *Carpets & Rugs*
Penthouse Carpets Ltd *Carpets & Rugs*
HA Percheron *International*
Judith Perry *Speciality Fabrics*
Philips *Antique Fabrics*
Ploeg *International*
Poppy for Children *Childrens Fabrics*
Punch Antiques *Antique Fabrics*
Putnams Collections Ltd *Cotton Prints*
Ramm, Son & Crocker Ltd *Chintz; Cotton Prints; Linen Union*
Reputation *Cotton Prints*
Zandra Rhodes *Chintz*
Rich & Smith *Cotton Prints; International*
Vanessa Robertson *Carpets & Rugs*
Marta Rogoyska *Speciality Fabrics*
Rosine Ltd *Cotton Prints; Childrens Fabrics*
The Royal Arts Society *Reference*
The Royal Institute of British Architects *Reference*
Ryalux Ltd *Carpets & Rugs*
Sahco Hesslein UK Ltd *International*
Arthur Sanderson & Son *Chintz; Cotton Prints; Cotton Weaves; Linen Union; Carpets & Rugs*

Ian Sanderson (Textiles) Ltd *Chintz; Cotton Prints; Cotton Weaves; Lace & Sheers; International*
Schemes *Chintz*
Scottish Woollen Publicity Council *Wool*
Sekers Fabrics Ltd *Chintz; Cotton Prints; Cotton Weaves; Wool*
Shaw Carpets *Carpets & Rugs*
Shelley Textiles Ltd *Carpets & Rugs*
Muriel Short Designs *Chintz*
Signature Rugs *Carpets & Rugs*
Silk Association of Great Britian *Silk Prints; Silk Weaves; Reference*
Skopos Design Ltd *Cotton Prints; Cotton Weaves; Wool*
Caroline Slinger *Carpets & Rugs*
Peta Smyth Antique Textiles *Antique Fabrics*
Spence Bryson & Co Ltd *Linen*
Spencer-Churchill Designs Ltd *Chintz*
Geraldine Sy Aubyn Hubbard *Speciality Fabrics*
St Leger Fabrics *Cotton Prints; Cotton Weaves; International*
Steeles Carpets *Carpets & Rugs*
The Coral Stephens Collection *International*
A Stitch in Time *Antique Fabrics*
Stockwell Riley Hooley Ltd *Carpets & Rugs*
Stoddard Carpets Ltd *Carpets & Rugs*
Sue Stowell *Chintz*
Stuart Renaissance Textiles *Silk Weaves; Wool*
Ann Sutton Textiles *Speciality Fabrics*
Michael Szell Ltd *Chintz; Cotton Prints; Cotton Weaves; Silk Prints; Lace & Sheers*
Jasia Szerszynska *Speciality Fabrics*
Tankard Carpets *Carpets & Rugs*
Dr Brian J Taylor *Trimmings*
Taylor & Littlewood Ltd *Wool*
Taylor & Lodge *Speciality Fabrics*
Taylor, Livesley & Co Ltd *Wool*
The Textile Gallery *Antique Fabrics*
The Textile Institute *Reference*
Textra Ltd *Chintz; Cotton Prints; Cotton Weaves; Linen Union*
Thornborough Galleries *Antique Fabrics*
Thorp & May Designs Ltd *Chintz*
Bernard Thorpe *Chintz; Cotton Prints; Cotton Weaves; Silk Prints; Linen Union; Lace & Sheers*
Jonathan Thorpe & Sons *Linen*
Timney Fowler Prints *Cotton Prints; Silk Prints*

Tintawn Ltd *Carpets & Rugs*
Tissunique *International*
Titley & Marr *Chintz*
Today Interiors *Cotton Prints; Cotton Weaves*
Tomkinsons Carpets Ltd *Carpets & Rugs*
Trafford Carpets Ltd *Carpets & Rugs*
Trendy Tuft Designs *Childrens Fabrics*
Turnell & Gigon *International*
GJ Turner *Trimmings*
Kenneth Turner *Cotton Prints*
Ulster Carpet Mills Ltd *Carpets & Rugs*
The Ulster Weavers Co Ltd *Linen*
Upstairs Shop *Cotton Prints*
V'Soske-Joyce *Carpets & Rugs*
Verity Fabrics *Chintz; Cotton Prints; Silk Prints; Childrens Fabrics*
Victoria Carpets Ltd *Carpets & Rugs*
Vigo Carpet Gallery *Antique Fabrics*
Virginia Antiques *Antique Fabrics*
Viyella *Cotton Prints; Wool*
Sasha Waddell *Cotton Prints; Cotton Weaves; Silk Prints; Linen; Wool*
Warner & Sons Ltd *Chintz. Cotton Prints; Cotton Weaves; Linen Union; Silk Weaves; Wool*
Watts & Co Ltd *Cotton Prints; Cotton Weaves; Silk Weaves; Trimmings*
Wemyss Houles *International*
Wilton Royal *Carpets & Rugs*
Woodward Grosvenor & Co Ltd *Carpets & Rugs*
Helen Yardley *Carpets & Rugs*
Yately Industries for the Disabled *Cotton Prints*
Brian Yates *Chintz; International*
WE Yates *Wool*
Yorkshire Tweeds Ltd *Wool*
Young Designers *Reference*
Zipidi *Chintz; Cotton Prints; Linen Union; Childrens Fabrics*
Zoffany *Chintz; Cotton Prints; International*